Power and Process

A Report from the Women Linking for Change
Conference, Thailand, 1994

be returned on

Geraldine Reardon

Oxfam
(UK and Ireland)

Published by Oxfam (UK and Ireland) 274 Banbury Road, Oxford OX2 7DZ

Designed by Oxfam Design Department OX245/PK/95
Cover illustration by Alison Moreton

Printed by Oxfam Print Unit

Oxfam is a registered charity no. 202918

Contents

Preface

This book is an analytical report of Oxfam UK/I's Women Linking for Change Conference, held in Thailand in February 1994. As the Coordinator of Oxfam's Women's Linking Project, which started in 1992, I felt that the Conference, which was the final stage in the two-year Women's Linking Project, ended with a very strong message from Oxfam staff, Southern women's groups, and other international development agencies. The message is that radical transformation is needed in many aspects of Oxfam UK/I's work, as it moves towards full implementation of the organisational Gender Policy, which was ratified in 1993.

The WLP Conference was a milestone for Oxfam; it provided an opportunity to listen to many different voices, enabling women and men at the front-line of development practice to make their various views heard and acted on. Yet, it is important to remember that the Conference was just one part of a much longer learning process. Oxfam's formal work on gender issues began in 1985, building on the many years of worldwide struggle of women and men to put gender issues on the agenda of mainstream development organisations.

However, despite ostensible commitment to gender issues, the power politics of development have in the past meant that the work of development agencies such as Oxfam UK/I has not, in the main, been shaped by, or even linked to, the women's movement in the South, where Oxfam UK/I's programme is largely based. The WLP was intended to be a first attempt to build a bridge, through beginning a dialogue between Oxfam UK/I and sister organisations from the North, and women's organisations in the South.

Within Oxfam UK/I, the WLP process signalled a significant shift in thinking about the implications of taking on the Gender Policy. We are changing as an organisation, and the vision and direction of those changes has been, to a great extent, inspired and guided by 'women

linking for change'. Clear messages and recommendations from the Conference have begun to make a real impact on Oxfam UK/I's work and culture. Voices in the WLP emphasised the need for a holistic view of development: economic, socio-cultural, and political factors cannot be delinked. Women are asserting their right to development, in all possible spheres of their lives. The WLP called on Oxfam UK/I to build on the work it has begun in hitherto unrecognised areas of legitimate concern to development: violence against women; promotion of women's human rights including reproductive rights; and promotion of women's political participation in civil society through capacity-building and leadership training.

Externally, these messages have been carried forward in extensive lobbying and advocacy work in the build-up to the World Social Summit on Development (Copenhagen 1995) and the United Nations Fourth Women's Conference (Beijing 1995). More than 20 Oxfam UK/I programmes have been actively involved in this work since the WLP Conference, building national and regional forums together with feminist organisations and networks in four continents.

The WLP Conference was a critical springboard for gender policy development, not only in Oxfam UK/I, but in other organisations in Oxfam International; representatives of some of these were present in Thailand. Links with our sibling Oxfams have grown and strengthened since the Conference, through co-operation both on the ground in programme development work, and in advocacy work on gender issues in international arenas. An International Working Group on gender policy and practice now exists across the breadth of Oxfam International, aiming to strengthen and monitor our shared commitment to gender-fair development.

Internally, within Oxfam UK/I, the WLP process highlighted the need to value the diversity of our human resources. This point has resonated throughout fora for Oxfam UK/I staff since the WLP Conference. Oxfam UK/I has now committed itself to a policy of capacity-building and staff development, and to recognising and responding to the cultural diversity which exists throughout the organisation. This means changing working culture to recognise the value of different ways of thinking and working, and taking positive action to promote and support women, and other under-represented constituencies, at all levels of the organisation.

The WLP Conference emphasised the need for Oxfam UK/I to scale up its support to women's empowerment, supporting different kinds of interventions, such as lobbying, and research on development theory and practice. Ways need to be found of linking good practice to policy development; funding across country boundaries needs to increase, to

support regional work, and funds need to be found for thematic work across regions.

The WLP Conference had much to say about gender and partnership; calls were made for the work which Oxfam UK/I undertakes with counterpart organisations to be informed by a gender perspective. The link between feminist organisations and development needs to be recognised, and Oxfam must work with organisations who have the empowerment of women as an explicit goal. Most importantly, the imbalanced power relations that exist between donor and recipient must be recognised and addressed as far as possible, through increasing transparency and accountability in the relationship.

Diversity of experience and view is both the main obstacle to, and opportunity for, dialogue on development issues. Through consultations with women's organisations from Africa, Asia and Latin America and the Caribbean, we all recognised differences in circumstances, perceptions of the world, and priorities. In spite of this variety, there was a strong message being forged in the different fora provided by the project: women's equality and gender issues can no longer be ignored. Networking and capacity-building of this sort is a powerful tool for development, and funding agencies need to support alliance-building and linking between South-North, South-South, and North-North organisations.

The WLP was launched with support from Oxfam UK/I's Fiftieth Anniversary Fund. Oxfam UK/I is grateful for further support from the Overseas Development Administration (SEADD), and the United Nations Fund for Women (UNIFEM), which made the Women's Linking Project possible. Finally, I would like to thank all the women and men who supported the project, and put so much work into its success. These include, in particular, the following Oxfam staff members who helped to co-ordinate and administer the WLP: Mercedes Cumberbatch, Kate Hamilton, Caroline Knowles, Sarah Perman, Dimsa Pityana, and Peta Sandison.

Candida March
Co-ordinator, Women's Linking Project

1

Introduction

Oxfam UK/I's focus is on gender, rather than on women, to ensure that changing women's status is the responsibility of both sexes. It acknowledges that development affects men and women differently and that it has an impact on relations between men and women. A focus on gender is required to ensure that women's needs (set in the broader context of class, ethnicity, race and religion) do not continue to be ignored.
Gender and Development: Oxfam's Policy for its Programme, May 1993

In February 1994, Oxfam UK/I funded an International Conference in Bangkok, Thailand, for Oxfam UK/I staff, staff from other organisations in the Oxfam Family, partner organisations, and international women's organisations, as the final stage of its Women's Linking Project (WLP), initiated in 1992 as part of Oxfam's fiftieth anniversary celebrations. The aim of the WLP Thailand Conference — the first of its kind for any European development agency working in the South — was to enable Oxfam UK/I field staff and Southern women's organisations to contribute to gender-fair policies and programmes that are sensitive to Southern women's perspectives. Specific objectives of the Conference included:

- engaging women from gender-focused Southern organisations and Oxfam UK/I in a dialogue on critical development issues from a gender perspective;

- fostering a dialogue and encouraging North-South co-operation;

- examining Oxfam UK/I's efforts to integrate gender into its programmes in the light of gender perspectives from the South;

- sharing information and cross-regional learning on gender and development issues;

1

- distilling examples of 'best practice', and consolidating lessons learnt in gender and development work in Oxfam UK/I to date;

- encouraging solidarity and support among development practitioners working on gender and development.

Participants at the Conference were a diverse group of people, representing different perspectives. The majority were Oxfam UK/I staff who work on gender and development issues; these were drawn from all parts and many levels of the organisation. Field offices throughout the world were represented, as well as Oxfam head office, and staff attending were from senior management to programme officer level. Beyond Oxfam staff, valuable input into the Conference came from representatives from Southern women's organisations who had attended the Global Meeting a few days previously, and from representatives of other funding agencies. Those participants who viewed themselves as committed feminists were matched by others who remained wary of the value of a gender analysis to development.

This book has been prepared to bring the main points raised and discussed at the WLP Conference to a wider readership, to encourage discussion of what it means to look at development through a gender lens. This is not a Conference report in the sense of a detailed hour-by-hour record, but attempts to draw on the issues and ideas of the Conference participants, and to reveal some of the tensions that arise in implementing a gender policy in a development agency like Oxfam UK/I. These tensions can be found at many points: between the demands made by Southern partners and the resources available; in attempting to reconcile an overall strategy for development with a plurality of needs; and, finally, in the resistance within organisations to personal and institutional change.

To open the debate, this Introduction will trace the history behind the WLP Conference, giving a brief survey of gender work within Oxfam UK/I. Chapter Two deals with some key issues and perspectives which underly gender and development work in general, and inform participants' views on the issues discussed at the WLP Conference. The rest of the book falls into two sections; the first consists of five chapters in which an introduction is followed by an expert paper addressing an aspect of the external context in which Oxfam works. These chapters offer a glimpse of the 'world outside' the work of development agencies. The 'world within' is explored in the final section of the book, which discusses the implications of taking on a gender policy for Oxfam UK/I as an institution.

Throughout, the book draws on the many case studies from Oxfam UK/I field offices, and reports of the five Regional Meetings and the

Global Meeting, which led up to the WLP Conference. It attempts to cover issues as they were raised at the Conference and as they were responded to, drawing on the records of the Conference facilitators, and the documentation team.

The challenge of change

Oxfam UK/I has field offices in 77 countries, through which it funds local non-governmental organisations (NGOs) in partnership. Oxfam is operational, implementing its own programme, in some countries. It supports education, research and lobbying in the North on policies and issues that affect the South. Over the years, a mountain of evidence from around the world has supported the claim that conventional development has by-passed, alienated, and harmed many more women than it has helped.[1] Just as people's class, caste, ethnicity, and disability affect their chances in life, and the depth and nature of their poverty, so, critically, does a person's sex. Women carry a heavier burden of work, and face social and cultural discrimination on the grounds of sex, which affects every aspect of their lives, including their economic, social and political participation in the processes of development.

Gender analysis in development looks at the different interests and needs of women and men in each community, and seeks ways of correcting the power imbalances in gender relations that deprive so many women of so much. The obstacles to such an objective cannot be underestimated; gender relations are concerned with power, and resistance to relinquishing power is to be expected.

An organisation which, like Oxfam, seeks to work with the 'poorest of the poor' must logically be drawn to working with, and resourcing, women living in poverty. Proponents of a gender analysis of development see a fundamental flaw in imposing a hierarchical and discriminatory order in the name of development. In theory, this is in broad agreement with Oxfam UK/I's approach to development: to provide the means to enable people to find their own power to determine the direction of their lives and decide what sort of 'development' they want.

Oxfam UK/I's Gender and Development Unit (GADU) was set up in 1986 with a brief to offer advice from a gender perspective to Oxfam's overseas programme activities. GADU became a focal point for research, education, and information exchange not only for Oxfam UK/I staff, but beyond the organisation, for development practitioners, academics, and students in the South and the North.

Since then, GADU — renamed the Gender Team in 1993, upon organisational restructuring — has made a strong contribution to the

attempts of inter-agency fora in the UK and Europe to influence official and non-governmental development policy. Oxfam takes an active and supportive role in the Gender and Development Network of the National Alliance of Women's Organisations (NAWO) in the UK, and in EUROSTEP, a group of European non-governmental development organisations working in the South.

Within Oxfam UK/I, the Gender Team has developed a programme of work, including staff training and consultation, with the objective of bringing gender and development analysis into the mainstream of the organisation's work. The Gender Team also focuses on issues which are only now being recognised as valid concerns for development agencies, such as violence against women, and reproductive rights, and which link the concerns of women's organisations and development agencies.

Oxfam UK/I's Gender Policy

In May 1993, during its fiftieth anniversary year, Oxfam UK/I ratified an organisational gender policy, formally acknowledging its concern about the fact that women are disproportionately represented among the very poorest people throughout the world, and that women are poorer than the men in their own social groupings. As Oxfam UK/I's Gender Policy states, 'development affects men and women differently'.

Oxfam UK/I's Gender Policy committed the organisation to far more than merely ensuring that all its programme work takes women's gender interests into account, and works towards meeting their practical and strategic needs. In taking on a gender policy, Oxfam UK/I committed itself to challenging the status quo in gender relations in its programme work, and to bring about radical change in the way development is analysed and practised. The gender policy challenges Oxfam to assess its own record on discrimination against women staff on grounds of gender, as well as examining the practices and projects of its partners. It stresses that attention must be given to Oxfam's own work culture, and how power is used within the organisation.

Seldom has a policy had such profound implications for the way Oxfam UK/I works: fully to implement its gender policy may prove to be one of the most difficult challenges Oxfam UK/I will ever face. As the single outstanding message from the Women's Linking Project Thailand Conference puts it: 'gender means doing things differently.' The point of taking on a gender perspective in development work is not to apply the current model of development more evenly, but to change the model itself. In order to achieve the aim of development which reaches women and overcomes the structural discrimination which they face, a dramatic

and comprehensive change of perspective and activity is needed, within the organisations which fund development activities (including multilaterals, bilaterals, international NGOs, and government structures), and those who receive funding (including NGOs in developing countries, and individuals and groups who are partners in development).

Addressing gender in development means examining imbalances in relationships, and therefore highlights the issues of power and decision-making within development organisations themselves. Although taking on a gender perspective means that all development work, with both men and women, should take into account women's and men's differing experience of life, there is a need to overcome existing discrimination against women by directing resources to activities and organisations which attempt to address women's current subordination. If women are to gain the capacity to determine their own development, which must include challenging gender discrimination, more resources have to be directed towards meeting their particular needs.

Oxfam's Women's Linking Project (WLP)

GADU launched the Women's Linking Project in 1992. The three-year project was based on a programme of consultation, with Oxfam UK/I staff and Southern organisations who were addressing gender and development issues in their work.

Initial objectives for the WLP were 'for women in development to exchange ideas on development practice; to network in the UK and Ireland; to publicise Oxfam's work with women and gender, and strategise on gender issues'.[2] The WLP, as envisaged even at this early stage, was a pioneering attempt to raise the profile of gender and development issues within Oxfam UK/I's programme and communications work, and to strengthen the organisation's commitment, at every level, to gender-fair development.

The WLP presented a chance for Southern and Northern women — staff, supporters and members of the wider public — to share experiences and ideas, and to discuss joint strategies. Gender analysis is a relatively new approach to development, and knowledge of the issues, and commitment to them, is not necessarily shared among development practitioners and the organisations with whom they have chosen to work. Those who were already working with a gender perspective needed an opportunity to discuss the issues and practicalities with others.

Genuine consultation between the different interest groups involved is an important part of a gender and development analysis. Throughout

5

the WLP, Oxfam UK/I staff and representatives of Southern organisations worked together to strengthen links between groups and to develop a body of recommendations for gender and development that is sensitive to Southern needs.

To facilitate such consultation, and to allow for an organic growth of the Project's aims and activities based on consultation, the WLP was designed as a series of stages, each a project in its own right, yet each building on what had been learned from the previous one. This idea of a 'process-oriented' development initiative, as opposed to a succession of discrete fixed projects, was central to the thinking behind the Project. This approach to development is currently part of debates on the practice of development, within and outside Oxfam.

The first stage of the WLP consisted of an exercise in 'North-South linking', involving consultation with Oxfam field officers and project partners in the South about what they themselves considered to be the important gender issues for development. The process of selecting issues to focus on began in the first stage of the Women's Linking Project, when eight women from the South identified issues which they were interested in debating with women in the UK and Ireland. These were: violence against women, health and reproductive rights, culture, and economics and IMF/World Bank Structural Adjustment Programmes (SAPs).

These issues became foci throughout the first and second stages of the WLP; the flexibility in the process-oriented approach allowed these initial issues to be joined by two additional ones — political participation and environment — for the Thailand Conference. The five papers in Chapters Three, Four, Five, Six, and Seven were written by recognised authorities on the issues, to provide an up-to-date summary for participants.[3]

In stage one of the WLP, eight Southern women participated in a visit to the UK and Ireland, with the objective of sharing experiences and analyses with organisations who had similar interests, and making the links between women's experience of social, economic, and political marginalisation in South and North.[4]

The second stage started with many of Oxfam UK/I's field offices joining in a review of the organisation's gender and development work, in preparation for a series of international events designed to provide an opportunity for Southern women, working at the grassroots, to bring to the discussions the needs and priorities of the women with whom they work. In late 1993 and early 1994, four Regional Meetings were held in Jakarta (South-East Asia), Harare (Africa), Santiago (Latin America and the Caribbean), and Dhaka (South Asia and the Middle East) for representatives of Southern organisations with which Oxfam UK/I works.

Representatives of these Regional Meetings carried the process forward to the final stage of the project, which consisted of two international conferences in February 1994 in Bangkok, Thailand. First came a Global Meeting of the representatives from the Regional Meetings, which concluded with the participants composing a Declaration from Southern Women's Organisations,[5] followed a few days later, by the Conference for Oxfam Staff.

The 'Women Linking for Change' International Conference for Oxfam Staff, Thailand 1994

The Declaration from the Global Meeting (see Appendix 2), together with the reports of the Regional Meetings and reviews from field offices, helped to shape the agenda for the final event of the WLP — an International Conference, entitled 'Women Linking for Change'. The Conference process took note of events on the world stage which formed the backdrop to its discussions. In particular, the UN Conference on Human Rights, held in Vienna in June 1993, had seen the united action of women from all over the world resulting in a belated recognition of women's rights as human rights, and violence against women as a violation of human rights. This perspective also informs the UN Fourth World Conference on Women in Beijing in September 1995.

'Women Linking for Change' was not an ordinary conference. The proceedings were designed by seven women facilitators from the South, knowledgeable in the theory and practice of gender and development, who met in Bangkok for 12 days before the Conference began, to consider the wide range of views and experiences which had been gathered on the main issues identified in the first stage of the WLP.

The facilitators' task was to design a conference methodology based on the principles of a gender perspective. The process of the Conference was important in itself, but the aim was always to propose recommendations for strategic action.[6]

The Conference programme was designed to fulfil two objectives. First, to provide the time and space necessary for participants to be able to voice their concerns, to share these with fellow participants from their geographical region and find common ground as well as links between different concerns, and to formulate recommendations for action.

The second objective was to devise a new way of conferring, which could accommodate both commonality and diversity, in a manner which did not seek to conceal potential areas of dissent or difficulty. To aim for transparency in debate and decision-making was in line with democratic procedures developed by women's organisations in the South, and an

7

essential part of a vision of a future, more equitable process of development. As Maria Suarez Toro, one of the Conference facilitators, stated, 'gender-sensitive development requires gender-sensitive methodologies in all encounters where a gender perspective is discussed. In this way, the small-group participatory and democratic methodologies which have been developed by women throughout the South will benefit not only small-scale activities but larger, mainstream events.'[7]

As a result of this philosophy, the Conference programme was not restricted to the conventional line-up of speakers and workshops. Prepared speeches were augmented by an exchange of information and ideas between participants, in smaller groups and plenaries. Role-play — a method for raising issues creatively — was used in discussing the five main issues. Role-play depends on the willingness of the whole group to participate; while in some groups it was very successful, in at least one it was a failure because not all members were willing to participate fully.

The organic and flexible nature of the process of the Conference was a particular challenge to those participants who had only experienced Conferences as events where experts sitting on platforms deliver speeches with a minimum of interaction with their audience. Here, although plenary sessions were used, they were always made lively by varied contributions from participants. Sometimes, indeed, the plenaries seemed too short, because the diversity of experience and opinion among participants meant there was so much to say and hear.

As a whole, the Conference was planned to facilitate the maximum possible interaction and participation from all those who came to Thailand. An essential element in this was to adjust the programme in response to the direction the Conference was taking. To ensure this flexibility, the Conference facilitators not only worked behind the scenes, but attended workshops, spoke on panels, chaired sessions, and observed. Every morning they summarised their own impression of the events of the previous day, to the plenary opening session. By admitting their role in shaping the course of the Conference in this transparent manner, participants could see how everyone's contributions — their own, and those of the facilitators — were informing the daily Conference agenda.

The Conference was planned to have coherence and movement, and required all participants to speak, as well as listen, and learn. Three official languages — English, French, and Spanish — were used at the Conference. This polyphony sometimes tested the skills and patience of participants — for example, where groups were mixed by language and culture the activity sometimes took considerably longer than scheduled.

However, this was outweighed by the knowledge that the conclusions of the Conference were not limited by participants' ability to speak one dominant language, and reflected a multiplicity of views from many cultures.

The Conference programme

The Conference programme was composed of three 'moments', seen as concentric cycles, each opening from the previous one. The moments were designed to encourage participation and, from that, an understanding of what was common to the group and what could be carried forward.

The aim of the first 'moment', entitled 'The Global Context Through a Gendered Lens', was to discuss the global economic, political and social context for development work, in relation to women's gender interests and needs. This was, perhaps, one of the most revealing parts of the Conference, as participants from different countries spoke of how they had linked their personal experience to the wider issues of gender subordination, and inequalities in national and regional development.

Each of these participants stated that she had become aware of gender issues in development, and was drawn into wider movements, through an initial experience of discrimination as a girl or young woman, and then through her involvement in specific issues. Galuh Wandita (Programme Officer, Oxfam UK/I, Indonesia) and Irene Machado (Project Officer, Oxfam UK/I, Hyderabad) worked with women as victims of violence, Dianna Melrose, as Director of Oxfam UK/I's Policy Department, has a lead role in implementing the Gender Policy within Oxfam UK/I, and Gurinder Kaur (Regional Representative, Oxfam America, New Delhi) worked as a trade union activist.

Two vivid and moving testimonies illustrated how gender relations and gender identity shape our awareness of ourselves and our surroundings, and our capacity to act. Although each woman's life story is unique, elements of individual experiences are shared by many other women. At the Conference, both women who gave their testimonies were able to relate their personal experience to social and political issues — violence, human rights, racism and development. Analyses of these issues often ignore the fact that personal power can be an instrument of repression. Self-realisation — leading to anger or to joy — is a precondition for personal development, which should be related to development of our communities and societies.

The second 'moment', entitled 'Our Practice Reviewed', was designed to look at how Conference participants addressed gender

issues in their development work. Are our organisations capable of meeting the demands created by a gender analysis, and if not, how can they be changed? Working groups looked at development goals, the roles of different stakeholders in development work, working practice, and the institutions involved in development. Three constituencies were represented here: women's organisations in the South, Oxfam UK/I's own field workers and policy makers, and representatives of other international organisations.

The aim of the third 'moment', 'Back to the Future', was to develop a common agenda and direction for future work. Here, the first and second moment were considered together, and participants identified strategies for action to promote women's gender interests, and the links between development constituencies which could foster solidarity and work on areas of shared concern.

Participants came to Thailand with a variety of concerns and expectations, and inevitably there were sometimes disagreements about the aims and agenda of the Conference. Some, who lacked materials or training on gender issues, were hoping to get practical information, and found the process of the Conference demanded, and valued, their participation. Different concepts of what constitutes 'development', and what is relevant to it, meant that some contributions were regarded as too radical or simply inappropriate by some; others found these same contributions almost too tame. Participants' varied reactions to issues previously regarded as concerns for the women's movement, rather development practitioners — for example the prevalence of sexual abuse and violence against women — were themselves catalysts for discussion.

The WLP Conference was an experiment in participation, communication, learning, and decision-making. It was a demanding process, which required full commitment and participation, and, at times, the programme seemed too ambitious for such a short period. Above all, the Conference offered Oxfam UK/I staff and women from the South the chance to listen to each other and together to visualise a strategy for gender and development into the twenty-first century.

2

Background: issues and perspectives

Feminism is treated [in development] as a dirty word: as an ideology which will corrupt the 'natives'. Policies on gender equality are more likely to be present in Northern NGOs because of their independence. Therefore, international NGOs such as Oxfam UK/I have a strategic role to play in investigating and exposing this 'North-South collusion of interest', and implementing radical policies.
Sara Hlupekile Longwe (Longwe Clarke and Associates, Zambia)

This chapter examines some of the key issues and perspectives which inform gender and development work, and the delibrerations of participants at the WLP Thailand Conference. First, and most critically, development, as it has been promoted by international donor agencies and most NGOs in the decades since the 1950s, has been detrimental to many women living in poverty in the South. Across the South and North, a growing number of women are speaking and writing about this scandal in highly critical terms. Development practitioners and activists, politicians, academics, artists and writers — all are becoming more critical, and more demanding, on behalf of women in their countries and regions.

As Mary Cherry (Chair of Oxfam UK/I) summed up in her opening speech in Thailand, 'gender transformation goes far beyond promoting women's equality. It means human beings relating to each other on a different basis. It means respecting differences for the common good. A gender dimension in development recognises that women's current condition will not really be changed without addressing other interactive issues of inequality: class structures, hierarchies, racism, a whole range of issues.'

The activities of these critics take all forms, from grassroots protests to interventions at inter-governmental conferences. A flourishing body of theoretical and research work by women of the South is emerging, which

is increasingly influencing the perspective of Northern development funding agencies. Although the gender and development literature is still dominated by Northern women, who were the first to publish their research and writings about the issues of women in development, this imbalance is beginning to change.

Women from the South and Southern women resident in the North have also formed influential intellectual and action-oriented organisations, which have changed the quality and direction of debate about the nature of development in the South. DAWN, Gabriela, Women Living Under Muslim Laws, AAWORD, Akina Mama wa Africa, Abantu for Development, FEMNET, APAC and Entre Mujeres are some of the organisations working for increased public awareness and new policies.

Coalitions which link Northern women who are also Southern by race, ethnicity or birth, and others who are working with Southern women in solidarity have not always felt comfortable, and valuable debates over the politics of identity continue. Nevertheless, dynamic international organisations are emerging to present a challenge to the North-South alliances of male-dominated élites which, for so long, have had a monopoly on defining development.

In the UK and Ireland in the 1980s, 'women's committees' became part of many solidarity campaigns, and some development funding agencies. Other independent and autonomous organisations were formed to support a particular cause or to pursue a strategy for broad-based change. The aims of these groupings have been to establish links with women in the South, to gain support for them in the North, and to influence policy in the North. Organisations committed to a new approach to development practice, and to influencing the policies of the dominant institutions, include Change, The Decade Network, Banúlacht, Women Working Worldwide, National Women's Network, Women in Development Europe (WIDE), the National Alliance of Women's Organisations GAD network, and the Global Network on Reproductive Rights.

Gender issues and women's issues

The existence of such committees and organisations demonstrates that, in an institutional setting, the challenge to change gender relations has largely come from women. Because relatively few men, and not all women, in mainstream organisations have been ready to engage with the subject, and to prepare themselves for involvement with women's empowerment by studying and learning, organisations set up to support the rights of women have often been accused of separatist tactics. Yet

such organisations have been forced to carry out their activities separately, because they have not been able to get women's issues and gender issues raised, or taken seriously, within the mainstream agencies. Many women and women's organisations have continued to work within the mainstream agencies, to try to influence development policy, and some women who are critical of gender-blind development are gaining positions of power in institutions. As a result, gender issues are slowly beginning to enter the vocabulary and the objectives of governmental and non-governmental development funding agencies, multilateral institutions, local and national governments, and grassroots organisations. However, organisational commitments to gender-aware activities differ in quality, scope, and intention.

Separate 'women in development' departments or desks can be used to isolate and marginalise women, and to suppress discussion of gender issues. All types of organisations are capable of such manoeuvres, but this phenomenon has been particularly obvious in governmental development departments. One WLP conference participant, Sara Hlupekile Longwe, believes that this is a symptom of a North-South patriarchal bond, which is essentially a government-to-government alliance. To break this bond, there is a special place for NGOs, 'in mobilising the North-South sisterhood to recognise its existence and to take action to expose it, undermine it, and destroy it'.[1]

Sara Hlupekile Longwe argues that by hiding behind a screen of welfarism, and restricting the discourse of development to non-political technical terms such as 'access to resources', organisations can avoid raising underlying questions of empowerment that can only be revealed by using a political vocabulary. In this light, there is a need for a critical examination of the policies and organisational structure of international NGOs. Sara Longwe asserts that in the NGO sector, a form of 'patriarchal bond' may also be a powerful force, and departments for 'women in development' may be regarded as a suitable remedy for what is often called 'the women problem'. Bringing issues of gender into the mainstream precludes such isolation of people and issues, and must inevitably involve men — as funders, as allies in development, and in relation to women project partners. As was pointed out at the WLP conference, men could play particularly useful roles in gender and development work including training, and in negotiating with male-dominated institutions such as the police and the judiciary. Their ideas and expertise are needed to help to formulate and implement policy, and to carry out research.

Men's role in women's liberation

The Conference discussion on 'Linking the Personal to the Global' warned that 'there is a danger of the feminisation of gender issues. Gender issues should not be only the responsibility of women.' Here, a distinction needs to be made between gender analysis, which simply uncovers the details of existing gender relations between the sexes, and a desire to empower women through a gender analysis, which is an agenda more likely to be attractive to women. Until more men find reason to adopt a gender analysis and work towards gender equity, together with women, gender will continue to be seen by many only in terms of women versus men. How this can be countered depends very much on the context in which women are working.

Consider the relative positions of men and women in terms of control of material resources and of self-determination, men having the most and women the least. Some argue that men pay a price for this by limiting their experience to a 'man's world', and that they would not lose by taking on a commitment to gender equity — rather, their lives would be enhanced by sharing the burden which comes with holding power, and also by sharing the pleasure of a caring role towards children and loved ones.[2]

Some men are not consciously part of the 'patriarchal bond', and are indignant at injustices done to women; they may be openly sympathetic to the idea that women should have equal rights with men. This commitment often fades, however, when put into practice at a personal level, at home and at work.

However, arguments that men suffer psychologically and physically from the gender division of labour and the narrowly-defined social code of masculinity have not been widely accepted — or even explored — outside academic circles. The argument that men would benefit by correcting the imbalance in gender relations does not meet with ready agreement. Most men fear losing power and status to women, and cannot see how gender equality would compensate them for this loss. A change in gender relations is also opposed by the many women who still define themselves according to social norms

Nevertheless, societies have changed and continue to change. Socially-defined gender roles are not fixed, and they are transformed and reconstituted as society changes. Gender is not women's exclusive concern; where their cultural and political identities are shared with men — in a situation of conflict, for example — the potential for transformation is present. But, as in many revolutionary societies where women played a prominent role in the struggle, this solidarity can be short-lived.

Development interventions form a catalyst to stimulate change, for better or worse. A gender and development policy must take a strategic view of working with men, and build on existing good will and shared concerns, while enabling women to become more powerful.

Challenging culture

Culture plays a major role in the development process. For this reason it was not a separate theme of the Conference, although many participants felt that it should have been addressed separately. The organisers' position was that culture is integral to all aspects of life, cross-cutting and underlying everything that would be discussed at the Conference and therefore it should not be limited to a single discussion group. As a result, cultural issues — reflecting differences, similarities, and contradictions — were raised in the context of the five discussion topics.

International funding agencies have tended to emphasise that it is the South which needs to 'develop' — itself a term loaded with Northern post-colonialist assumptions about what constitutes development and human progress. A vocabulary of development has now emerged which is identified conceptually with the South.

As Northern-based development agencies begin to focus on gender issues, the inference is that gender awareness and a commitment to gender equity are rooted in the North. This ignores the gender awareness and women's resistance to oppression which is actually present in Southern organisations and cultures.

No development intervention is culture-free, yet gender and development analysis and feminism have been targeted as particular dangers to the cultural integrity of Southern communities — a view coming from within Northern funding agencies as well as from powerful elements in the Southern countries in which they work. The burgeoning women's movement in the South has voiced its own view that women's oppression is a concern for women worldwide, and is a major barrier to development.

As was demonstrated throughout the Conference, commitment to gender equality is shared by a growing number of individuals and organisations. Nevertheless, in the name of cultural integrity, there is still strong resistance to these principles even being discussed. The following exchange reported by Mariam Dem, of Oxfam UK/I in Senegal, is typical of the accusations of cultural interference which are frequently levelled at those working on gender issues: 'At a seminar on gender, a man said to me: "It's all right for you intellectuals, bringing your ideas from the North to impose upon us." So I looked at him, I noticed he was wearing

a shirt. I said: "What's that shirt you are wearing, where did you get that from? That's not Senegalese."'

Whereas choosing garments, whether African or Western, is seen as a culturally-neutral decision, choosing to take on a gender perspective is condemned — by those who are challenged by the prospect of change — as being alien to Southern culture. This ignores the fact that women in Southern countries have put up their own resistance to gender oppression. Male-determined notions of culture and tradition are used to maintain oppressive gender relations. In development organisations which are insensitive to gender issues, gender is likely to be dismissed as a concept imposed on women in the South, and in particular on women at the grassroots, who do not understand it. This is not only incorrect, but belittles the analysis and self-awareness of grassroots women.

Gender and development work is made difficult where culture imposes a particularly restrictive code of behaviour. For example, a harsh interpretation of a religion can restrict the movement of women. But work can still be done; if culture erects barriers for women, it can also be harnessed to provide opportunities for change. Women's networks which promote a tolerant and liberal version of religion can be strengthened, and links with women working with other religions developed, to challenge the rigidity of dogma.

Culture reflects the social and political structure of time and place, and bears the weight of history; but it is also dynamic, and can be changed. A shirt, for example, symbolises the gender, as well as the international, division of labour: wherever it originated, it is likely to have been made by a woman on a very low wage. As a result of macroeconomic changes in international trading relations, communities worldwide are in transition, economically and socially, and traditional power bases are shifting.

Age-old cultural assumptions and attitudes may be openly challenged, particularly by the young. When this creates a climate of insecurity for those who fear what they might lose, culture and custom become tools with which to restore order or to prevent power slipping away. Similarly, where the position of women is weak, 'development' can rebound on them in the form of greater cultural rigidities and conformity.

Culture and the language of gender equity

One of the greatest cultural barriers to understanding is the misuse of language. In addition to its primary purpose of linking and informing, language also has the potential to offend and confuse, due to its

rootedness in culture. As Colletah Chitsike (Programme Co-ordinator, Oxfam UK/I, Zimbabwe) stated at the start of the Conference, 'within the cultural context ... there is a need for a redefinition of the concept of gender.'

Rajamma Gomathy (Project Officer, Oxfam UK/I, Bangalore), reporting for the South Asia and Middle East-based participants, also said that 'the vocabulary in which "gender" is used needs to be changed In India for example, ... this word "gender" is used by the media ... so the influence is more in the cities and among the middle classes. But by experience in the local and the grassroots level, women's organisations are using the words which are most suited to the local situation, ... according to the needs of women's situations. Most of the grassroots women's organisations are not using — and are mostly avoiding — the word "gender", but are using the word which is locally understood.'

Many gender and development practitioners would recognise this method of working with a concept by using familiar vocabulary. Most poor and working class women, both North and South, might not understand the word 'gender', but they would understand the concept when it is expressed in their own terms. Laura Renshaw (Programme Specialist, Oxfam America) reporting for the Europe and North America-based participants, stated that 'while gender language may be mystifying in a Southern context, many find it alienating in a Northern context. ... we have to find a way to present the gender issue ... as one of social transformation in which both sides benefit, or women will not achieve their broad agenda. In this respect, Northern agencies need to look inward more systematically, both at their own country contexts and at themselves, to avoid a double standard and a paternalistic attitude ...'.

To work effectively on gender issues in development, the language used to express the concepts must be clear, so that everyone, enthusiasts and sceptics, understands the process of social transformation in which they are involved. Increasingly, Northern-trained researchers and development practitioners are learning to recognise concepts of gender inequity, and challenges to this, which come from the grassroots and do not use the jargon of gender studies.

Speaking to the WLP conference, Sara Hlupekile Longwe said that 'we should pick [the opportunities that arise] and then provide the forum for grassroots women'. Drawing on her own research experience in Zambia, Longwe gave an example of interviewing a group of village women: 'we wanted to know who lived there, so we asked, "How many are single-headed households? How many are widows?" A few put their hands up and then one woman slowly put her hand up and everybody laughed We asked her why everyone was laughing, and before she could answer, others said "No, she is married, she does have a husband",

and we looked at her, and asked "How come you are a widow?" She said: "I live like a widow, so I might as well be a widow". So, she [could] see gender issues, [could] see the [similarity] between her "male-headed household" and another's "female-headed household".'

It is crucial to recognise that, whereas women's subordination to men is universal, the details of relations between women and men vary from society to society. It is important to understand what women are saying within their different cultural and socio-economic contexts; and to recognise when they are dealing with gender issues, even when they might not use the vocabulary of GAD and Northern funding agencies.

Working at different levels

Making the links between policy research and the grassroots works both ways. 'Scaling-up' is emphasised in gender and development analysis as a means of linking the grassroots to organisations, policies and activities on other levels. As a WLP briefing to Oxfam staff[3] observed: 'Too often, valuable lessons learnt in small community projects are not ... fed into strategic planning at the wider level of the state and the region.' There are encouraging examples of programme work where this lack of learning has been overcome. One of these is Programme des Femmes en Milieu Urbain (PROFEMU) in Senegal, funded by Oxfam, which enables women involved in small trading activities to 'scale up' their activities by providing a forum for them to voice their opinions on wider concerns and increase their autonomy, recognition and power within their communities.

It was an aim of the WLP that the experiences of individuals and communities should be linked to the macro- issues of global economics and politics. By bringing together development practitioners and researchers, and field office staff and head office staff, the Conference drew out the connections between the personal, the regional, and the global, and attempted to bridge the gap between the micro and the macro level of analysis.

The process of scaling-up within a development agency, the object of which is to learn from experiences in the field, has already influenced many aspects of development work. For example, participatory rural assessment (PRA) and other action-research techniques have adopted many of the principles of feminist research. Scaling-up within an analytical framework of gender and development holds enormous potential for genuinely developmental work in which grassroots women acquire the skills to assess, analyse, and determine their own development process.

In 'Linking the Personal to the Global', Luz Ilagon, of the Women's Studies and Resource Centre in the Philippines, spoke of how organisations in the South-East Asian region rely on each other in a situation of rapid economic and political change. 'We look to one another for role models and we look to one another for exchange of resources. The constant shift in relations between women and men requires tools and strategies in development work to be constantly updated and analysed. ...we rely on one another for the development of these tools and strategies.'

Strategies for gaining power

Luz Ilagon went on to explain that 'many women and women's organisations are already working together to share their tactics and strategies for gaining power.' Earlier in the WLP conference, during the session entitled 'Linking the Personal to the Global' one working group offered three recommendations. For the group, Gurinder Kaur of Oxfam America in India, reported that they 'felt that [firstly] we should work towards greater solidarity between the North and the South, between the South and the South, between women and women, and between women and men; and [secondly] ... we ought to build strategic alliances between different interest groups who work on gender issues. Therefore, building globalisation from below should be a very conscious strategy. Thirdly, development agencies promoting gender concerns could play a constructive role, by sharing resources, lobbying and trying to influence policies within the agencies and with their partners and others.' Gurinder Kaur is talking of solidarity based on practical as well as theoretical issues, which is not afraid to confront inherent conflicts in the course of pursuing a common cause.

In line with this vision, despite the limitations imposed on them by poverty and patriarchy, most women are actively organising for change. As their organising ability increases, women create their own alliances, and set their own agendas. Voices at the Conference confirmed that many women are tired of the miserable and misleading stereotypes created for them by paternalistic development agencies, and are demanding that Northern funding NGOs and partner organisations alike listen to what they are saying about development. As the Declaration from Southern Women's Organisations uncompromisingly states, 'we demand the political will to support gender justice and concrete plans of action. This requires change at all levels.'

3

Health and reproductive rights

Reproductive rights need to be seen in the context of the right to health, of which reproductive health is only one part.
EUROSTEP Position Paper on Population and Development

This, the first of five issue-based chapters, takes the form of a brief introduction, and a paper written for the WLP Conference. All too often, the whole range of complex issues relating to women's health are ignored in favour of highlighting just two aspects — maternity and reproductive health, which is too often seen as a problem to be addressed through involving women as acceptors of contraception, rather than as individuals with the right to determine their own fertility. As this chapter's paper argues, the assertion of women's reproductive rights, related to their right to health care of all varieties, is critical for women. Reproductive rights include the right to decide how many children to have, when to have them, and the right to appropriate and accessible health care during pregnancy and delivery,[1] to reduce the risk of maternal mortality and morbidity.

The working group on health and reproductive rights at the Conference found a wide consensus among participants from Africa, Asia, Latin America, and the Middle East on the need for development policymakers to link health to rights, and the importance of a gender perspective in understanding failures to deliver health care to women. Government health policies in a number of countries were compared with the policies of Oxfam UK/I, and of local NGOs.

Betania Avila of SOS-CORPO in Brazil has worked for many years on health and reproductive rights, which were the focus in a speech she made to a plenary session during the second 'moment', 'Linking the Regional to the Global'. The common element in Betania Avila's analysis,

and that of the Health and Reproductive Rights working group, was that there is vital work to do in helping women to gain control over their own bodies. To achieve this, women need information, resources, and, ultimately, political power. According to Betania Avila, the first point to be recognised is 'the gap between policy and action'. This gap has grave consequences for women's health, and highlights the power of organisations — national and international — which are supposedly concerned with health as a development issue. Women's health and female fertility are all too often foci for policies over which women have no say but which affect them profoundly. In Betania Avila's words, '[in government and many international agencies], women's health is understood as reproductive health, and reproductive health is understood as family planning; this is a tool for the population control perspective that has been strongly directed towards Southern countries. Health service is taken as a mere mechanism to improve population control, but not to improve rights or basic needs.' In short, women are being coldly manipulated without any consideration for their personal rights.

Betania Avila identified as a second critical issue, 'the lack of information from the micro level to the macro level and also how it's harmful for women's health'. In the majority of national contexts, there is a dearth of information at all levels on basic health issues — for example, how the female body functions — linked to a general failure to provide health education in health facilities and mainstream education.

The working group on health and reproductive rights drew up a list of 'needs' for analysis and action in development practice:

- Basic information on women's bodies, and on the physical and mental consequences of harmful practices is needed.

- Health professionals and funders must change their basic assumptions, and their health care framework, to recognise that women's health care cannot be addressed in isolation from women's health rights.

- The micro-macro links must be made as a priority, between women's health at grassroots level, and the international economic and political context.

- There should be wider dissemination of information on health, targeted more efficiently.

- There needs to be more information about the funding of projects, by international funding agencies, which flout women's health and reproductive rights — in particular, programmes which emphasise 'population control'.

- There is need for improved institutional learning on best and worst practice in development projects and programmes.

- How and why health policies are formed, and the analysis behind the policy, should be reviewed.

As Betania Avila told the plenary in her working group report, 'women have traditionally pursued control of their own bodies under fertility and health ... In the new perspective, childbirth, delivery, contraception and abortion are perceived as inter-related factors ... Reproductive rights go beyond women's health care, but women's health care is very important in effecting those rights.'

Gender, maternity, and women's health status

As stated above, maternity is closely associated — and indeed frequently viewed as synonymous — with women's health. Just as women's health is much more than maternity, maternity itself is more than a single health issue, as the working group, who had all personally witnessed high rates of maternal mortality in their own country, confirmed.

Maternal mortality rates are an indicator of the status of women's general health, and of their social and economic status. In Betania Avila's view, shared by others, the danger to poor Southern women which pregnancy and childbirth presents is directly connected to 'the pattern of a social development model which has been based itself on discrimination. Maternal mortality is symbolic of the status of women that prohibits their self-determination.' A long history of discrimination brands 'both the body of each woman individually, and the female body historically. When a woman dies from maternal mortality, as a result of childbirth, one should ask how this death began What was her working environment throughout pregnancy? What type of contraceptive method had she used before becoming pregnant? Did she suffer violence in her marriage? Did she receive prenatal care, and of what quality?'

Betania Avila recommended reversing a common approach to evaluating the relationship between pregnancy and health: 'often, one considers and measures the effects of the pregnancy on the pre-existing health condition. I feel one should begin measuring aspects of life, such as violence, and the resulting morbidity in the female body that is pregnant, while completely healthy.'

A case study by Galuh Wandita (Programme Officer, Oxfam UK/I Indonesia), who also participated in the working group, identifies gender relations as a factor in women's health. Women's economic and

reproductive status within society and the wider political economy have a direct bearing on their well-being.

Women's health and poverty

Health status is linked to every facet of life: economic, political, social and cultural. The health of the individual, and her or his access to health care, are affected by macro-economic policies. Of particular concern at the moment are the effects of structural adjustment policies (SAPs) and other neo-liberal economic trends, which cut public resource allocation for social welfare and promote privatisation. Women's subordination to men means that it is women who suffer the brunt of such cutbacks in welfare expenditure, which reduce quality and availability of health care. Where they lack social power, women are rarely able to influence such policies.

Betania Avila referred to the Brazilian experience: 'The political and economical doctrine of liberalism, where the market is promoted as offering all the possibilities for choice, could never fully incorporate the issues implied in the notion of reproductive rights. Reproduction does not take place in a social void, but in the context of conditions permeated by power relations, including gender domination.'

Colletah Chitsike, (Programme Co-ordinator, Oxfam UK/I, Zimbabwe), also told the Conference of the direct effects of structural adjustment on services which both employ women and are used by women: 'the government is clamping down on health services. With the AIDS problem, community-based care is increasingly becoming a serious issue, as a result it is women who are doing the caring.' For women, care in the community means more work, which itself leads to additional health problems for the carers themselves.

Reproductive rights as civil rights

Women's experience of health care links their health to their subordinate status. Betania Avila told the conference that from her own work on health assistance and reproductive rights, contraception, and maternal mortality, 'attention to health must go beyond offering a service. It must guarantee quality, and promote a new relationship between health care professionals and users based on mutual respect. Women must be considered as citizens with rights and as whole human beings.' In this light, health and reproductive rights are civil rights. The working group agreed that 'reproductive health is very important for achieving

reproductive rights, but it is not the only issue to be considered in reproductive rights.'

The basis for this new relationship is, according to Betania Avila, 'the shared history of the body and the life'. This history may contain experiences which are forgotten or repressed, or not understood. Therefore, 'it is necessary to grant time and the possibility for women to express in depth what their feelings are, so that they may ask questions and clarify their doubts.' Such full assistance should be part of a method of education in which the client acquires the knowledge necessary to allow more control over their own health. In many countries development agencies can support this new type of health care, in conjunction with health education.

Health, culture and gender violence

Concepts of health and reproduction are more than physiological definitions. The body cannot be seen in strictly medical terms; it also has a social history, marked by culture. The working group found that in some regions women are often responsible for traditional healing and medicines. This provides another linking point for women to work with practitioners of health care so that both can learn, and gives an opportunity for addressing the role of women in perpetuating harmful practices, such as female genital mutilation, child marriages, and certain food taboos. In addition, where women have traditionally been responsible for health care, they can be effective in overcoming cultural prohibitions, such as against training for midwives, as is the case in some parts of Sudan.

Many health practitioners are inadequately trained to deal with the relationship between female anatomy and social rules. Women and men should know how to relate the condition of their body to other aspects of their life and to their relations with others, so that on the basis of what they see they need for their own body, they can begin to change the social, economic and environmental factors that affect it.

Gynaecology, for example, is an aspect of health care that should start from childhood and continue into old age, yet gynaecological problems may not be treated because of social prohibitions against male doctors treating female patients. Such prohibitions prevent examination and treatment for many conditions, including sexually transmitted diseases (STDs), IUD infections, and infections arising from female genital mutilation.

In addition to formal health education, sharing information can contribute greatly to health promotion, often through leading to

collective action locally in other areas, such as social relations, education, health and safety at work, environment, and macro-economic policies. Improved health education — for health practitioners and for all women — is a necessary part of a longer-term strategy which will allow women fuller knowledge of their health and bodies, and enable them to gain knowledge of their right to health care.

The health and reproductive rights working group asserted that violence against women is justified by culture, and continues to limit women's ability to take control of their lives; '[considering violence] is critical in considering sexual and reproductive life'. Gender violence, as discussed during the conference, and as described later in Chapter Five in Lori L Heise's paper, *Overcoming Violence: A Background Paper on Violence Against Women as an Obstacle to Development*, takes many forms: physical and sexual abuse, mutilation, and intimidation.

Health care which is insensitive, inept or inappropriate, and results in death or illness, can also be seen as gender violence. This includes unnecessary invasive medical treatment, poor medical treatment, unwanted pregnancy resulting from a failure to provide contraception, and the use of unnecessary and damaging pharmaceutical products.

Health education

The linkages between ill-health, medical interventions, and social and cultural aspects of life, are not always apparent, and formal health education may not be a suitable means of conveying vital information. Health service users need information about their bodies, and how to use this information to make demands for the health services they need.

As Fatoumata Sow (Secretaire Executive, APAC, Senegal) pointed out, 'in Africa ... almost 70 per cent of women are illiterate. Women live in a state of ignorance and a lack of education. [Many] do not even know how the human reproductive system works. At this stage, when talking about the issue of reproductive rights, we are talking theoretically since this is beyond the reach of the average woman. [First] it is necessary to talk to women about anti-malaria medicine, for example, because most of them are anaemic. They also need information on AIDS, since this is now a major issue at stake for the Africa region But at the agencies' level, when the issue of communication and information is raised, what do they tell you? That it is not an issue "at stake". And I believe that this is where there is a point for agencies like Oxfam and others to consider communication and information not only as a luxury for people, but as a fundamental aspect in relation to access to information, in relation to violence, in relation to women's rights, in relation to health.'

Research, campaigning, and information networks may be linked to local health actions. Contact with international campaigns and researchers can provide important technical and legal information, as well as moral and financial support for local and national actions.

Family planning and political participation

Many NGOs see the process of women gaining control over their fertility as an important stage in women's empowerment; however, these NGOs are working against more powerful organisations that prefer a top-down approach expressed in terms of 'population control'. Population control and the promotion of contraception continue to be among the most controversial issues in North-South relations, involving a struggle for recognition of women's rights as human rights. Betania Avila reminded the Conference that 'contraception has been hard won for the women in the South. The expression of this has been through emergencies and necessities, power relations and lack of understanding of the factors of reproduction as a part of citizenship.'

Contraceptives have been dispensed to women in the South as a means of reducing population rather than improving the lives of women and their families. As Betania Avila said, 'lack of information has allowed contraceptives to be thrown into the lives of these women and perceived as beneficial.'

Women's organisations need support in combating damaging policies and practices, and defining health care. Organisations already active in this field have been both marginalised and used by government: Rina Roy (Project Officer, Oxfam UK/I, Bangladesh) told the conference that the Bangladeshi government, in common with many others, had planned to send a country report on health issues for the United Nations Population Conference 1994 in Cairo, without consultation with women's organisations.

'On learning that there would be no consultation with women's organisations, NGOs, or funding agencies, one women's organisation thought [it] should get involved and give some input, so they tried to link up with the Government. After continually pushing for recognition, [the two parties] met ... and, after several meetings and difficult discussions, the Government agreed that they could have some input. The women's organisation began to hold a series of workshops in different areas with the grassroots level women about health and population issues. The results will go into the government report.'

Despite this being an example of women organising for effective information flow from the grassroots to the policy-makers, in another

light this might be regarded as government appropriation of the hard work of the women's organisation. As Rina pointed out, 'when the government looked at this [work] ... they put it in their report, ... and they gave all their responsibilities to the women's organisation.' Nevertheless, good came out of the experience related by Rina Roy. Oxfam UK/I in Bangladesh organised the workshops, thereby making a bridge between NGOs, and with the state.

Health and the role of NGOs

During the Conference, a working group discussing work with women's organisations raised a number of question as to the practical steps which could be taken by women's organisations, their funders, and other international NGOs, to improve the quality of work on health and reproductive rights. They suggested:

- Developing new methods of qualitative evaluation based on alternative social indicators that measure the impact of health policies on women's lives.

- Recognising the fact that the concept of health is understood differently in different societies and cultures, and working towards a common definition of health which could be shared in inter-regional linking.

- Challenging cultural taboos and religious restrictions on women's health, reproductive and sexual rights, through public debates, petitions and consciousness-raising activities.

- Linking reproductive rights to sexual rights of women in relation to gender imbalance and AIDS, in popular education on sexuality (for grassroots women and NGO staff); through direct services and action; through information and research on AIDS, gender violence, women's health, family planning, and marital relationships.

- Ensuring a common and comprehensive analysis of health issues as related to economics, politics, and culture; and dissemination of these to the grassroots.

- Demystifying the language of health, through meetings and workshops.

- Linking with international networks on health and reproductive rights to acquire updated information, and finding new ways to obtain information.

- Analysing the power structures and operations of multilaterals and international NGOs involved in women's health issues; utilising this analysis and information for lobbying and networking; strengthening partnerships with international NGOs by exchanging information and going beyond mere project relationships.

- Lobbying for consistency in NGO policy and project implementation on health concerns, and co-ordinating with other women's organisations in other countries.

- Monitoring transnational companies that produce and promote drugs, contraceptives and baby foods; raising women's awareness of these activities and of the adverse effects of the products. Lobbying and taking other appropriate action, such as boycotts, against these companies. Linking with international health networks to resist government policies in certain countries on distribution of banned products as part of overseas development aid, and analysing existing policies of UNICEF and other international NGOs.

In conclusion, participants at the Conference challenged the notion that women's health can be equated to reproductive health, asserting not only that women suffer non-sex specific-ill health in addition to reproductive disorders, but also that women's experience of ill health, their access to treatment, and the manner in which they are treated are all mediated by their gender. There was complete consensus that health is linked to wider economic and social issues, and gender is a factor in determining health status. Although solutions to health problems are often assumed to be medical, health and reproductive rights are particularly sensitive areas for which education and information-sharing among women is particularly effective.

Reproductive rights are a human rights issue for women, yet such rights are still largely defined in terms of fertility. Male fertility and attitudes to childbearing, and its persistent impact on the lives of women, is generally ignored. Participants called for a new perspective on women's health and reproductive rights, which addresses women as whole beings, and understands pregnancy, childbirth, contraception, and women's rights as human rights as inter-related factors. This perspective would bring women's health and reproductive rights into a political framework, admitting the importance of gender subordination in affecting women's health and fertility.

Sia Nowrojee's paper, *Gender, Reproductive Rights and Health: Emerging Frameworks*, supports much of what was said at the WLP conference. In particular, she points out how reproductive rights have been marginalised in international development policy: 'defined as

individual and intimate and thus, minor in relation to the broader 'common' good' — a perfect example of policy which lacks gender sensitivity.'

Nowrojee's overview of the international movements around population control illustrates not only how women are poorly served by organisations apparently concerned with their health, but how geo-political considerations — in China, for example — can override the most basic regard for human rights. In most societies, women's human rights remain subordinate to socio-economic and political systems. Women's health status is inextricably linked to socio-economic status, and reproductive rights are denied because 'their achievement would threaten entrenched power dynamics in gender relationships', which also determine socio-economic status. The ability of women to organise against both of these facets of their lives has brought the issues together and broadened the international health development agenda in a way that other development initiatives have failed to do.

In the area of women's health and reproductive rights, Nowrojee is in agreement with many WLP Conference participants that change through public advocacy and projects on the ground must reflect the specific values and needs of women in their different contexts. In both areas of work, women acting for change must be supported financially and politically by international funding agencies.

• Gender, reproductive rights, and health: emerging frameworks

Sia Nowrojee

Introduction

In the last 30 years, reproductive rights have been a sometimes debated, sometimes neglected, aspect of international development policy. In the last few years, however, despite lingering disagreement and unclear definitions, reproductive rights have been firmly placed on the map of international policy discussion and programme development. This is the outcome of women's organising globally to ensure that their diverse and complex realities are recognised and addressed in broad development and rights policies and programmes.

This paper will provide an overview of the international policy arenas within which reproductive rights have traditionally been addressed. It will then describe the impact of women's organising to broaden these arenas, for the protection of reproductive rights, as well as the creation and implementation of development policies which provide the enabling conditions for the exercise of those rights. The paper will end with recommendations for action in a variety of sectors, particularly as we move towards the Social Development Summit in Copenhagen and the World Conference on Women in Beijing, to continue the momentum towards the achievement of all women's reproductive rights, regardless of gender, race and class.

International development policy

Reproductive rights have traditionally fallen within two international policy arenas; population and human rights. In both, they have been narrowly conceived. Often, due to an artificial divide of 'public' and 'private' issues, reproductive rights have been minimised in the population field by what are defined as 'broad' or 'macro' issues, such as economic development and demographic outcomes. Viewing women as agents of these outcomes, the field has often focused only on their capacity to reproduce or not reproduce. As a result, the full range of women's reproductive and sexual health needs are rarely addressed

comprehensively. Similarly, when reproductive rights have been addressed by the human rights field, there has been little discussion or action taken regarding existing socio-economic conditions and gender inequities. The result is that women's reproductive rights have been delegated a marginal status; defined as individual and intimate and thus, minor in relation to the broader 'common' good.

The population field

In the last few decades, fertility control has been presented as a solution to a range of political and economic issues by international agencies and national governments, rather than as a means to enable and enhance women's reproductive health and rights (Correa, 1994). In 1974, at the first international population conference in Bucharest, North-South political struggle dominated proceedings, as Southern governments rejected the imposition of Northern demographic imperatives. However, as a result of both Northern investment and internal political decisions, many Southern governments adopted clear fertility control policies and expanded their internationally-funded public family-planning programmes.

The World Population Plan of 1984, coming out of Mexico City, could be interpreted as a North-South agreement on neo-Malthusian or population control policies. This may have been overshadowed by the position of the United States (under the Reagan administration) and the Vatican, both proposing a reduction in international aid for population activities, as a result of the strong anti-abortion lobby. However, the outcome was not a retreat from population control, but rather a trend towards privatisation of family planning services and a growing sense that government should have no role in correcting existing inequities within gender relations (Nowrojee, S. based on Correa, 1994).

Similarly, during activities around the recent 1994 International Conference on Population and Development in Cairo, discussions about environmental degradation and armed conflict focused on fertility control as a solution, rather than on existing socio-economic and interpersonal inequities. Additionally, conservative fundamentalist elements from both the North and the South tried to curtail discussion of women's reproductive and sexual rights. In spite of these efforts, comprehensive reproductive health and rights and gender equity were important priorities at the ICPD and in the resultant Programme of Action (UN, 1994a).

Despite this accomplishment, reproductive health and rights have continued to be overshadowed by broad political and economic interests within the population field. The family-planning programmes implemented under population policies have provided millions of

women with much needed means for fertility regulation. However, they have also made women and girls primarily responsible for fertility control, and ignored the factors that leave them vulnerable to morbidity and mortality due to forced sex and other violence, unwanted pregnancy, disease, and social discrimination. Gender-based power imbalances often undermine the ability of women to protect themselves from unwanted and unsafe sex (Nowrojee, S. 1994), and the lack of comprehensive reproductive health services compound this reality, leaving women and girls at risk of infection and death.

Around the world, 500,000 women die annually as a result of unsafe deliveries and septic abortions, as a result of unplanned pregnancies and lack of access to good quality services (Antrobus, Germain and Nowrojee, 1994). Lack of contraceptive choice leaves women, particularly poor women, desperate to prevent pregnancies. For example, in Brazil, women are vulnerable to surgery through reliance on sterilisation, often administered during otherwise unnecessary cesarian-sections (Correa, 1994). The lack of women-controlled protective technologies have resulted in high rates of sexually transmitted disease (STD), including HIV/AIDS, in girls and women unable to insist that their partners use condoms. By the year 2000, the annual number of AIDS cases in women will equal or exceed those in men (Elias and Heise, 1993).

When family-planning programmes are seen as a political imperative rather than a reproductive health and human rights necessity, involving informed consent and voluntary use of services, incentives and coercion provide the basis for direct human rights violations, such as forced fertility control. The family planning programme in China — a programme that continues to receive international financial and political support, in spite of widely publicised human rights violations — is an example of this. Other family planning programmes around the world, while less publicised, are responsible for similar practices, including withholding information or services and implementing incentive programmes (Article 19, forthcoming, 1995; Boland, Rao and Zeidenstein, 1994; Hartmann, 1987).

The human rights field

The Universal Declaration of Human Rights of 1948 and the International Covenants on Civil and Political Rights, and Economic, Social and Cultural Rights, provide the foundation for understanding the relationship between individuals and the nation-state in international law. These documents include fundamental principles of human rights, dignity and freedom regardless of race, gender, religion, nationality or other classifications.

In 1968, reproductive rights were first mentioned in the context of international human rights policy, when the International Conference on Human Rights in Teheran passed Resolution 18, which states that 'Parents have a basic human right to determine freely and responsibly the number and spacing of their children, and a right to adequate education and information in this respect.' Subsequent world conferences on women and population recognised and expanded this right. The 1975 Declaration of Mexico on the Equality of Women and Their Contribution to Development and Peace adopted language on the right to bodily integrity, stating that 'the human body, whether that of woman or man, is inviolable and respect for it is a fundamental element of human dignity and freedom.' The World Population Plan of 1984 espoused individual reproductive rights, stating that 'all couples and individuals have the basic right to decide freely and responsibly the number and spacing of their children and to have the information, education and means to do so.' (Boland, Rao and Zeidenstein, 1994; Freedman and Isaacs, 1993).

In 1981, the Convention on the Elimination of All Forms of Discrimination Against Women (CEDAW) was adopted by the United Nations General Assembly, and became the first legally-binding international treaty in which states that ratify the treaty are bound to eliminate all forms of discrimination against women. In 1993, the document of the Conference on Human Rights in Vienna included important language on the 'equal status and human rights of women'. Both of these documents are important because they place gender-based discrimination within the context of the international rights debate.

In spite of this movement toward a cognisance of reproductive rights and bodily integrity and against gender-based discrimination, the human rights field faces a number of dilemmas in the implementation of these instruments. For example, the conflict between national sovereignty and the international protection of individual rights; the question of universal international human rights standards in a diverse and complex world; the problem of implementing the recommendations of both binding and non-binding documents; the articulation of equal rights for men and women in the reproductive arena, when in fact women carry a greater burden; and the lack of accountability mechanisms, particularly regarding violations that are not in the political and civil arenas. These are just some of the questions that have not been adequately resolved, and affect the implementation of a clear agenda on reproductive rights.

The end result has been that in spite of the development of good human rights language, within broad socio-economic and political systems, women's individual rights, including reproductive rights, continue to be

grossly violated. In Bosnia, Haiti, and Liberia, these violations have escalated into weapons of war and humiliation (often on the basis of ethnicity), through the calculated use of rape (Swiss and Giller, 1993; Thomas and Ralph, 1994; Zephir, 1994). In the United States, poor women and women of colour have long been the target of punitive reproductive health policies. For example, proposed government policies would require poor women to accept long-lasting contraceptives or face losing their health and social benefits, and even their children (United States Women of Color Delegation, 1994). In Africa, millions of girls undergo female genital mutilation each year as a means to control their sexuality and their reproduction (Toubia, 1993). Across the globe, women are trafficked and sold into sexual slavery. Many are placed at risk of HIV infection, and their serostatus can place them at further risk of violations (Human Rights Watch, 1993; The Panos Institute, 1990).

These excruciating violations occur in an everyday context of few or misused reproductive health services and limited mechanisms for recourse for the majority of women. Refugee, immigrant, internally displaced, and minority women are even more vulnerable to abuse and lack of protection as a result of the socio-economic, political and cultural barriers they face (Nowrojee, B, 1993; National Asian Women's Health Organisation, forthcoming, 1995).

Implications for development

As a result of these violations and existing global economic policies, the burdens on women in both informal and formal economies and political systems have increased in most societies, while their access to resources and rights has been curtailed (Pyne, 1994). For example, women produce 70 per cent of the food in developing countries, yet still suffer from high rates of anaemia and malnutrition (WHO, 1991). Women in these countries have maternal mortality rates that are 200 times higher than those of Europe and North America and many of those deaths are preventable. Parallel disparities exist between women in affluent and poor communities within each region (Smyke, 1991; WHO, 1994).

The split between public and private development and rights has thus been crippling for many women. Over 70 per cent of the world's poor are women, and their health status is directly linked to their poverty (UN, 1994b.). The implications for development are equally negative. The democratisation processes so necessary to foster true and sustainable development are adversely affected when women are unable fully to participate in both interpersonal and societal decision-making. The World Health Organisation (WHO) has therefore recognised health as both a goal and a means of achieving social development. Negotiations

of the World Summit for Social Development (WSSD) are addressing the links between health, poverty and social development and recognise equity in access to the full range of health services as a cornerstone of social development (UN, 1994c; UNDP, 1994; WHO, 1994).

In this international context, reproductive health clearly becomes more than the prevention of disease. Reproductive health and rights play a crucial role in the definition of women's status and in their ability to function in their communities (Maine and Freedman, 1994). The lack or misuse of comprehensive reproductive health services and the range of violations that occur against women's reproductive, sexual and bodily integrity all represent, in differing degrees, an international complicity in violations against women *because* they are women (Bunch, 1990; Freedman and Maine, 1992). Without a comprehensive reproductive health approach and the protection of reproductive rights, the individual functioning of women as political, economic and social citizens is hampered and this has an adverse impact both on their individual rights and the societal process of development.

Women organising

Perhaps the greatest obstacle to reproductive rights is the fact that their achievement would threaten entrenched power dynamics in gender relationships. The presented conflict between the public 'common' good and the rights of individual citizens can essentially be understood as the preservation of a domain that is dominated by men at the expense of the rights, health, and well-being of women. Women organising around the world have long recognised the interests implicit in their oppression and how the divisions between 'public' and 'private', reproduction and production, and civil political and socio-economic rights are false.

Women's realities — particularly those of poor women — are often a composite of all the above. They face inequality in all the arenas in which they operate, whether in their intimate sexual relationships or in the economic market place; whether in the area of voters' rights or the right to abortion. Thus, women's organising in the last few decades, in the realm of both population and human rights has been to broaden the agendas of both fields, as well as bring them together.

Conceptualising a new agenda

In the last 20 years, women from both the South and the North have worked towards a broad agenda on reproductive health and rights (Dixon-Mueller, 1993; Garcia-Moreno and Claro, 1994). Advocating a

comprehensive reproductive health framework has been a strong thrust of the international women's health movement (Garcia-Moreno and Claro, 1994). While it is recognised that there is no single blue-print, a comprehensive reproductive health approach suggests a framework of services that addresses the range of women's reproductive and sexual health needs, not just family planning. This framework includes a full range of contraceptive methods and safe abortion services; pregnancy services, including prenatal and postnatal care, safe delivery, nutrition and child health services; STD prevention, screening, diagnosis and treatment; gynaecological care, including screening for breast and cervical cancer; sexuality and gender information, education and counselling; health counselling and education in all services; and finally, referral systems for other health problems (Germain, Nowrojee and Pyne, 1994).

Additionally, concepts of sexual and reproductive rights have begun to encompass the broad socio-economic needs that enable women to enjoy those rights (Correa and Petchesky, 1994). For example, the framework for women's reproductive rights and health proposed by the Southern women's network, Development Alternatives with Women for a New Era (DAWN), 'incorporates attention to women's economically productive and cultural roles in addition to their biological reproductive functions' (Correa, 1994). Some feminists explicitly include sexual self-determination in their framework. For example, a women's organisation in the Philippines urges that 'self-determination and pleasure in sexuality is one of the primary meanings of the ideas of "control over one's body" and a principal reason for access to safe abortion and birth control' (Fabros, as quoted in Correa and Petchesky, 1994).

Advocacy on such a comprehensive agenda has proved no easy task, given the vertical trends of international agencies, donors, national governments and even activists in both fields. Vertical programmatic and funding channels within the population field have made it difficult to develop and implement comprehensive reproductive health services, as evidenced by the difficulties in integrating even STD services into family planning programmes (Wasserheit and Holmes, 1992). Similarly, the traditionally individualistic Western view of 'rights' has often proven alienating or limiting to many communities, where conceptions of rights and responsibilities are more collective.

Southern and Northern feminists are conceptualising an ethical basis for reproductive and sexual rights that is based on existing human rights principles, but is more reflective of women's realities, and reconciles some of the perceived dissonance between individual and reproductive rights and social and reproductive responsibility. They propose, for example, that 'bodily integrity' does not only concern the individual's right to

control what happens to her body, but the fact that such control has an impact on her ability to fulfil social responsibilities. Similarly, 'self-determination' in the realm of reproduction and sexuality does not necessarily imply individualism, selfishness, and isolation, but rather a 'respect for how women make decisions, the values they bring to bear, and the networks of others they chose to consult' (Correa and Petchesky, 1994).

Feminists affirm the need to respect cultural diversity in the articulation and exercise of rights and responsibilities. However, they caution that such respect must not be confused with political efforts by governments and others who use the excuse of cultural or national autonomy to deny the universality of women's human rights. (Correa and Petchesky, 1994). DAWN affirms that a Southern women's perspective does incorporate respect for cultural diversity and national sovereignty, with the understanding that when these contribute to women's subordination they must be challenged. This would, for example, require the alignment of customary and statutory laws with existing international human rights and other instruments, such as the ICPD Programme of Action, to protect women's basic rights and provide adequate services (Cook, 1992; Correa, 1994; Pine, 1994). Similarly, given the imbalances implicit in gender relations and reproductive responsibilities, the concept of 'equality' must be rooted in a broad agenda of social development and social change (Correa and Petchesky, 1994).

In addition to redefining existing population and human rights concepts, women are also working towards a new framework that may be more reflective of the voices of women who are not ordinarily heard in international policy settings. For example, the International Reproductive Rights Research Action Group (IRRRAG) provides a forum to explore how women in diverse settings understand their entitlements, such as autonomous decision-making and access to good services, in the reproductive realm. The project consists of interdisciplinary research teams in seven countries: Brazil, Egypt, Malaysia, Mexico, Nigeria, Philippines and the United States, and will use the term 'reproductive rights' (broadly defined to include reproductive and gynaecological health, childbearing, contraception, abortion, child care, and sexuality) until 'such time as the research itself points to a change in terminology' (IRRRAG, 1994).

Campaigns for action

These conceptual efforts go hand in hand with timely and specific global campaigns led by women. At a time when the women's movement has essentially come of age in the international policy arena, the impact of these efforts has been substantial.

For example, as a result of women's advocacy, the Vienna Declaration acknowledges that violence against women is a violation of human rights, whether by public or private perpetrators, and a Special Rapporteur on Violence Against Women was appointed by the Commission on Human Rights. The ongoing Global Campaign for Women's Human Rights is coordinating a series of actions as part of a campaign, 'From Vienna to Beijing: Building Human Rights Accountability to Women.' This will include activities at forthcoming world conferences, pressure to implement the Vienna document, and continued monitoring of human rights violations against women. The annual international campaign of '16 Days of Activism Against Gender Violence' of the last three years continues effectively to galvanise women globally (Center for Women's Global Leadership, 1994).

Similarly, the ICPD Programme of Action focuses substantially on reproductive health and on the overall empowerment of women, as a result of local, national, regional, and international women's meetings and advocacy (Garcia-Moreno and Claro, 1994). For example, the Women's Declaration on Population Policies identified minimum programme requirements for population policies and programmes regarding women's reproductive health and rights (Germain, Nowrojee and Pyne, 1994). Participants at 'Reproductive Health and Justice: International Women's Health Conference for Cairo '94' designed strategies for advocacy at the ICPD and guidelines for mechanisms of accountability and reproductive rights (CEPIA and IWHC, 1994).

These campaigns on human rights and reproductive health have gained momentum and have begun to converge. In Cairo, at the non-governmental forum, over 20 women's organisations from all over the world came together in a series of ten workshops on 'Human Rights Dimensions of Reproductive Health.' The series created a forum for activists from both fields jointly to explore specific issues, such as political uses of religion, ethnicity and culture, and strategies, such as using the human rights system to advance women's sexual and reproductive rights and health and accountability, enforcement and monitoring indicators, and strategies (Human Rights Dimensions of Reproductive Health, forthcoming, 1995; Copelon and Hernandez, 1994). Finally, the Women's Environment and Development Organisation (WEDO) is facilitating a process through which to ensure continuity in the representation of women and women's concerns in ongoing United Nations and associated processes (WEDO, forthcoming 1995).

While not exhaustive, these initiatives illustrate the range of action by women working together to move both population and human rights agendas towards the protection of women's human rights, including reproductive rights.

Next steps and recommendations

In conclusion, in the reproductive health and rights arena:

• International agencies and donors must support the work of women financially and politically. Women must be involved in all stages of policy and programme development, implementation and evaluation.

• Governments must include representatives of women in national efforts, delegations to international conferences, and include women in the process of fulfilling internationally agreed standards — even when not legally binding.

• Women must continue their advocacy, particularly in the development of implementation and accountability mechanisms. Given the recent accomplishments by women, representatives of women must be cautious of uses of rhetoric and the risk of cooptation. There must be continued efforts to allow for conceptual debate and growth and diversity of views within the international women's movement.

Women have shown the centrality of reproductive health and rights to both the lives of individual women and their families and the overall process of development. They have also brought creativity and a clear sense of justice to the international policy arena; two qualities sorely missing from both the population and human rights fields. As the international community moves towards the WSSD in Copenhagen and the World Conference on Women in Beijing, it is crucial that the work of women in the arena of reproductive health and rights be sustained.

References

Antrobus, P., Germain, A. and Nowrojee, S. (1994), 'Challenging the Culture of Silence: Building Alliances to End Reproductive Tract Infections', report of a conference, Barbados, Women and Development Unit, University of the West Indies and International Women's Health Coalition (IWHC).

Article 19 (forthcoming, 1995), *The Right to Know: Reproductive Health Information and Human Rights*, London: Article 19.

Boland, R., Rao, S. and Zeidenstein, G. (1994), 'Honoring Human Rights in Population Policies: From Declaration to Action,' in Sen et al (eds.) *Population Policies Reconsidered: Health, Empowerment and Rights*, Cambridge: Harvard University Press. 1994.

Bunch, C. (1990), 'Women's Rights as Human Rights: Toward a Re-vision of Human Rights,' *Human Rights Quarterly*, 12.

Cassen, R. and contributors (1994), *Population and Development: Old Debates, New Conclusions*, U.S.-Third World Policy Perspectives, No. 19. Washington: Overseas Development Council.

Cidadania, Estudos, Pesquisa, Informacao, Acao (CEPIA) and IWHC (Secretariat) (1994), 'Reproductive Health and Justice: International Women's Health Conference for Cairo '94,' report of conference in Rio de Janeiro, January 24-28, 1994.

Cook, R. (1992), 'International Protection of Women's Reproductive Rights,' *New York University Journal of International Law and Politics*, 24:2.

Copelon, R. and Hernandez, B.E. (1994), 'Sexual and Reproductive Rights and Health as Human Rights: Concepts and Strategies. An Introduction for Activists.' Prepared for Human Rights Dimensions of Reproductive Health Workshop Series, NGO Forum, ICPD, Cairo. New York: International Women's Human Rights Law Clinic, City University of New York and Center for Law and Public Policy, St. John's University.

Correa, S. with Reichmann, R. (1994), *Population and Reproductive Rights: Feminist Perspectives from the South*, London: Zed Press, in association with Development Alternatives with Women for a New Era (DAWN).

Correa, S. and Petchesky, R. (1994), 'Reproductive and Sexual Rights: A Feminist Perspective', in Sen *et al, op. cit*t.

Dixon-Mueller, R. (1993), *Population Policy and Women's Rights: Transforming Reproductive Choice*, Westport, Connecticut: Praeger.

Elias, C.J. and Heise, L. (1993), 'The Development of Microbicides: A New Method of HIV Prevention for Women,' Working Papers, No. 6, The Population Council.

Freedman, L.P. and Maine, D. (1992), 'Women's Mortality: A Legacy of Neglect' in Koblinksky et al (eds.) *The Health of Women: A Global Perspective*, San Francisco: Westview Press.

Freedman, L.P. and Isaacs, S.L. (1993), 'Human rights and reproductive choice,' *Studies in Family Planning*, 24.

Garcia-Moreno, C. and Claro, A. (1994), 'Challenges from the Women's Health Movement: Women's Rights Versus Population Control', in Sen et al (eds.) 1994 op. cit.

Germain, A., Holmes, K.K., Piot, P. and Wasserheit, J.N. (eds.), (1992), *Reproductive Tract Infections: Global Impact and Priorities for Women's Reproductive Health*. New York: Plenum Press.

Germain, A., Nowrojee, S. and Pyne, H.H. (1994), 'Setting a New Agenda: Sexual and Reproductive Health and Rights', in Sen *et al , op cit.*

'Global Center News' (Fall, 1994) Volume 1, No, 1. New Brunswick: Center for Women's Global Leadership.

Hartmann, B. (1987), *Reproductive Rights and Wrongs: The Global Politics of Population Control and Contraceptive Choice*, New York: Harper and Row, Publishers.

Human Rights Dimensions of Reproductive Health (forthcoming, 1995), report of workshop series. New York: Columbia University, School of Public Health.

Human Rights Watch (1993), *A Modern Form of Slavery: Trafficking of Burmese Women and Girls into Brothels in Thailand*, Washington: Human Rights Watch/Asia and Women's Rights Project.

International Reproductive Rights Research Action Group (IRRRAG) (1994), Programme Statement, New York: Hunter College.

Koblinsky, M., Timyan, J. and Gay, J. (1992), *The Health of Women: A Global Perspective*, San Francisco: Westview Press.

The Panos Institute, (1990), *The Third Epidemic: Repercussions of the Fear of AIDS*, London: Panos Publications Ltd.

Pine, R.N. (1994), 'The Legal Approach: Women's Rights as Human Rights,' in *Harvard International Review*, 16:4

Pyne, H.H. (1994), 'Reproductive Experiences and Needs of Thai Women: Where has Development Taken Us?' in Sen and Snow (eds.) (1994) *Power and Decision: The Social Control of Reproduction*, Cambridge: Harvard University Press.

Maine, D., Freedman, L., Shaheed, Frautschi, S. (1994), 'Risk, Reproduction and Rights: The Uses of Reproductive Health Data,' in Cassen *et al, op. cit.*

National Asian Women's Health Organisation (NAWHO) (forthcoming, 1995), 'South Asian Women's Health Project: Health Needs Assessment Report,' Oakland: NAWHO.

Nowrojee, B. (1993), *Seeking Refuge, Finding Terror: The Widespread Rape of Somali Women Refugees in Northeastern Kenya*, Washington: Human Rights Watch/Africa and Women's Rights Project.

Nowrojee, S. (1994), based on text by S. Correa and R. Reichmann, *Population and Reproductive Rights: Feminist Perspectives from the South*, Summary of DAWN's Platform for ICPD. Barbados: Development Alternatives with Women for a New Era (DAWN).

Nowrojee, S. (1994), 'Sexuality, Health and Rights: Gender Lessons from Africa,' in *Women's Global Network for Reproductive Rights*, Newsletter 47, July-September, 1994

Sen, G., Germain, A. and Chen, L. (eds.) (1994), *Population Policies Reconsidered: Health, Empowerment and Rights*, Cambridge: Harvard University Press.

Sen, G. and Snow, R.C. (eds.) (1994), *Power and Decision: The Social Control of Reproduction*, Cambridge: Harvard University Press.

Smyke, P. (1991), *Women and Health*, London: Zed Press.

Swiss, S. and Giller, J.E. (1993), 'Rape as a Crime of War: A Medical Perspective,' *Journal of the American Medical Association*, 270:5.

Thomas, D.Q. and Ralph, R. (1994), 'Rape and War: Challenging the Tradition of Impunity,' *SAIS Review*, 14:XIV,1, p.81, Johns Hopkins University.

Toubia, N. (1993), *Female Genital Mutilation: A Global Call to Action*, New York: Women Ink.

United Nations (UN) (1994)a., 'Programme of Action of the United Nations International Conference on Population and Development', New York: United Nations Population Fund (UNFPA).

_____ (1994)b., 'Attacking Poverty,' Backgrounder 2 prepared for the World Summit for Social Development, Copenhagen, Denmark, 6-12 March, 1995, New York: UN.

_____ (1994)c., 'Population and Social Development,' Backgrounder 4 prepared for the World Summit for Social Development, Copenhagen, Denmark, 6-12 March, 1995, New York: UN.

United Nations Development Programme (UNDP), (1994), *Human Development Report*, Oxford: Oxford University Press.

United States Women of Color Delegation (1994), 'Statement on Poverty, Development and Population Activities,' prepared by the US Women of Color Delegation to the International Conference on Population and Development. Washington: Women of Color Delegation to the ICPD.

Wasserheit, J.N. and Holmes, K.K. (1992), 'Reproductive Tract Infections: Challenges for International Health Policy, Programmes, and Research,' in Germain *et al* (eds.), *op. cit.*

Women's Environment and Development Organisation (WEDO) (forthcoming, 1995), 'Women's Global Strategies Conference,' report of workshop working groups. New York: WEDO.

World Health Organisation (WHO), (1991), *Health: A Conditionality for Economic Development. Breaking the Cycle of Poverty and Inequity*, Report of an international forum, Accra, Ghana, 4-6 December, 1991. Geneva: WHO.

_____, (1994), 'Health: Cornerstone of Social Development,' Fact sheet prepared for the World Summit for Social Development, Copenhagen, Denmark, 6-12 March, 1995, New York: United Nations.

Zephir, C. (1994), Presentation on Haiti, 'Women Without a Voice,' panel organized by DAWN at the NGO Forum, ICPD

4

Women's socio-political rights

*Creating the basis for a political democracy is absolutely fundamental if we are
going to achieve social democracy … our political organisation at national and
at international levels, is not just [a way of] expressing publicly what [women]
need, but we also have to ensure that [women] are represented in the decision
making model. We need to be involved in decision making because this is
essential for women's autonomy. Autonomy is not just the chance to choose
among options that are offered to us. Rather, … we have to establish the
conditions in which we … carry out our different options.*

Morena Herrera, Mujeres por la Dignidad y la Vida, El Salvador

In the paper which forms the core of this chapter, *Promoting women's
political participation in Africa*, Florence Butegwa suggests many ways for
women's organisations, international funding agencies, and governments
to promote women's political participation. Although focused on Africa,
and Uganda in particular, while using illustrations from other parts of the
world and from international conferences, her analysis has relevance for
women in all countries.

While concentrating on women's political participation in
government, Butegwa underlines the need for women to be active at all
levels and in all aspects of society. As she asserts, women 'have a wealth
of experience to contribute thereby improving the quality of the
decisions. Conversely, participation is a learning experience, which can
improve the quality of women's work in areas in which they are already
involved and stimulate their interest in sectors of development.'
Therefore, women's participation in governmental politics depends on
their participation at other levels. Florence Butegwa points out that
governments, NGOs, and donor agencies all have a role to play in
creating the necessary conditions for women's effective participation.

43

Donor agencies, in particular, can support the aims of indigenous NGOs and foster links between these organisations and their own gender units.

As we approach the end of the twentieth century, women continue to lack proportional representation in national political structures world-wide, their views and needs are still largely absent from mainstream debate and action, and, in almost every country, the level of representation by women on decision-making bodies within civil society is very low. As Florence Butegwa argues, concern for women's socio-political rights must lead to work which concentrates on areas beyond the boundaries of the politics of government. Women have the right to play a determining role in all organisations, institutions and movements that shape society and decide how people live their lives. A primary right is to be enabled to organise, and build autonomous organisations and movements.

Through political involvement at such a fundamental level, the political discourse can be widened to include aspects of life that have so far been disregarded by mainstream politics. 'We need to widen our concepts of political participation,' Jane Esuantsiwa Goldsmith (National Alliance of Women's Organisations, UK) told participants at the WLP Conference. 'We need a much wider interpretation of what politics and political participation is for women. All activities involving a movement for social change are political.'

In her article, Florence Butegwa argues that for women, the problem of political exclusion is circular. Lack of education and training are often singled out as an explanation for their low level of participation in politics, and certainly these are crucial factors. However, the real barriers are the combined social and economic forces that prevent women from gaining the necessary education and training. Public policies for education and training for girls and women will not be formulated, or made effective, without the political participation of women, charged with representing women's interests at all levels.

Luz Ilagon reported to the Conference, on behalf of the South Asia and Middle East working group (Nepal, Sri Lanka, India, Afghanistan, Pakistan, Lebanon, and Yemen) that 'our societies are still hierarchical, and within these systems the status quo is being maintained more than it is being challenged, and ... is even reproduced inside the home. Women have relatively high educational levels, but these have not resulted in significant changes in gender and equality. Specific examples [are] ... of Vietnam and Cambodia where many women during the socialist regimes were made to study and even go abroad to acquire professions ... when they went back, they [returned] to ... being domesticated, homebound and subordinated.'

Despite education to high levels, and competence in their field of work, many women can attest to their exclusion from participation in

political and social movements. The Africa regional working group spoke of the low number of women in politics, asserting that there is 'inadequacy ... both in terms of numbers [of women politicians] and the quality of gender sensitivity of the women that are there. As a result, many discussions take place, and many policies are made without the consultation of women.'

Breaking the circle of exclusion is one of the greatest challenges for women today, but it is one that women's organisations can meet, with the support of international funding agencies. As the South Asia and Middle East group stressed: 'there is a need ... to look into the structure in which these women are participating and ... those women who are participating in the political parties ... should be supported by the women's movement ... to deal with men at the party political level.'

Barriers to participation

As Florence Butegwa points out, although it is important to look at women's representation and participation in politics, this cannot be seen in isolation from the number of women participating socially and economically. The barriers which women face to participation in all aspects of society are interlinked.

The South Asian and Middle East group reported that actual numbers of women representatives may mask a real lack of representation for women. While in some countries, such as India, Nepal, and Bangladesh, there are special reserved places for women in parliamentary structures, women's participation 'is influenced by the political parties, or by a husband or relative, or a well-known person in the party'.

Even in political groups that consider themselves progressive, a woman's political identity may be defined by her relationship to the men of her family and by her role of mother. The moral weight of conservative social values may marginalise women who insist on their independent participation. At the conference, Kanchan Sinha (Project Officer, Oxfam UK/I, Lucknow) related her own experience of being excluded from a political group when she was pregnant and after her husband had resigned from it: 'Everybody in the group expected me to resign because I am a mother and because my husband had a difference of opinion with the organisation. So I thought, this is the situation of educated women: unless and until women get organised on the political front we are going to feel more and more powerless. I stayed in the group — by then we had our women's organisation. But our comrades in the movement will say [in these circumstances] "you are not a good wife." So what is this, a demarcation between good women and bad women? For them, we are

bad women, but it is OK to be bad women, to have something which is better for our future.'

The Africa regional working group echoed these points, saying that in addition to the lack of education and training for women, 'the main reason is cultural attitudes ... Most women ... in politics are there because they are wives or sisters of present politicians. That way they get support. There are very few women who are in politics of their own accord because of fear of losing that security.' How many other women politicians around the world do not speak out on behalf of women, because they fear losing the security of family support?

One of the most pressing challenges to women participating in political movements today are the growing anti-democratic movements, which invoke interpretations of custom and tradition to curtail women's participation in the public sphere. These movements were identified at the conference by one of the working groups during the 'Linking the Personal to the Global' section of the Conference, as 'authoritarian processes [worldwide]. They include racism, both ... individual[ly, at] micro-level, and [in communities, at macro-level]'. Reporting for the group, Gurinder Kaur (Regional Representative, Oxfam America, New Delhi) communicated their 'strong concern [about] ... fundamentalism and religious issues in development. This concern cut across practically all the global regions that were represented in the group.'

Participation and conditionality

Western-style representative democracy is assumed by many to be the key to achieving, not only fair government, but 'good governance' in the form of efficient government. Economic development assistance to the South has in this way been linked officially to the embracing of the government policies of the North.[1]

Since the mid-1980s, African governments in particular have been pressed by international financial institutions and Northern governments to adopt multi-party democracy. This demand is not only tied to a threat not to renew aid, but is accompanied by a requirement that states adopt structural adjustment packages which are characterised by neo-liberal policies favouring the operations of a 'free market' and cuts in the state's role as public service provider. Social services, which employ large num-bers of women, have been cut, so more women are unemployed; while cuts in health services and education mean that women are being required to do additional unpaid work and children are not attending school.

The overwhelming majority of participants at the WLP Conference made a direct link between the imposition of neo-liberal economic policies

and Western-style representative democracy, and the lack of political participation of women,and the absence of people with gender awareness in positions of power. Colletah Chitsike Oxfam UK/I, Zimbabwe) reported that the government of Zimbabwe had appeared to be sensitive to gender issues for a period after Independence was declared in 1980, but that now 'it looks as though the authorities have taken fright of changes which they had made and [this], coupled with [the effect of] SAPs, [means] women seem to be worse off.' The likelihood is that this phenomenon will be repeated wherever macro-economic policies are made without the representation of women. Assitan Gologo Coulibaly (Programme Co-ordinator, Oxfam UK/I, Mali) observed that 'the one positive aspect of [the] experience [of Structural Adjustment] is that ... men here now see that they are not as powerful as they had thought they were.'

Political and economic conditionality has given some room for manoeuvre on the part of previously marginalised constituencies. However, without grassroots involvement from all constituencies including women's, moves towards pluralism may either lack credibility and fail, or may be manipulated by those who traditionally hold institutions of power, and replicate the government of the past. Such moves do not address the demands of marginalised groups, or the gender imbalance of power ingrained in the dominant political groups. Sara Longwe (Gender and Development Consultant, Zambia) made the point very graphically when she described the situation in parts of southern Africa, where, she stated, 'political parties arise, but pluralism, or democracy, is simply the same people wearing different jackets, the imposition of dictatorships still comes through those people, and women's lives are still disadvantaged.'

However, the trend towards imposing political conditions on the disbursement of economic funding can be seen in another light: it has, perhaps unwittingly, provided an opening for gender and development activists to promote the idea of women's equal political participation. Women's organisations are increasingly deciding to take up the issue of political conditionality currently being placed on governments of the South, and attempt to turn it to their advantage.

Helen O'Connell (One World Action/Women in Development Europe network) argued for this at the Conference: 'At the international level, there is a lot of talk about good government, good governance, transparency, and accountability. I think that one of the things that we need to do is to involve ourselves in these debates and say what good governance means to us. It means human rights; it means the capacity to participate. I feel we need, however reluctantly, to take part in these debates, to redefine what is meant by these concepts, and hi-jack these issues that [come] from the World Bank and donor governments.'

Working on national agendas at international level

It is more important now than ever before for gender and development practitioners, and the women's movement, to form international alliances, as powerful political groups strive to form their own international alliances which are often threatening to notions of gender equity. Fundamentalist movements, associated with a wide range of religious persuasions, are increasingly involved in national politics, and have become part of worldwide alliances against policies which promote women's reproductive rights. For example, participants at the World Conference on Population and Development in Cairo in 1994 witnessed co-ordinated attempts to undermine the rights of women to control their fertility. To challenge these attacks, much greater support for strong and focused international networks, linked with local programmes, is needed.

Jane Esuantsiwa Goldsmith told the conference that, from her experience, she sees a need to 'ensure that we work at all levels. We need to ensure that women are supported to be politically effective wherever they are positioned, within development agencies themselves, political parties, businesses, the women's movement, and academic institutions. If any of these women are acting to empower other women, then they are all engaging in political participation, and they are all part of the women's movement, and that's where we need to make our alliances.'

Finding the right methods to counter malicious and divisive tactics is a skill that is needed by women who enter the world of party politics. In Europe, North America, and Latin America, women have a long history of activity in political parties, liberation movements, religions, trade unions, and government. Involvement in such activities demands skills for campaign organising, press and public relations, and the maintenance of a constructive 'group dynamic' in the event of the group being threatened with division from outside. All these can be shared with individuals and organisations which have only recently begun to participate in a formal manner in activities in the public arena.

Socio-economic movements of Indian women workers, as trade unionists, and as organisations of self-employed women — Self-Employed Women's Association (SEWA) and Working Women's Forum (WWF), for example — have served as inspiration and models for social organisation in other countries. Links with these organisations have been made by campaigners and organisers of homeworkers in the UK and other European countries. The Grameen Bank of Bangladesh provides a case-study of an alternative means of credit provision and saving for women and men living in poverty, and as such has been widely publicised and emulated by development NGOs working in the South and by community organisers in the North.

In many parts of Africa, women's participation is now beginning to be felt in party politics, and Conference participants felt that these women might benefit from a structured exchange drawing on experiences from other parts of the world. Relating her personal experience of the 1991 elections in Zambia, Sara Longwe described how a women's group, unprepared for the underhand tactics of party politics, was manipulated and divided by the main political players. 'This is where we need to make alliances; because as soon as you start a movement in your own national context it gets nipped in the bud, destroyed before it has grown, by dividing and ruling the people who are starting it. ... but we didn't stand up strongly enough, the divide and rule went on so much that at the end, we were not very effective and only eight women got elected.'

Issues of representation

In any alliance for the promotion of women's political participation, women need to have open access and equal opportunities for such participation across race, class, disability and sexuality. In common with men, women who participate in politics, both within government and in 'civil society', tend to have had the benefit of education and training: they are thus often charged with representing a constituency of which they are not a part. As the South Asia and Middle East working group stated, women in politics 'are generally not women who take up grassroots women's issues'.

In this light, breaking into existing political structures is not the only challenge. Women also need to understand these structures to see how they can be changed to make them more inclusive of all marginalised groups. As Betania Avila of SOS-CORPO in Brazil, told the Conference: 'It is very important to understand the construction of political democracy as a fundamental prerequisite for building social democracy in our countries. Often ... people do not remember that only a few years ago, in the majority of our countries, we achieved freedom of expression and freedom of organisation. So if we are going to try to transform the imbalances, ... we have to ensure the consolidation of political democracy. This is absolutely vital for women, it's a question of life and death for us because apart from political repression in general, we have also had to achieve freedom of expression in a battle against the patriarchal system which is very strong and which has very strong roots.'

Gender relations are being addressed by women within a wide range of political organisations, and women are carrying gender issues into the main political arena. Such 'scaling-up' should be applauded, but not at the expense of the women left behind. Mary Sue Smiaroski (Oxfam

UK/I, Chile) reminded the Conference how important it is 'as we support women who are going forward to empower other women, not to forget about the women who still need to find their way to organisation and participation, and who are still taking steps in their identity as women. We have had a very painful experience in Chile of losing many, many women to political participation, leaving behind the women's movement, and the women's movement becoming weakened by this. ... It has to be ... a link in a chain, [rather than] a few brave and pioneering women going ahead and leaving the rest behind.'

The terms of political practice need to be changed: not only do women need to question what is being discussed, but where and with whom. Women's political participation should not be limited to educated, articulate women talking to each other. We have to make sure we have democratic structures to allow all women to participate and be represented.

According to Morena Herrera (Mujeres por la Dignidad y la Vida, El Salvador), this 'implies [the need to work] from different perspectives. On one hand it is important that we work in order to 'feminise' the power spaces, so that there are increasingly more women in the spaces where decisions are taken, both nationally and internationally. But on the other hand, and simultaneously, it is important to strengthen the women's movement as a political lobbying factor that is prepared to establish a dialogue with those very power structures. Maybe ... when we have changed all of this, we will no longer need this political support. But in the meantime, it is fundamental.'

Linking mainstream politics with the women's movement

Strategically-directed support is needed to give women assistance to enter mainstream politics, and to develop the skills and resources necessary to define their own political needs. On the international stage, we need alliances of women in the North and South, and South and South. In all countries and regions, women are needed in positions of power, but it is also important to have a strong women's movement to maintain the alliance between women in politics and women at the grassroots, and to keep pressing for a gender dimension to politics. As Maria Suarez Toro (FIRE, Costa Rica) commented, 'the autonomous women's movement must sustain a presence in mainstream politics.'

Speaking on behalf of the Latin America and Caribbean regional working group, Morena Herrera stated that 'strengthening the structures of women's organisations is fundamental to any strategy for

self-determination, because this also strengthens the voices of people and movements at levels of society not normally heard from in national and international issues.' By extending the concept of democracy in such a way, a new political and social democracy can be built. Challenging the status quo is, in itself, a political act.

The need for maintaining continuous linkages between the grassroots, other organisations, and political parties, was raised again by Lajana Manandhar (Oxfam UK/I, Nepal). She referred to the dangers of projects being funded without due thought being given to linking the work to a longer and wider process: 'different organisations say "go and train the women in legal aid"; and the women learn their basic rights, and what support they can get from the law. After that, they have no connections to the organisers who trained them ... I would like to stress that a continuous link is important at the grassroots level, and, where there is a political leader, ... she [should] also ... develop links with all the local institutes, government, and other organisations.'

Popular education, the media, and participation

As Lajana Manandhur reminds us, working on gender and development is a long-term process in which only a limited amount can be achieved by intervention in the public domain. Formal democracy and improved legislation do not guarantee participation; the system can be manipulated. Gender sensitisation extends women's capacity to analyse political changes, such as new or proposed legislation, and enables women to develop strategies to secure good and responsive law makers of their choice.

The law, which is the chief tool for government in a democracy, is a necessary, but insufficient, means of guaranteeing women's human rights. Where knowledge of the law is lacking, or where the law itself is inadequate, action must be taken to promote knowledge and work for change. Where legislation is passed in the name of women, women must be made aware of their rights under this legislation, and how they can use it to become true participants in democracy. Juliana Kadzinga (Programme Officer, MS, Zimbabwe) spoke of the work that needs to be done with grassroots women to ensure that laws achieve their aim: 'There is no Northern agency that is committed to funding training of grassroots women so that they are [made aware of gender politics]. So many laws [which have potential to benefit women] have been passed in Zimbabwe, for example the Legal Age of Majority Act, but how many rural women have benefited or are benefiting from these laws?'

There are many ways of learning about rights and political

participation. Public broadcasting, as every demagogue knows, is an efficient means of political propaganda. It can also be a forum for popular debate, and can play an effective part in a mass information campaign. For example, Maria Suarez Toro, (Feminist International Radio Endeavour, Radio for Peace International, Costa Rica), told the conference of the 50-year silence of Filipina women who had been abused by Japanese forces during the Second World War. Their silence was broken when one women spoke on radio: 'others heard her, and many others have since disentangled an international network of sexual slavery by the military.' As a result, a case went to court to gain recognition of these women's ordeal, and secure financial compensation for them. Nynoshca Fecunda (De Beuk, The Netherlands), explained how the women's movement in Cambodia found a strategy to get women's concerns onto the political agenda. Women's Voice, a national women's organisation in Cambodia first organised lobbying for an end to violence, and then formed a pressure group concerned with the national constitution. Women's Voice continues to run a regular radio programme 'to talk about women's problems'.

Women need access to the media to counter the gender bias of news dissemination and to promote positive images of women, offering an alternative to reductive and stereotypical views and opinions on women. Giulia Tamayo (Centro Flora Tristan, Peru), told Conference participants that many Peruvian women had supported the leader of Sendero Luminoso (The Shining Path), because they had been misled by propaganda and were unaware that he had been responsible for the death of the feminist leader of the women's movement in Peru. In such cases, said Giulia, 'it is very important for us to have the power to construct our own information flows'. Supporting gender-sensitive popular education initiatives is one of the ways in which Northern funding agencies can play a major role in providing practical support for women's political action.

Promoting women's participation: issues for funders

A suggestion made at the Conference was that funding agencies should seek to promote leadership training, to enable women to develop skills which are not only useful in party politics, but can also help women to negotiate with development agencies, and promote the formation of independent organisations. Training in leadership skills also helps women and men to monitor the manner in which laws are implemented, identify allies and share information, and research new ways in which to promote political participation. Funding agencies could also increase the

currently limited support for participatory research into the legal system and political processes, and popular education on these.

All these activities need the back-up of a women's movement whose aim is to get women's concerns recognised as political concerns. Yet, as Jane Esuantsiwa Goldsmith pointed out, funding to support the lobbying activities of the women's movement is the hardest to obtain, because most funders do not think this is relevant for development. Jane Goldsmith stated ironically 'in rich Northern countries, as in the South, when you are operating to empower women, nobody wants to fund you. Only when you are producing handicrafts do funders become interested in what you are doing.' A further consideration for Northern funding agencies is that funding to promote political education and participation risks the charge of 'neo-imperialism'. This charge continues to be used by political opponents to block initiatives such as support for women's organisations in the South by women's organisations in the North. Here, feminism is portrayed as a new form of imperialism; needless to say, political conditionality is seldom questioned on that ground.

The ideal of women's full participation in politics is also relevant to development agencies, where the presence of staff sensitive to gender issues can make a significant contribution to supporting the transformation of gender relations. Maria Suarez Toro, adding to the report of the Conference's Socio-Political Rights working group, stressed that women's political participation is needed to achieve change on all the key issue areas discussed at the Conference. Participants called for Oxfam UK/I to recognise this wider interpretation of political participation, and makes support and resources available to promote change.

Maria Suarez Toro also highlighted the need to 'look at the political participation of women in a sustainable way … for a sustained strategy that guarantees the transformations that we have been talking about. In the long run, that is what shows our commitment to change the overall development paradigm. … In this perspective, political participation of women includes the strategies and links we make to strengthen the political participation of women in development agencies, so that they, in turn, can be empowered … with all of us.'

• Promoting women's political participation in Africa

Florence Butegwa

Introduction

Political participation is one of those terms whose meaning, at least by current usage, appears to be indeterminate.[2] It seems to vary on a sliding scale, depending on the user and the occasion, from mere rhetoric to a situation where real social change is envisaged. Without a clear understanding of the concept, efforts at promoting the political participation of women in Africa can only result in minimal success. This paper gives me an opportunity to communicate my personal views on the meaning of the concept of political participation. The paper looks at the experience of women in Uganda, the United States of America, and during preparations for the World Conference on Human Rights. It makes some suggestions to highlight the challenges for the future in promoting political participation for women in Africa, and seeks to encourage women to define for themselves what political participation means in real life situations.

Political participation for women?

'Political participation for women in Africa? Do I detect some contradictions in the concept?' a colleague once asked. Although the inquiry was made in jest, it expresses some of the difficulty that planners, development workers, human rights activists, and women in general encounter when trying to promote women's political participation. In most African countries, as in many other countries of the world, there is some consensus that women's political participation is essential for fair development. Donor agencies have also, over the past decade or so, been ready to fund programmes designed to promote women's political participation.

What then *is* political participation? Article 25 of the International Covenant on Civil and Political Rights which guarantees for all citizens of a country a right to participate in public affairs does not define what is meant by participate or to 'take part'. Neither does it explain how the

citizens are to exercise that right. One writer has defined political participation as: 'behaviour designed to affect the choice of governmental personnel and/or policies, both through positive action and through protest'.[3]

The Commonwealth Secretariat has described political participation as having a variety of emphasis including: the involvement of individuals and groups in policy-making; their participation in decisions which affect them directly; making bureaucracy responsive to their needs and rights thereby improving the quality of policy.[4] The Oxford Advanced Learner's Dictionary of Current English[5] defines 'political' as '... of the State; of government; of public affairs in general'. Participation means taking part or getting involved.

Political participation, therefore, may be explained as the effective involvement of a person or persons in the affairs of the State, government or in public affairs in general. The phrase 'affairs of the State' or 'of government' refers to the formulation and implementation of public policy at all levels of a society (community, local, national, or international). Public policy may itself be explained as decisions on a set or sets of ideals or goals on what is good for the general public and on a plan of action for achieving those goals. Decisions by governments or their agents relating to public health, medical services, economic development, environmental protection, education, and a host of other concerns, are all public policy decisions. Every individual has a fundamental right to participate in the making and implementation of such decisions.

Therefore, political participation of women means the effective involvement of women in any country in the process of deciding what the goals are in each of these areas and other public interest areas, and how those goals are to be achieved. Women's political participation also extends to their involvement in the implementation of the plan of action, either directly or through people genuinely elected or selected by the women as their representatives. Their involvement can also be effected by influencing those institutions which implement policy decisions.[6] It has also been argued that where the political structures do not allow for such involvement, protests would constitute political participation.[7]

However, political participation within the above meaning is not limited to women exercising voting rights once every five years. Such a restricted interpretation of the concept can only be seen as an attempt to deny women their right to get involved in the public affairs of their countries. At community level, and within the agriculture, industrial, and financial sectors, other realistic and appropriate measures must be taken to ensure women's effective involvement.

Why should women participate in public affairs?

The next question that needs to be addressed is whether or not it is necessary for women to participate in the affairs of government or public affairs in general. Is it for the sake of participation? Is it for African governments and women to conform to a trend or to comply with demands of some foreign government or donor agencies?

Firstly, women constitute over half of the population on the continent. They are a resource that no country should ignore in terms of their potential in different development fields. In Zimbabwe, for example, women constitute almost 70 per cent of the labour force in the agricultural sector.[8] In Uganda this percentage is 80 per cent.[9] Policy decisions in agriculture should not be made without the active involvement of women. They have a wealth of experience to contribute thereby improving the quality of the decisions. Conversely, participation is a learning experience, which can improve the quality of women's work in areas in which they are already involved and stimulate their interest in new sectors of development.

Secondly, women have very specific needs in such areas as health, education, economic activity, the family, and the environment. These so-called special needs need to be articulated by women themselves and to be taken into consideration when policy decisions are being made. Women's effective involvement (as opposed to mere co-option) would ensure that decisions that affect women's lives are taken with their input.

Thirdly, participation in the decision-making process is a major motivating factor towards implementation and adherence to goals. As was noted in Arusha, Tanzania: 'the political context of social development has been characterised ... by ... impediments to the effective participation of the overwhelming majority of the people in social, political and economic development. As a result, the motivation of the majority of African people and their organisations to contribute their best to the development process, and to the betterment of their own well-being as well as their say in national development has been severely constrained ... and their collective and individual creativity has been undervalued and under-utilised.'[10]

Real development (as opposed to the accumulation of wealth by a few) cannot be achieved without popular support and effective participation of the people. Women's participation, therefore, is not a luxury but a necessity for African countries and others worldwide.

In addition to the functional-oriented basis for women's participation, political participation is a fundamental right for every woman. The International Covenant on Civil and Political Rights, ratified by over 21 African countries[11] provides thus:

Article 25
Every citizen shall have the right and opportunity without any of the distinctions mentioned in Article 2[12] and without unreasonable restrictions:
a. to take part in the conduct of public affairs, directly or through freely chosen representatives;
b. to vote and to be elected at genuine periodic elections ...;
c. to have access, on general terms of equality, to public service in his country.'

The right of every woman to participate in affairs of her country is further reaffirmed by the African Charter on Human and Peoples' Rights[13] and the Convention on the Elimination of All Forms of Discrimination Against Women. The latter provides:

Article 7
States Parties shall take all appropriate measures to eliminate discrimination against women in the political and public life of the country and, in particular, shall ensure to women, on equal terms with men, the right:
a. to vote in all elections and public referenda and to be eligible for elections to all publicly elected bodies;
b. to participate in the formulation of government policy and the implementation thereof and to hold public office and perform all public functions at all levels of government;
c. to participate in non-governmental organisations and associations concerned with the public and political life of the country.'

The African Charter has been ratified by over 40 African States while over 35 have ratified the Convention on the Elimination of All Forms of Discrimination Against Women. Ratification means that these states have assumed an obligation to take all necessary measures to ensure women's effective participation in the public life of their respective countries.

The environment for effective participation

The kind of involvement envisaged in the concept of political participation and the obligations assumed by states in the international human rights instruments referred to above, presupposes a suitable environment, including:

- a legal framework allowing for women's effective participation;
- adequate civic education and public awareness of the power of effective political participation;
- adequate organising and mobilisation skills.

The legal framework

Law has a major role to play in determining the extent to which women can effectively participate in public affairs.[14] Issues like citizenship, voting rights, the right to hold public office and access to valuable property become very important.[15] Although the statutory laws of most African countries apparently permit women to vote and to hold public office, their impact can be, and frequently is, reduced by customary and religious practices which define the role and place of a woman in the society. Thus married women are commonly required to vote for candidates of the husbands' choice. Culture, and the moral responsibility of the husband as head of the family, are given as the justification for denying the women's right to vote for candidates of their own choice. A woman wishing to stand for elective office or to apply for a senior post may be asked to show proof of no objection from her husband. This is in spite of the fact that there is no such legal requirement. Women may also fail to turn out for voting or other public activity because of their social role as carers for children and the sick. The absence of alternative facilities to relieve her must be seen as an impediment to her capacity to participate in public affairs.

Access to valuable property is also an important determinant of effective political participation, especially in the formal structures. Standing for elected office is an expensive venture in most African countries. In Africa, the majority of women do not own land and do not have access to commercial credit.[16] They are also among the lowest income earners.[17] This lack of access to valuable property and credit negatively affects women's participation in all aspects of commercial and public decision-making, as information and consultations tend to be restricted to property owners.

Admittedly, some of the factors preventing effective women's political participation may not constitute legal impediments. The failure of the legal system, however, to acknowledge these factors and make provision for alleviating or eliminating them, negates women's capacity to participate. The promotion of women's participation must involve legal reforms.

Civic education and public awareness

It is not enough for the legal system to provide for women's participation if women themselves are not aware of it. Awareness of the right to participate is also not enough, if it is not accompanied by an appreciation of the importance and power associated with effective participation. From the functional point of view, women need to appreciate the following:

Firstly, that they have a right to vote; to stand for elections for village, local and national elected offices; to contribute to debates on any local or national issue and to participate in any lawful activity that contributes to self-, and national, development. They need to know that this is a legal right which is not subject to any person's consent.

Secondly, that effective participation is the only key to have their voices heard at all levels. It is also the key and power to holding public institutions in all sectors of public life accountable to them as women. The idea here is for women to know that their involvement in public affairs is for a purpose: for each woman to get the best out of the development process while contributing her best to that process. They must, therefore, involve themselves in creating the structures and in designing the policies and programmes that serve those interests. At the formal institutional level, for instance, the appreciation of the power of the vote would enable women not to vote for a candidate unless that candidate commits herself or himself to promoting and protecting women's interests. The elected official, in turn, is more likely to be accountable to the electorate if it is clear that they appreciate their power as voters.

The experience of women in the United States has lessons for all of us. During the most recent presidential campaign, there was an identifiable women's lobby or constituency which supported the Democrats. It was unified on issues but clearly identifiable as women. Part of this constituency was pushing for abortion rights, part was pushing for a greater role for women in a new administration, while another part was pushing for gay people's rights. What they had in common, and which they emphasised, was that they were women. The Clinton Administration, I believe, by its actions and policies since coming into office, got the message that there is a substantial women's constituency that is serious.

This experience brings to mind an often-heard argument that women are not a homogenous group with the same interests and demands. This is true. Not appreciating this can lead to serious misunderstandings, especially among women themselves. It cannot, however, be used to mean that women cannot organise as women, nor that they cannot co-ordinate their political participation and demands. In addition to the experience above, the work of women in preparing for the World Conference on Human Rights in Vienna, 1993, is of some interest. As women from around the world they were determined to have an impact on the Conference, particularly its declaration, which would determine the course of human rights into the next century. These were women from different continents, races, political inclination, religious following, economic status, and so on. They were different in as many ways as can

be imagined. Yet they knew that they had to work together and present as united a front as possible in order to affect the Conference. This required a willingness to understand the legitimacy and importance of each group's key issues, and the maturity to devise strategies together on how to move forward with their different (and at times opposing) interests. There were negotiations and trade-offs, but in Vienna there was a feeling of overall unity as women. And this message was strongly felt by government delegates.

It must be acknowledged that strategies of this kind are in their infancy. The Vienna Conference and the US election were learning experiences for many women. But these two examples show that it can be done, even at national and local levels for maximum advantage to all groups or sub-groups.

Thirdly, that public institutions, including government departments and their field staff, local authorities, and elected officials are there to serve the public. Every member of the public has a right to have access to them and demand service. This includes women. Policy decisions are made and implemented in these institutions. Making use of them can only benefit us as women and make the institutions more responsive to our needs.

Finally, that political participation starts at the personal and family level. Women need to learn how to assert themselves, to put their arguments forward in the best and most convincing manner, and to deal with power (that of others and their own). This needs to start at the private and family level. Civic education for women must include training and practice in this crucial area.

Thus, for women who are trying to use political participation as a tool for breaking traditional social-economic patterns of inequality, civic education is not just a knowledge of the constitutional right to vote. It is not just voting to bolster political statistics of the percentage of the population which turned out to vote, thus legitimising despotic leaders. Civic education must be a strategic first step towards the empowerment of women to use their involvement for their benefit. That involvement must not just be at election time. It must be continuous, sustained, co-ordinated and at all levels of public life.

Organising and mobilisation skills

There is truth in the old adage that there is strength in unity. If political participation by women is unco-ordinated it is unlikely to lead to change. This can be seen from various African countries where women form the majority of actual voters during parliamentary elections, yet women's concerns do not feature as major election issues. Neither do the people

voted into office ever feel accountable to the women who voted for them. In order for women's participation to work effectively for them, it must be co-ordinated into a constituency pushing certain concerns into policy decisions and implementation mechanisms.

Experience has shown that in times of great crisis, women are very good organisers with a high degree of viability and fearlessness. In Algeria, for example, after the 1992 elections, reputedly won by the fundamentalist Islamic Front for Salvation (FIS), large numbers of women led or joined in demonstrations, to demand the union of all other political parties to stop FIS from taking power. 'It is interesting ... that all styles of clothing, supposed to symbolise the politico-religious beliefs of the women wearing them, were represented.'[18] Differences in socio-economic status and religion did not seem to matter. Similar scenes have been seen in Somalia in recent years.

This highly visible participation need not be episodic and crisis-centred. Women need to make it part of their daily lives at all levels. The starting point for the majority of women has to be at the personal, family and community level; building women's self confidence; changing power relationships within the family; and, playing a more active, substantive and independent role within her immediate community.

The way forward

The role of women

Given the growing consensus that women's participation is necessary for fairer development, what is the best way towards this goal? Obviously, women have a critical role to play in promoting their own participation. As indicated above, women must make progress in three key areas.

At the personal level, every woman needs to appreciate her own sense of self-worth and potential. Wherever you are and whomever you are, black, white, brown, educated, non-educated, rich or poor, you are a human being. You are endowed with certain rights that guarantee you a minimum dignity like any other human being. This applies within the family, the community, religion, and an other cultural institutions. This must be considered the bottom line, the absolute starting point — to motivate women to seek for themselves what is rightfully theirs. Asserting the right to personal dignity, thereby actively rejecting treatment that negates that dignity, must start at the individual level and within the family and continue to the community, within national structures and at the international level.

At the organisational or mobilisation level, women must identify themselves firstly as women regardless of political, economic, religious status or racial or geographic origin. In spite of the diversity among women there is commonality of interest that forms the only chance for women to agitate for and achieve structural change in the social and economic structures that perpetuate women's subordinate positions. Our diversity is a weapon we should remove from the proponents of the status quo. As women work together, there is room for addressing the concerns of different classes and groups of women.

At the issue-definition level, we need to accept the fact that women all over the world are faced with many problems. They are often all very serious concerns to those affected. We need to develop strategies that seek to address as many of those concerns at the appropriate levels with as much coordination and mutual support as possible. If, for example, women in South-East Asia are concerned about trafficking in women and are organising to put pressure on their governments to stop the problem, women in countries which receive trafficked women could put pressure on *their* own governments to put a stop to the practice. Women from countries with economic and political influence could exert pressure to stop this practice. The issue is not just as an Asian women's issue but an issue all over the world.

This calls for developing effective linkages across countries and continents. It calls for a willingness to treat each other's concerns as important enough for us to be involved with feeling and compassion. It calls for communication channels and technology that cut across language and cultural barriers. It is a challenge that women need to grapple with.

The role of governments

The participation of women in the public affairs of their country is not a luxury. It is a necessity for development. Governments, therefore, have a crucial role to play in promoting women's participation. Aspects of these roles have been indicated above, including law reform to remove legal and structural impediments to participation. Governments must also play a role in neutralising cultural and religious beliefs and/or practices that act as a bar to women's participation. In most countries governments have abdicated their responsibility in this respect leaving it to non-governmental organisations (NGOs), which are often under-funded. Laws and policy decisions are not enough; in fact they may serve to reinforce the status quo.

In Uganda, for instance, the National Resistance government decided that women were to have reserved seats in the National Resistance Council (parliament) and all local councils. Each administrative district was to elect

a woman to represent women of the district in the National Resistance Council (parliament). Similarly, there would be a woman (secretary for women's affairs) in the village, parish, sub-county, county and district committees which were the effective local authorities at those levels.

Although women were not barred from contesting seats other than the 'women's seats', it was soon clear that almost all women who offered themselves for election stood for the women's seats. Most of those few women who offered themselves for the 'general seats' were not voted for on the grounds that 'women already had their seat'. The same pattern can be seen at the lower levels of the political structures, where women were elected only for the 'women's seat'.

In the National Resistance Council members are sometimes heard calling on a woman member to speak if the issue concerns women. Conversely, some women's representatives never contribute to debates on issues other than those they consider of specific concern to women. A similar demarcation can be detected at the lower levels. Committees have some limited judicial powers at the village, parish and sub-country level. Women members of the committees complain that they are not called for court sessions unless the dispute concerns a 'woman's issue'. Positive discrimination in favour of women may have unwittingly served to emphasise the perceived demarcation between wider public affairs and specifically women's issues. Governments need to do more to ensure the policy decisions have the desired effect.

The role of NGOs

Most women's NGOs appreciate the fact that they have a role to play. What appears to be problematic is balancing the need to address women's immediate needs and their long-term or strategic needs. Although there is no inherent contradiction, the practice of NGOs has shown artificial boundaries in these two areas. There is no reason why income generation cannot be used, not as an end in itself, but as part of an empowering process: as part of a political participation strategy. Indigenous NGOs need to take the lead in designing integrated programmes that do not perpetuate the status quo. Foreign development and donor organisations also need to understand the disadvantage of boundary-setting.

The role of donor agencies

Donors should continue to play their funding role, but with a difference. Priorities set at headquarters often derail indigenous NGOs from addressing the real needs of the communities to those in which funding

is available. A spirit of mutuality of purpose between the gender division of the donor agency and the partner NGO and community should be fostered.

Differing priorities on the part of Northern funding agencies often derail indigenous NGOs from addressing the real needs of the communities; rather they must change their agenda to match the funding which is available. A spirit of mutuality of purpose between the gender division of the donor agency, and the beneficiary NGO and community, should be fostered. Donor agencies may be able to make representations to governments about official development policies. An advocacy role can greatly facilitate changes that indigenous NGOs are working for.

In conclusion it must be stated that political participation is a learning process for women of the world. They have been kept out of key roles for centuries. Women must not be discouraged by the mistakes we make nor by the slow progress. What is needed is clear goals. As one author wrote, 'as long as we understand what we are aiming for, it is a matter of strategy, sustainability and resilience.'[19]

5

Violence against women

*Violence against women constitutes an infringement of basic human rights,
[and] undermines their self-determination and their ability to participate fully
in, and to benefit from, development.*
Gender and Development, Oxfam's policy for its programme, May 1993

Male violence against women is a worldwide phenomenon. Although
not every woman has experienced it, and many expect not to, fear of
violence is an important factor in the lives of most women. It determines
what they do, when they do it, where they do it, and with whom. Fear of
violence is a cause of women's lack of participation in activities beyond
the home, as well as inside it. Within the home, women and girls may be
subjected to physical and sexual abuse as punishment or as culturally
justified assaults. These acts shape their attitude to life, and their
expectations of themselves.

As was agreed at the WLP Conference, and substantiated in the paper
by Lori L Heise, which is part of this chapter, *Overcoming violence: a
background paper on violence against women as an obstacle to development*,
gender violence does not exist in a vacuum; it is carried out in the name
of culture, religion, health care, justice, control, and development. It is,
Lori Heise asserts, 'perhaps the most pervasive yet least recognised
human rights abuse in the world'.

In addition to mental and physical abuse in the form of violent, non-
sexual assault, forms of violence inflicted on women include child sexual
abuse, rape — by strangers, by acquaintances and by sexual partners, in
peacetime and in conflict — murder and mutilation, forced prostitution
and trafficking in women, and female genital mutilation. Ada Facio
(ILANUD, Costa Rica), pointed out at the WLP Conference that 'violence
against women exists in every society, in every class, in every culture in
this planet, it exists everywhere and it has existed in many cultures for

thousands of years, it is not a new phenomenon.' Gender-based violence works at two levels. It may be a very personal act, often contained within the privacy of the family, but it is often condoned by that most public of institutions, the law — for example, where the definition of rape restricts legal recourse for women. At national and international levels, the women's movement has worked over the past decades to change the law itself and its implementation in the legal system, so that violence against women can be re-defined in terms of human-rights abuse.

Increasingly, international agencies which fund development, such as Oxfam UK/I, are adopting gender-sensitive policies for development, and supporting organisations that are working against the continuance of policies that are damaging to women. Nevertheless, violence against women remains widely viewed as an issue which it is inappropriate for development organisations to address; rather, it is seen as an issue for the women's movement. Despite the continuing lobbying of organisations which have experience in working on the issue of violence against women, most development funders have yet to recognise the true nature and extent of male violence against women by altering their funding criteria and operational practice.

Gender and development theoreticians and practitioners, including Sara Longwe (Gender and Development Consultant, Zambia) stress that gender issues should be recognised as human rights issues, arising from the injustice of gender relations which subordinate women. Male violence to women 'is the last resort in patriarchal control ... From the feminist point of view, this ... has its positive element, because maintenance by violence is a sign that ideological legitimation has failed, and the underlying crudities of male dominance are exposed.'[1] Speaking at the WLP Conference, Sara Longwe pointed out that 'violence and gender disparities do not come out of thin air; they have been created by societies, by systemic discrimination against women.' Individual men, or groups of men, may also experience discrimination, but there is no equivalent to the universal and 'systemic discriminatory systems that work against women from a patriarchal basis that favours men'.

Violence is the worst expression of women's oppression, arising because, Sara Longwe believes, '[women] are voiceless, as my sisters have been saying at this conference. Lack of a voice — although we have a tongue — leads to the poverty which they have described and which we should be getting rid of; it leads to battery, rape, incest, AIDS, displacement and it leads to all kinds of gender disparities which are uncalled-for injustices. We are voiceless, we are powerless [despite the fact that] all of this happens for everyone to see. We don't know what more we have to say we will do in order for people to see.'

Violence against women as a human-rights issue

In December 1993 the United Nations General Assembly adopted the Declaration on the Elimination of Violence Against Women. In the same year, after a long and intensive international struggle, the United Nations Declaration of the World Conference on Human Rights had indirectly conceded that violence against women is a human rights violation, and the position of a Special Rapporteur on Violence Against Women was established.

In her paper, Lori Heise considers the issues of domestic violence, rape, and sexual abuse. In addition, she points out that 'other forms of gender-based abuse can be as damaging and potentially fatal': preference for male children resulting in female foeticide, infanticide, and selective feeding, murder of brides involved in disputes about dowry, genital mutilation of girls, and acid attacks on women activists. No matter where they take place, Lori Heise believes that 'all forms of gender violence share a common theme: they are violent acts that are socially tolerated in part because the victims are female.'

The definition of violence in the 1993 Declaration is broad: '... any act of gender-based violence that results in, or is likely to result in, physical, sexual or psychological harm or suffering to women, including threats of such acts; coercion or arbitrary deprivation of liberty whether occurring in the public or the private life.'[2] The Declaration states that: 'violence against women is the manifestation of historically unequal power relations between men and women, which have led to domination over, and discrimination against, women by men, and to the prevention of their full advancement. Violence against women is one of the crucial social mechanisms by which women are forced into a subordinate position compared to men.'[3]

The significance of the Declaration cannot be underestimated. For the first time, abuse of women is recognised as being both a cause and a symptom of unequal relations between men and women; as such, the only way to eliminate male violence against women is to eliminate the inequality of men and women. Although this UN Declaration is likely to go unheeded like so many others, it gives activists a powerful basis of support, lending legitimacy where none has existed before. In speaking about the work she has been involved with in making violence an international human rights issue, Alda Facio (ILANUD, Costa Rica) told the conference that 'now we have an international instrument that I hope people will start using, to convince people that violence [by men against women] is not itself caused by war, it is not caused by economic deprivation, it is not caused by the economic crisis.'

Violence: the ultimate barrier to development

Although violence against women is the ultimate barrier to women's participation in all aspects of life, and as such prevents women from benefits that development interventions may offer, the abuse of women has been protected by the widespread view of culture as being both sacred and unchanging. Violence against women, which is often protected by cultural norms and traditional practices, has been largely unchallenged by development theory and practice.

A statement from Sudan testifies to the entrenched problem of gender violence which is justified by culture: 'It is very difficult to change people's attitudes towards cultural acts, especially if it is a very deeply rooted culture ... in our society women are suffering much from tradition, which in most cases lies under the umbrella of religion. Women are inferior ...they are married at a very young age and they [do] not choose their partners. If they refuse they [are] punished and subjected to different sorts of violence from the family, especially fathers or brothers. At the same time there are other sorts of violence, like circumcision of the girls in childhood, which affects [them] psychologically and physically.'

A Conference participant from West Africa pointed out that in many situations women themselves do not prioritise working on the issue of violence since it is so widespread and culturally condoned: 'Where we come from, violence against women is not always expressed and externalised by women. ... Therefore, I think that one of the mistakes that we could make would be to [try to make uniform priorities at a global level] regarding the issues that we want to tackle.'

In situations where there appears to be no alternative to enduring violence, women may develop coping mechanisms or see it as the bad side of a bargain in which conformity may be ultimately rewarding. In the Conference working group on violence, it was stated that in some African societies women may tolerate beatings when they know these will be followed by gifts; while, in some communities in parts of India, there is a belief that the part of the body that is beaten goes to Heaven. Such examples of desperate coping mechanisms may be interpreted mistakenly as positive acceptance of male violence.

Violence as a development issue

Not only do many people, including women who work with women, fail to understand the extent of violence against women, but it is still generally seen as a personal problem, or one that is experienced by another class or another culture. The economic and psychological effects

of exposure to violence in conflict have been studied at length, and are widely recognised. However, there is no similar recognition of the effects of frequent and often-repeated violent attacks on women and girls in their home and wherever they work or travel. Such violence is invisible because it is viewed as normal and a part of life; yet it results in fear, ill-health, injury, psychological trauma, and often death. The quality and effect of development interventions are affected, Lori Heise asserts, by the indirect and direct effects of gender violence and fear of violence. Women can be physically threatened by the men in their family for participating in development projects of which they do not approve, or which they feel calls into question their own relatively higher status.

Research shows that the trauma women experience as a result of gender violence is likely to affect their personal development. Fear of strangers leads to inhibitions about going out, to obtain education or look for work. Lori Heise quotes one researcher who found that 'threats or fears of violence control women's minds as much as do acts of violence, making women their own jailers'. For example, this 'distinctly female fear' has implications for women living in so-called protected areas, such as refugee camps, where they may be too afraid to collect firewood, water or food. For such women, fear manifests itself in malnutrition.

In addition to the effects of violence on the individual, there are wider effects on the family and the community: low productivity, dysfunctional behaviour, low expectations, and more violence, including in the next generation. In general, development funding agencies — including NGOs- have not tended to support organisations whose express purpose is to try to sensitise society at large about gender violence. By taking the attitude that violence is a personal problem, or a social problem concerning only the family, development agencies deny their role in perpetuating violence by failing to recognise it. At the root of this is the perpetuation of inequality and gender-based discrimination.

At the Conference, the working group on violence played out a simulation of a local health-based development NGO dealing with the common problem of wife-beating. The simulation showed how a lack of consciousness of socially-sanctioned violence against women had prevented this case coming to light. The NGO manager interpreted women's poor health as a sign of low educational achievement. Yet, how many women and girls are kept from school, not by violence in itself, but by the same social structures that permit violence against them?

Alda Facio (ILANUD, Costa Rica), herself a survivor of gender violence, commented on the simulation exercise: 'I think that the problem is [that] we all feel guilty, we feel embarrassed, we feel ill at ease with the topic itself. What came out strongly in the simulation, ... was the

isolation of the battered woman, how she felt that no one was really listening to her, or thinking of her needs. ... We saw that violence is not seen as a health issue, an economic issue, a development issue, a human rights issue; and usually the only people that deal with violence are women's organisations. ... Trade unions don't talk about violence, development agencies don't talk about violence, and yet violence is happening everywhere, in all aspects of life.'

The simulation highlighted the futility of implementing a development project for people who are vulnerable to intimidation and abuse, without also addressing the root cause of their fear. The fact that many women of the South have identified male violence as an important issue in their lives should make it an issue for development agencies, both funders and local NGOs. When development agencies fail to make the connection between violence and fear of violence, and the freedom to engage in development programmes, they reveal a failure to appreciate the significance and incidence of violence in the everyday life of women.

Fatumata Sow, (APAC, Senegal), described her personal struggle to get women's issues accepted as development issues: 'Ten years ago ... the issue[s] of violence against women and reproductive rights of women were important issues on our platform. However, we came up against a blunt refusal from many organisations with whom we wanted to develop partnerships, because for these organisations, these issues were ... raised by intellectuals, by an élite, and they thought that these were ... not those of [grassroots] women ... through North-South relations — and this is an important link as far the issue of violence is concerned — international campaigns and international coalitions were formed, and [the funding agencies] were forced to accept that this was an important issue. But then [the funding agencies] said, "yes, ... you were right, but still it is a little bit too early for the issue to be raised." I say it is never too early.'

Ways of working on violence

Eugenia Piza-López of the Oxfam UK/I Gender Team, expressed an opinion shared by many at the conference: 'in the name of culture, violence against women has been ... considered as natural. The perspective of the women's movement is to transform ... culture. Culture is not something fixed, but something to be transformed.' Early in the Conference, during a discussion centred on 'Linking the Personal to the Global', Gurinder Kaur (Regional Representative, Oxfam America, New Delhi) reported on behalf of a discussion group on the role and pressure of culture and social customs in oppressing women. The

group had concluded that 'it is very hard to counter these factors, because mostly [they are] in the form of attitudes and the cultural values … imposed on women and on society. Also, social customs and practices need to be worked at over a long period of time.'

A West African participant stated that, in her view, working on the issue of women abuse 'should be done … through support to women's organisations that wish to carry out much deeper research and analyses in their own context as to what kind of violence they encounter.' As many Conference participants testified, from their personal and professional experience, development needs to be seen as a process so that all the contributing factors are addressed. Research is indeed needed into violence against women in different societies, as are immediate solutions to combat the abuse. These activities can be complementary. As Maitrayee Mukhopadhyay (Gender Adviser for South Asia, Oxfam UK/I) said, 'we need to do research in our own cultural contexts about what is going on, But we should not lose sight of the fact that [gender violence] is a phenomenon which is very widespread. And women are not coming out and telling us about it because they don't have the means to do so.'

In a safe and sympathetic environment, women will be able to communicate, and will prioritise the need to address gender violence as they feel they need to, if they know they will be supported. Maitrayee Mukhopadhyay recounted the experience of the women's movement in India in the 1980s: 'when we started a movement against the death of young brides, … within a space of three years autonomous women's organisations were flooded with women telling us about the horrible everyday violence that they experienced. … I think it's also a question of creating the structures where women can come out and tell us what is going on. … Just because certain cultures tolerate violence, we should not … tolerate it.'

Women are not only victims of violence, but also resist it: credit for the UN Declaration on the Elimination of Violence Against Women and the achievements of the UN Convention on Human Rights must go to the persistent campaigning of the international women's movement. Women are working at several levels for greater understanding of the causes and effects of violence against women. At the community level this can be particularly difficult, but also very rewarding.

It is commonly believed that most if not all women's problems could be solved by education. In line with this, during the conference plenary there were a number of calls for more, and better, education for women so that they become aware of their rights. It is also necessary to ask to what extent education can empower women to challenge endemic violence. Melka Eisa Ali (Oxfam UK/I, Sudan) spoke on the role of

education in strengthening women's visibility and position in society and thus acting as a protection against violence by men: 'violence against women ... is because of the seclusion of women from the benefit of other parts of life. Violence becomes a part of women's lives and I think that men are the cause of this violence. ... We cannot fight men or struggle against men because this is our nature, ... so the only thing to do is to empower ourselves and empower other women. I think that this cannot be done by projects, by handicrafts or other projects. Empowerment can be done by the education of women because the majority of women in the world are illiterate and this is a cause of their weakness. ... Most women can do nothing, because they are always frightened of men. Because of that I think that education is the most important element in the empowerment of women. We should all of us link together to empower women and our aim is to educate women, the oldest women and the youngest women.'

However, Alda Facio reminded the Conference that 'education per se doesn't eliminate violence against women. Very well-educated women are raped, are battered by their husbands, are sexually harassed in their work, so education does not guarantee freedom from violence.' While education alone does not guarantee freedom from rape, from sexual harassment, and from beatings by a husband, it is easier for educated women to find out their legal rights, to use them, and to make alliances with other women and supportive organisations. Education can also build confidence; literacy projects can therefore can be part of a strategic programme for combating violence against women and addressing other development issues.

To enable the law to serve women, it is necessary to raise the awareness of the police and judiciary to the complexity of the issue of gender violence, and the barriers that exist which stop women from reporting abuse. Luz Ilagon (Women's Studies and Resource Centre, Philippines) told the Conference how women's organisations 'lobbied the local council to have women police officers present at the initial investigation of each rape case. These officers attended a gender-sensitising seminar so that they would know how to go about the questioning process, and also so they would be more sympathetic to the victims. Since then, a Women's Desk, composed of these police officers, has been established in the local police stations. A positive development of this is that these policewomen have become members of the women's organisations.'

In several countries, women's groups have sprung up in support of cases in which a woman has been charged with the murder of the man with whom she lived and whose deadly violence she feared. Although progress has been made in some countries, woman's organisations

working to change the law face opposition from the legal system, and religious and cultural institutions. International support is a very important factor in providing publicity and support for such cases, and in bringing the attention of those who frame international policy and laws to the need to change attitudes and legislation to support the victims of abuse.

Transforming culture means not only working sensitively with a deep understanding of social structures, but also means countering the tide of sexist and violent images and messages brought by the new worldwide popular media. Neelam Gohre (Stree Aadhar Kendra, Pune, India), reporting for the WLP Regional Meeting which immediately preceded the Conference, stated: 'in Asia, popular media play a very important role in stereotyping the exploitation of women and glorifying the violence. In songs and films women are portrayed as commodities, as objects. This is a cultural phenomenon that could be tackled by a regional coalition of women's organisations with a permanent base.' This contribution to the debate counters mainstream reports of campaigns on violence against women, that have tended to see violence as a concern of Northern so-called 'radical' feminism. This leads to an assumption that, while women of the South have the problems, Northern women have solutions. As mass communications systems proliferate in the South, it will become apparent that women everywhere share the problem of male violence; and that, just as Northern women have problems, women of the South also have solutions.

Placing violence on the development agenda

To place male violence against women on to the agendas of development funding agencies necessitates the formation of alliances with other interested constituencies, including feminist organisations and other organisations which work with women. Addressing violence against women requires long-term funding of a range of programmes including counselling, lobbying, and campaigns to raise awareness of the extent of violence against women and its effect on women's morbidity, mortality, and quality of life. Time is needed to develop discussions on this sensitive issue between funders, predominantly from the North, and activists. Throughout the Conference, participants made suggestions of ways in which Oxfam UK/I and other development agencies could address the issue of gender violence:

• acknowledging the various forms which gender violence takes;

- addressing women's particular needs in conflict, which increases levels of violence against women, and in refugee and displacement camps;

- raising awareness of the extent of violence against women and its effect on their well-being, rights and quality of life, through an information campaign, working with national and international women's organisations worldwide;

- facilitating training and sensitisation about the issue at every level: in management, at the grassroots, and within the legal system;

- supporting the work of women's organisations on the issue;

- creating opportunities for formerly marginalised women in North and South to speak out;

- raising awareness of women's need to participate fully in the activities of their society, free of harassment or intimidation;

- promoting more gender-sensitive staff, and more women, in management structures of development agencies, as well as in local NGOs, which requires a change not only in recruitment policy and practice, but in the culture of the workplace;

- taking action against sexual harassment in organisations, including funding criteria, and personnel policies.

The range of these recommendations attests to the breadth of discussion on this issue at the Conference, which addressed not only violence itself, but the social and political structures which harbour it. Funding agencies committed to working in support of women and with a gender perspective, cannot also support social structures which work against women. Not only is there considerable scope for working together on this issue, but it is necessary to do so.

In conclusion, there are, as Lori Heise points out in the following article, many and complex explanations for gender violence, and they cannot all be challenged in the same way. But they must be challenged because they go against the basic aim of development, which is to expand choices. 'What more critical choice do women deserve', Lori Heise asks, 'than to live life free of violence and sexual coercion?' Neither the explanations for nor the consequences of gender violence should be disregarded by development agencies and funders, who, Lori Heise states 'have a responsibility to help women organise to achieve this freedom..'

• Overcoming violence: a background paper on violence against women as an obstacle to development

Lori L. Heise

Introduction

A common proverb in pre-revolutionary China ran: 'A wife married is like a pony bought; I'll ride her and whip her as I like' (Croll, 1980). Unfortunately, the notion was often carried out in deed. Similar adages and actions can be found to this day in almost every culture. Violence against wives — indeed, violence against women in general — is as old as recorded history, and cuts across all nationalities and socio-economic groups. Every day, thousands of women are beaten in their homes by their partners, and thousands more are raped, assaulted and sexually harassed. Then there are the less recognised forms of violence: In Pakistan, female babies die from neglect because parents value sons over daughters; in Sudan, girls' genitals are mutilated to ensure virginity until marriage; and in India, young brides are murdered by their husbands or in-laws when parents fail to provide enough dowry. This is not random violence; the risk factor is being female.

Violence against women is perhaps the most pervasive yet least recognised human-rights abuse in the world. More women are maimed, killed or beaten because they are female than for any political or religious belief they may hold. From a woman's perspective, it makes little difference if her rapist is a government agent or a private citizen, both acts represent fundamental violations of her bodily integrity (Although the mainstream human rights community has historically only recognised abuse which takes placve in the public arena.) In June 1993, however, an international coalition of over 900 women's organisations lobbied for and won formal recognition of violence as an abuse of women's human rights at the Second World Conference on Human Rights held in Vienna, Austria.

Female focused violence also undermines widely held goals for economic and social development, especially in the developing world. The development community has come to realise that problems such as high fertility, deforestation, and hunger cannot be solved without women's full participation. Yet women cannot lend their labour or

creative ideas fully when they are burdened with the physical and psychological scars of abuse.

In recent years, the world community has taken some tentative, yet important, steps toward urging greater attention to the issue of gender-based abuse. Various United Nations bodies have passed resolutions recognising violence as an issue of grave concern, and the United Nation's General Assembly adopted the Declaration on the Elimination of Violence Against Women in 1993. Negotiations are also under way through the Organisation of American States to draft a Pan American Treaty Against Violence Against Women which would create legal obligation for action among countries in the Western Hemisphere. Likewise on the development front, the Pan American Health Organisation (PAHO) adopted gender-based abuse as its priority theme for 1994 under its Women, Health and Development Program and the United Nations Fund for Women (UNIFEM) published a major document outlining the impact of gender violence on socio-economic development (Carrillo, 1992).

This international attention, however, comes on the heels of over two decades of organising by women's groups around the world to combat gender-based abuse. In country after country, women have started crisis centres, passed laws, and worked to change the cultural beliefs and attitudes that undergird men's violence. A recent directory published by the Santiago-based ISIS International, lists 379 separate organisations working against gender violence in Latin America alone (ISIS, 1990). By any measure, it has been women and women's NGOs who have led the battle against sexual exploitation and gender-based abuse.

The magnitude of the problem

Domestic violence: The most pervasive form of gender violence is abuse of women by intimate male partners. Over 35 well-designed surveys are now available from a wide range of countries showing that between one-fifth to over half of women interviewed have been beaten by a male partner (See Table 1). The majority of these women are beaten at least three times a year with many experiencing persistent psychological and sexual abuse as well.

According to a recent review in the *Journal of the American Medical Association*, 'Women in the United States are more likely to be assaulted and injured, raped or killed by a current or ex-male partner than all other assailants combined (Council on Scientific Affairs, 1992).' The same could be said of women elsewhere in the world. In Papua New Guinea, 18 per cent of *all* urban wives surveyed had received hospital treatment

for injuries inflicted by their husbands (Toft, 1986). In Alexandria, Egypt, domestic violence is the leading cause of injury to women, accounting for 28 per cent of all visits to area trauma units (Graitcer et al., 1993). And in countries as diverse as Brazil, Israel, Canada, and Papua New Guinea, over half of all women murdered are killed by a current or former partner (Heise with Pitanguy and Germaine, 1994).

Rape and sexual abuse: Regrettably, statistics suggest that sexual coercion is a also a common reality in the lives of women and girls. An island-wide survey of women in Barbados revealed that one in three women had been sexually abused as a child or adolescent (Handwerker, 1994). In Seoul Korea, 17 per cent of women report being a victim of attempted or completed rape (Shim, 1992). And in the United States, 78 adult women — and at least as many girls and adolescents — are raped each hour, according to a national survey (Kilpatrick et al, 1992). Cross-cultural data compiled by the United Nations Statistical Office confirm that these statistics are not out of line with those available from other parts of the world (*The World's Women*, 2nd edition, forthcoming).

International data also demonstrate a remarkable consistency in the 'demographics' of sexual assault. Contrary to popular perception, the majority of victims (more than 60 per cent) are raped by men whom they know, a reality confirmed by rape crisis and justice system statistics from Malaysia, Peru, Panama, Chile and Papua New Guinea. Moreover, a large percentage of sexual assaults (40 to 58 per cent) are perpetrated against very young girls, including many younger than nine or ten years old (See Table 2).

Rape survivors exhibit a variety of trauma-induced symptoms including sleep and eating disturbances, depression, feelings of humiliation, anger and self-blame, fear of sex and inability to concentrate (Koss, 1990). Survivors also run the risk of becoming pregnant or contracting STDs (sexually transmitted diseases), including HIV. A rape crisis centre in Bangkok, Thailand reports that 10 per cent of their clients contract STDs as a result of rape and 15 to 18 per cent become pregnant, a figure consistent with data from Mexico and Korea (Archavanitkui and Pramualratana, 1990; COVAC, 1990; Shim, 1992). In countries where abortion is illegal or unavailable, victims often resort to illegal abortion, greatly increasing their chance of future infertility or even death.

In addition to injury, physical and sexual abuse provide the primary context for many other health problems. Victims of sexual abuse, rape and domestic violence are at increased risk of suicide, depression, drug and alcohol abuse, STDs, hypertension, chronic pelvic pain, irritable bowel syndrome, asthma, gynaecological problems, and a variety of psychiatric disorders (Heise 1994; Council on Scientific Affairs). These conditions make gender-based victimisation an important 'risk factor'

for future ill-health and disease. In fact, the World Bank's *World Development Report 1993* estimates that on a global basis, the social costs indirectly imposed by gender-based victimisation is comparable to that posed by other conditions already high on the world agenda (see Table 3). In established market economies, where the overall social cost of ill health is lower than in the developing world, the Bank estimates that gender-based victimisation is responsible for *one out of every five healthy days of life lost to women of reproductive age* (World Bank, 1993).

Recent studies also link early sexual victimisation with other high risk behaviours in adolescence and adulthood including excessive drug and alcohol use, unprotected sex with multiple partners (Zierler et al.,1991; Handweker 1993); prostitution (Finkelhor, 1987; James and Meyerding, 1977); and teenage pregnancy (Boyer and Fine, 1992). Compared with teenagers who became pregnant but were not abused, sexually victimised adolescents begin intercourse earlier, are more likely to use drugs and alcohol and are less likely to practice contraception (Boyer and Fine, 1992). By making women less skilled at self-protection, less sure of their own worth, and more apt to accept victimisation as part of being female, early sexual trauma also appears to increase a woman's chance of future victimisation (Koss, 1990). Psychologists believe that the sense of stigmatisation and shame that survivors experience leaves them feeling vulnerable, unloved, and unable to say 'no' to things they do not want to do such as having sex or using drugs.

Women are particularly susceptible to sexual coercion in situations of conflict, where women's bodies are considered the 'spoils of war' and women are forced to flee home and community in search of safety (80 per cent of refugee and dispossessed peoples are women and children). Massive raping of women during war has recently been documented in Bosnia, Peru, Liberia, Cambodia, Somalia and Uganda (Swiss and Giller, 1993). Refugee women are also subject to sexual violence and abduction at every step of their escape, from flight to border crossings to life in the camps. Even when the immediate threat of rape is gone, the stigma of violation lingers on. Many refugee women who have been raped are shunned by their families and communities, being perceived as used, violated or sexually suspect (Mollica and Son 1989).

Other forms of gender-based abuse: while less overt, other forms of gender-based abuse can be as damaging and potentially fatal to females as rape or assault. The preference for male offspring in many cultures is a case in point. Studies confirm that where preference for sons is strong and resources scarce, girls receive less food and inferior medical care and education (Chen et al. 1981; Mercant and Kurz 1993). In fact, the pressure to bear sons is so great in India, China and Korea that women have begun using amniocentesis and ultrasound as sex selection devices, in order to

selectively abort female fetuses. One study of amniocentesis in a large Bombay hospital found that 95.5 per cent of fetuses identified as female were aborted compared to only a small percentage of male fetuses (Ramanamma 1990).

Elsewhere, young girls suffer another form of violence, euphemistically known as female circumcision. It is estimated that 85 to 114 million girls and women have been genitally mutilated, the majority in Africa (Toubia 1993). While a host of beliefs help to perpetuate the practice, the core belief that drives the tradition is that men will not marry uncircumcised women, believing them to be promiscuous, unclean, and sexually untrustworthy (Mohamud 1991).

The list of abuses continues: 'acid throwing' to disfigure young women in Bangladesh; date rape on college campuses in the United States; child prostitution in Thailand; forced sex within marriage. The setting may change as well as the abuse, but all forms of gender violence share a common theme: they are violent acts that are socially tolerated in part because the victims are female.

Why focus specifically on violence against women?

Although men are victims of street violence, brawls, homicide, and crime, violence directed at women is a distinctly different phenomenon. Men tend to be attacked and killed by strangers or casual acquaintances, whereas women are most at risk at home from men whom they trust (Kellerman and Mercy, 1992). Violence against women is grounded in power imbalances between men and women, and is caused and perpetuated by factors different from violence against men. As such, it must be analysed and addressed differently. While women are occasionally violent against intimates, research has shown that female violence is usually in self-defence and that it is women who suffer the bulk of injury (Dobash et al., 1992; Brush, 1990).

Moreover, data from around the world demonstrate that almost universally the perpetrators of violent crime are men, an observation that seldom attracts the attention that it deserves (Gartner and McCarthy, 1991; Miedzen, 1992). In the United States for example, men represent 83 per cent of all offenders arrested; 99 per cent of persons charged with rape and 86 per cent of person charged with offenses against the family and children (Flanagan and McGarrell, 1986 as cited in Koss, 1990). On the other hand, when it comes to sexual crimes, the vast majority of victims are female. According to Costa Rican statistics, for example, 94 per cent of victims of child sexual abuse are girls and 96 per cent of the perpetrators are male (Claramunt, 1991; see Heise 1994 for more examples).

Impact on health and socio-economic development

Despite the wealth of grassroots activity to combat violence against women, few mainstream development organisations have made violence a focal issue. It took a concerted campaign by women's advocates to get violence recognised as a legitimate development concern even within UNIFEM, the UN agency charged with women's development. But as this section will show, violence against women and girls is a problem that affects all facets of development from family planning and health to income generation and education.

Violence during pregnancy, for example, threatens the goal of 'Safe Motherhood' for all women. Surveys from a variety of countries suggest that pregnant women are prime targets for abuse. Among 80 battered women seeking judicial intervention in San Jose, Costa Rica, 49 per cent report being beaten during pregnancy (Ugalde, 1988). Battered women run twice the risk of miscarriage and four times the risk of having a low birth-weight infant (Stark et al., 1981; Bullock and McFarlane, 1989). In some regions, violence also accounts for a sizeable portion of maternal mortality. In Matlab Thana, Bangladesh, intentional injury — motivated by dowry disputes or stigma over rape and unwed pregnancy — accounted for 6 per cent of all maternal deaths between 1976 and 1986 (Fauveau and Blanchet, 1989).

Likewise, fear of male violence can interfere with efforts to curb population growth and to control the spread of AIDS. According to research generated by the US Agency for International Development's Women and HIV project, women are frequently afraid to raise the issue of condom use for fear of abandonment, accusations of infidelity or physical reprisal (Rao Gupta, 1993). Not surprisingly, this greatly complicates efforts at control of AIDS. In some cultures, men believe that the use of any birth control implies promiscuity or a women's desire to be unfaithful so conversations about contraception can also put women at risk. In Kenya, women regularly forge their partner's signature on spousal consent forms for contraception rather than ask their partner's permission (Banwell, 1990). When family planning clinics in Ethiopia removed their requirement for spousal consent, clinic use rose 26 per cent in just a few months (Cook and Maine, 1987).

There is also new empirical data linking wife abuse in women to the nutritional status of their children. In a census study of married women in three villages in rural Karnataka, qualitative and quantitative data indicated that inadequate payment of dowries and alcohol consumption by men were the single greatest predictors of whether a wife would be beaten. The children of women who were beaten also received less food than other equivalent children. The authors suggest that wife beating

may be undermining children's nutritional status by adversely affecting a woman's bargaining position in marriage (Rao and Bloch, 1993b)

New evidence from the United States similarly suggests that sexual abuse may serve as a direct break on socio-economic development by affecting a woman's educational and income level. A recent study shows that women who have been sexually abused during childhood achieve an annual income 3 to 20 per cent lower than women who have not been abused depending on the type of abuse experienced and the number of perpetrators (after controlling for all known income factors) (Hyman, 1993). Incestuous abuse affected income indirectly through its impact on educational attainment and mental and physical health status. Women sexually abused by strangers suffered an additional direct effect on income as well. The author speculates that girls sexually abused by strangers (as opposed to family members) learn that the outside world is dangerous, and limit their engagement in the world accordingly.

Violence against women further thwarts development through its impact on women's participation in development projects. A study commissioned by UNIFEM/Mexico to ascertain why women stop participating in projects found that threats by men was a major cause of attrition. Men perceived the growing empowerment of their wives as a threat to their control, and used beatings in an attempt to reverse this process of empowerment. Similarly, a revolving loan fund of the Working Women's Forum in Madras, India almost collapsed when the leaders of the project stopped participating because they experienced increased incidents of domestic violence (Carrillo, 1992). As Dr. Christine Bradley, Principal Project Officer for the Papua New Guinea (PNG) Law Reform Commission observes:

Simply attending a meeting may be dangerous for a woman whose husband does not want her to go. In PNG some husbands prevent their wives from attending meetings by locking them in the house, or by pulling them off the vehicle they have boarded to take them to the meeting, or even by pursuing them to the meeting and dragging them home (Bradley, 1990).

In a recent particularly gruesome example of male backlash, a female leader of the highly successful, government-sponsored Women's Development Programme in Rajasthan, India was gang raped by male community members because they disapproved of her organising efforts against child marriage. The woman was raped in her home in front of her husband, who was warned, 'Keep your wife in line or we'll rape her again.' The incident and the fear it induced dealt a major blow to the momentum of the project (Rao Gupta, private communication, 1993; Mathur, 1992).

Elsewhere, men do not prevent women's involvement, but instead use force to divert the benefits of development from women to men. Case studies of victims of domestic violence in Peru and of garment workers in the Mexican *maquiladoras* reported that men frequently beat their wives to obtain the income the women had earned (Vasquez and Tamayo 1989 as quoted in Carrillo, 1992).

To avoid violence, women learn to censor their behaviour based on what they think will be acceptable to their husbands or partners. As Bradley (1990) observes, 'Threats or fears of violence control women's minds as much as do acts of violence, making women their own jailers.' In Papua New Guinea, for example, women represent only 39 per cent of the primary school teaching force and only 5 per cent of head teachers. According to a recent study, one of the main reasons married female teachers do not apply for or take up promotions is that they fear a retaliation from their husbands (Givson, 1990).

Fear of stranger-perpetrated violence similarly limits women's full participation in public life. In a 1990 newspaper survey in Seoul Korea, women identified fear of sexual violence as a principle cause of stress in their lives (Korea Sexual Violence Relief Center, 1991). In a separate survey of 2,270 Korean women, 94 per cent said they felt uneasy due to the spread of sexual violence against women. Forty per cent felt 'extremely uneasy' and mentioned restricting their activities because of this fear.

The consequences of this distinctly female fear can have insidious and unexpected effects. Fear of rape, for example, has exacerbated under-nutrition among Ethiopian refugee families living inside Sudanese border camps. During a recent survey of women's mental health sponsored by UNDP (LaPin, 1992), Ethiopian women refugees mentioned reducing the number of cooked meals they fed their children because they feared being raped while out collecting firewood. Many have been raped during the two- or three-hour walk necessary to collect fuel. Similarly, when discussing obstacles to their work, female health promoters working in rural Gujrat, India emphasised their reluctance to travel alone between villages for fear of being raped. The health promoters requested self-defence training as a skill they needed to continue performing their work (Khanna, 1992). Far from isolated instances, such examples illustrate the paralysing and largely unrecognised effect violence can have on women and on social development.

What can be done?

Violence is an extremely complex phenomenon with deep roots in the power imbalances between men and women, sexuality, self-esteem, and

social institutions. As such, it can not be addressed without confronting the underlying cultural beliefs and social structures that perpetuate violence against women. Indeed, in many societies the right to dominate women is considered the essence of maleness itself and woman are defined as inferior. Confronting violence thus requires re-defining what it means to be male *and* what it means to be female.

Fortunately, cross-cultural research shows that sexual coercion and battering are not inevitable. Although violence against women is an integral part of the vast majority of cultures, there *are* isolated examples of societies where gender-based abuse does not exist (Counts, Brown and Campbell, 1992; Sanday, 1981; Levinson, 1989). Such societies stand as proof that social relations can be organised in such a way as to minimise or eliminate violence against women. A careful comparison of societies with frequent violence against women, with those with little or no rape and abuse, shows that low-violence cultures share certain features, including:

- strong sanctions against interpersonal violence
- community support for victims
- flexible gender-roles for men and women
- equality of decision making and resources within the family
- a cultural ethos that condemns violence as a means of resolving conflict
- female power and autonomy outside the home
- a definition of masculinity that is not linked to male dominance, honour, or domination of women
- sanctuary for women i.e. a place to escape to.

These features suggest directions for future prevention including:

- enacting and enforcing laws against wife battering, rape and sexual abuse and/or developing community-based sanctions such as public shaming or community intervention;
- promoting public support for victims and accountability for perpetrators through community education and media;
- dismantling traditional gender stereotypes, especially definitions of 'manhood' linked to dominance, aggression or male honour;
- expanding the availability of shelters and support groups for victims;
- incorporating gender awareness training, parenting skills, and non-violent conflict resolution into school curricula;
- eliminating gender stereotypes and gratuitous violence from the media;
- increasing women's economic and social power by expanding their access to wage employment, low income housing, credit, child care, and divorce.

Other research indicates that certain individual factors can increase the likelihood of violence by a man. These include excessive alcohol use, a history of physical or sexual abuse within his own childhood, witnessing parental violence as a child, and unemployment. But none of these factors accounts for why women are so systematically a target. Only the pervasive existence of cultural, economic and social systems that subordinate women can explain the overall pattern of abuse.

While the goal of eliminating violence may be the same, particular responses to violence must largely be forged from within each community, recognising that community's unique social and cultural history. Development workers should not underestimate the role they can play in this process. Whether they work on health, income generation, or agricultural extension, organisers can catalyse discussion around this theme and be attentive to the fact that the process of empowerment itself can put individual women at risk. Not infrequently, women who start to expand their horizons through participation in development work, suffer aggression from their partners. Experience suggests, however, if women can be supported through this critical time, abuse will eventually decline as a new more equitable power balance is established in the family. Even simple interventions like an invitation to discuss the tensions at home around a woman's new-found autonomy can prove extremely helpful.

Increasingly, NGO-sponsored projects are incorporating the themes of gender violence directly into their health and development programs. The Women's Programme of Uraco Pueblo in Honduras, for example, includes socio-dramas, discussion, and role plays around domestic violence and sexual harassment in its training programme for health promoters; promoters regularly hold community meetings on domestic violence, including inviting lawyers in to offer women legal advice and holding joint meetings with husbands and other village men (Maher, personal communication, 1993). Likewise, at the suggestion of rural women, Asociacion Peru-Mujer added scenes related to domestic violence in the colouring books they prepared to instigate discussion among non-literate women around family planning and child immunisation. A description of the project notes that 'many women cried when they saw scenes of a husband beating his wife, as they had not realised that other women shared such problems (Haffey, Newton and Palomino, 1990; 21).'

Recommended steps forward

For development practitioners, the most important contribution is to be aware. Be aware that women health workers who must travel between

villages may be at risk of rape. Be aware that a woman who refuses to discuss condom use with her partner may be trying to avoid abuse. Be aware that allowing men to control the distribution of food in a refugee camp may lead to situations where women are forced to grant sexual favours in order to obtain supplies. With awareness comes the ability to detect the subtle impact of violence, a reality that too many women and too many development projects have learned to accommodate rather than confront.

For development agencies, the most important step forward is equally clear: support the nascent anti-violence initiatives already under way. There are hundreds of women's organisations around the world working on this theme — lobbying for law reform, assisting victims, educating the public — but they currently function with little if any outside support. This is because no one sees violence against women as their responsibility. Health funders do not see it as a health issue, development funders do not see it as a development issue, and human rights groups disclaim responsibility for any abuses not directly perpetrated by agents of government. In reality, violence affects all of these sectors and more. At its most basic, development is about expanding people's choices. What more critical choice do women deserve than the chance to live life free of violence and sexual coercion? Development agencies and funders have a responsibility to help women organise to achieve this freedom.

Table 1 Prevalence of domestic violence, selected studies

1 In a study of 1,388 women seeking services (not related to violence) at Costa Rica's national child welfare agency, one in two report being physically abused (Chacon et. al, 1992).

2 Colombia's Demographic and Health Survey (DHS Colombia 1991) revealed that one out of every five Colombian women have been beaten by a partner; one out of every three have been emotionally or verbally abused.

3 A 1992 study among women in the barrios of Quito, Ecuador found that 60 per cent of women have been beaten by their partners at least once. Among those beaten, 37 per cent were assaulted frequently (every day up to once a month), 25 per cent were beaten regularly, (every two to six months), and 36 per cent were beaten once a year or less (Barragan, Ayala and Zambrano, 1992).

4 In Norway, a random sample of women in the city of Trondheim revealed that 25 per cent have been physically or sexually abused by their mate (Schei and Bakketeig 1989).

5 In a detailed family planning survey of 733 women in the Kissi district of Kenya, 42 per cent said they were beaten regularly by their husbands (Raikes 1990).

6 In a prospective study of 691 low-income pregnant women in the United States (sponsored by the Centres for Disease Control), one in six reported physical abuse during their present pregnancy. One in four report physical abuse in the last calendar year (McFarlane et al., 1992)

7 A 1990 study of 1,000 women in the department of Sacatepequez, Guatemala found that 49 per cent have been physically, sexually or emotionally abused, 74 per cent by an intimate male partner.

8 In one study of 109 households in an Indian village, 22 per cent of higher caste husbands and 75 per cent of Scheduled Castes (lower) husbands admitted to beating their wives. The Scheduled Caste wives reported that they were 'regularly beaten' (Mahajan 1990).

9 A statistical survey conducted in Nezahualcoyotl, a city adjacent to Mexico City found that one in three women had been victims of family violence; 20 per cent report blows to the stomach during pregnancy (Shrader Cox and Valdez Santiago 1992).

10 In Papua New Guinea, 67 per cent of rural women and 56 per cent of urban women have been victims of wife abuse, according to a national survey conducted by the PNG Law Reform Commission (Bradley 1988).

11 In Canada, a nationally representative survey revealed that 29 per cent of ever-married women report being physically assaulted by a current or former male partner (Statistics Canada 1993).

Table 2 Statistics on sexual crimes, selected countriesa

	Per cent of perpetrators known to victim	Per cent of victims 15 yrs and under	Per cent of victims 10 yrs and under
Lima, Peru	60	—	18[d]
Malaysia	68	58	18[b]
Mexico City	67[c]	36	23
Panama City	63	40	—
Papua New Guinea	—	47	13[e]
Santiago, Chile[f]	72	58	32[d]
United States	78	62[g]	29

[a] Studies include rape and sexual assaults such as attempted rape and molestation except for U.S data which includes only completed rapes.

[b] Percentage of survivors age 6 and younger.

[c] Data from *Carpeta Basica*. 1990. Mexico City: Procurador de Justicia del Distrito Federal de Mexico.

[d] Percentage of survivors age 9 and younger.

[e] Percentage of survivors age 7 and younger.

[f] Based on five-year averages derived from crimes reported to the Legal Medicine Service, 1987-1991; Anuario Estadistico del Servicio Medico Legal de Chile

[g] Percentage of survivors age 17 and younger.

Sources: Malaysia data from (Consumer's Association, 1988); Panama City data from (Perez, 1990); Peru data from (Portugal, 1988); Papua New Guinea data from (Riley 1985 as cited in Bradley, 1990); Mexico City data from (COVAC, 1990); Chile data cited in (Avendano and Vergara, 1992); United States data from (Kilpatrick et al., 1992).

Table 3 Estimated health burden of various conditions for women aged 15 to 44, globally

Maternal Conditions	29.0 million DALYS
a. Sepsis	10.0 million
b. Obstructed Labour	7.8 million
STDs excluding HIV	15.8 million DALYS
a. PID	12.8 million
Tuberculosis	10.9 million DALYS
HIV	10.6 million DALYS
Cardiovascular Disease	10.5 million DALYS
Rape and Domestic Violence[a]	9.5 million DALYS
All Cancers	9.0 million DALYS
a. Breast	1.4 million
b. Cervical	1.0 million
Motor Vehicle Accidents	4.2 million DALYS
War	2.7 million DALYS
Malaria	2.3 million DALYS

[a] Rape and domestic violence, which are included in this table for illustrative purposes, are risk factors for disease conditions, such as STDs, depression, and injuries. They are not diseases in and of themselves.

Note: The calculation of the disability-adjusted life years (DALYs) lost due to domestic violence and rape is based on estimates of the portion of life years lost to different morbidities that can be attributed directly to gender-based victimisation. The exercise counts every year lost due to premature death as one DALY and every year spent sick or incapacitated as a fraction of a DALY, with the value depending on the severity of the disability (For further details, see Heise 1994).

References

Archavanitkui, Kritaya and Pramualratana, Anthony.(1990) 'Factors Affecting Women's Health in Thailand'. Paper presented at the Workshop on Women's Health in Southeast Asia. Population Council, Jakarta, October 29 to 31.

Avendano, Cecilia and Vergtara, Jorge. 1992. 'La Violencia Sexual en Chile, Dimensiones: Colectiva, Cultural y Politica. Santiago, Chile: Servicio Nacional de la Mujer.

Banwell, Suzanna Stout. (1990) 'Law, Status of Women and Family Planning in Sub-Saharan Africa: A Suggestion for Action.' Nairobi: The Pathfinder Fund.

Barragan, Alvarado, Lourdes, Alexandra, and Gloria Camacho Zambrano. 1992. 'Proyecto Educativo Sobre Violencia de Genero en la Relacion Domestic de Pareja.' Centro de Planificacion y Estudios Sociales (CEPLAES), Quito, Ecuador.

Boyer, Debra and Fine, David. (1992) 'Sexual Abuse as a Factor in Adolescent Pregnancy and Child Maltreatment,' *Family Planning Perspectives* 24(1):4-10.

Brush, Lisa. (1990) 'Violent Acts and Injurious Outcomes in Married Couples: Methodolgical Issues in the National Survey of Families and Households.' *Gender and Society* 4:56-67.

Bullock, Linda, F. and McFarlane, Judith (1989) 'The Birth/Weight Battering Connection.' *American Journal of Nursing.* pp. 1153-1155.

Carrillo, Roxanna. (1992) *Battered Dreams: Violence Against Women as an Obstacle to Development.* New York: United Nations Fund for Women.

Chacon, D.; Herrera, F; Rojas, A.M.; Villalobos, M. 1992. 'Caracteristicas de La Mujer Agredida Atendida en el Patronato Nacional de la Infancia.' San Jose, Costa Rica as cited in Batres Gioconda and Claramunt, Cecilia. 'La Violencia Contra La Mujer En La Familia Costarricense: Un Problema de Salud Publica.' Report prepared for the First Central American Seminar on Violence Against Women: A Problem of Public Helath, Pan American Health Organization, Managua, Nicaragua, March 11-13, 1992.

Chen, Lincoln; Huq, Emdadul and D'Souza, Stan. (1981) 'Sex Bias in the Family Allocation of Food and Health Care in Rural Bangladesh.' *Population and Development review* 7(1):55-70.

Claramunt, Cecilia. 1991. Caracteristicas de la poblacion atendida en el programa de atencion amor sin agresion (julio 1990-1991). San Jose, Costa Rica as cited in Batres, Gioconda and Claramunt, Cecilia. 1992. 'La violencia contra la mujer en la familia costarricense: un problema de salud publica.' Report presented at the First Central American Seminar on Violence Against Women: A Problem of Public Helath,

Pan American Health Organisation, Managua Nicaragua, March 11-13, 1992.

Consumers Association of Penang. 1988. *Rape in Malaysia*. Penang, Malaysia.

Cook, Rebecca and Deborah Maine. 1987. 'Spousal Veto Over Family Planning Services.' (1987) *American Journal of Public Health* 77(3):330-344.

Council on Scientific Affairs, American Medical Association. 1992. 'Violence Against Women: Relevance for Medical Practitioners.' *Journal of the American Medical Association* 267,23:3184-3189.

Counts, Dorothy, Brouwn, Judith, and Campbell, Jacquelyn. 1992. *Sanctions and Santuary: Cultural Perspectives on the Beating of Wives.* Boulder, Co.: Westview Press.

COVAC. (1990) 'Evaluacion de Proyecto para Educacion, Capacitacion, y Atencion a Mujeres y Menores de Edad en Materia de Violencia Sexual, Enero a Diciembre 1990.' Mexico City: Colectivo de Lucha Contra La Violencia Hacia las Mujeres.

Coy, Federico. 1990. Study cited in Castillo, Delia et. al. 'Violencia Hacia La Mujer en Guatemala.' Report prepared for the First Central American Seminar on Violence Against Women as a Public Health Problem, Managua, Nicaragua, March 11-13, 1992.

Croll, Elizabeth. (1980) *Feminisim and Socialism in China*. New York: Schocken Publishers.

Dobash, Russel; Dobash, R. Emerson; Wilson, Margo; and Martin Daly. (1992) 'The Myth of Sexual Symmetry in Marital Violence.' *Social Problems* 39(1): 71-91.

Fauveau, Vincent and Blanchet, Therese. (1989) 'Deaths from Injuries and Induced Abortion Amoung Rural Bangladeshi Women.' Social Science and Medicine. 29:

Finklehor David. (1987) 'The Sexual Abuse of Children: Current Research Reviewed.' *Psychiatric Annals*, 17:233-241;

Flanagan, T.J. and McGarrell, E.F. 1986. *Sourcebook of Criminal Justice Statistics-1985* (NCJ-100899). Washington D.C.: U.S. Department of Justice, Bureau of Justice Statistics.

Gartner, Rosemary and McCarthy, Bill. (1991) 'The Social Distribution of Femicide in Urban Canada, 1921-1988.' *Law and Society Review* 25(2):287-311.

Gibson, M.A. 1990. 'Equity for Female Teachers: A National Survey of Employment, Training and Promotional Opportunities for Community School Teachers in Papua New Guinea.' Unpublished draft of Report No. 65 of the Educational Research Division, National Research Institute, Waigani.

Graitcer, Philip and Youssef, Z. (eds). (1993). *Injury in Egypt: An Analysis*

of Injuries as a Health Problem. Jointly Published by USAID and the Ministry of Health, Cairo, Egypt.

Haffey, Joan and Newton, Nancy and Palomino, Hugo. 1990. 'Colouring-in our lives.' *PEOPLE* 17(2):20-21.

Handwerker, Penn. (forthcoming). 'Gender Power Differences Between Parents and High Risk Sexual Behaviour by their Children: AIDS/STD Risk Factors Extend to a Prior Generation. *Journal of Women's Health.*

Heise, Lori, with Jacquieline Pitanguy and Adrienne Germaine. 1994. *Violence Against Women: The Hidden Health Burden.* Washington D.C.: The World Bank.

Hyman, Batya. 1993. 'Economic Consequences of Child Sexual Abuse in Women.' Ph.D. Dissertation. Heller School of Policy, Brandeis, University, Waltham, Massachusetts.

ISIS International. 1990. *Violencia en Contra de la Mujer en America Latina y El Caribe.* Santiago, Chile: Isis Internaitonal.

James, J. and J. Meyerding. (1977) 'Early Sexual Experience and Prostitution.' *American Journal of Psychiatry.* 134:1381-1385.

Kelkar, Govind. 1992 'The Woman's Movement in India: Issues and Perspectives from India.' In *Freedom from Violence: Women's Strategies from Around the World.* Margaret Schuler, ed. Washington D.C.: OEF International. (Available from UNIFEM, New York, N.Y.)

Kellermann, A.L. and Mercy, J.A. (1992) 'Men, Women, and Murder: Gender-Specific Differences in Rates of Fatal Violence and Victimization.' *The Journal of Trauma.* 33(4):1-5.

Khanna, Renu. (1992). Personal Comunnication. SARTHI. (Social Action for Rural and Tribal Inhabitants of India) Baroda, Gujurat State, India.

Kilpatrick, D.G., Edmunds, C.N. and Seymour, A.K. 1992. *Rape in America: A Report to the Nation.* Arlington, VA.: The National Victim Center.

Korea Sexual Violence Relief Center. 'Information Booklet.' 1991. Seoul, Korea.

Koss, Mary P. 1990. 'The Women's Mental Health Research Agenda: Violence Against Women.' *American Psychologist.* 45,3:374-380.

LaPin, Deirde. 1992. 'Assessing Psychosocial Needs of Refugee Women And Children Using Rapid Field Techniques.' Presentation at the 120th Annual Meeting of the American Public Health Association. Washington D.C., November 8-12.

Levinson, David. 1988. 'Family Violence in Cross Cutlural Perspective.' In *Handbook of Family Violence.* Van Hasselt, Vincent et al. (eds). New York, NY:Plenum Publishers

Mahajan, A. 1990. 'Instigators of Wife Battering.' In *Violence Against*

Women, pp.1-10 Sushma Sood, ed. Jaipur, India: Arihant Publishers.

Maher, Monica. 1993. Private communication. Director, Project Concern's Women's Program of Uraco Pueblo, Uraco, Hondurus.

Mathur, Kanchan. 1992. 'Bhateri Rape Case: Backlash and Protest.' *Economic and Political Weekly*, October 10.

McFarlance, Judith. et. al 1992. 'Assessing for Abuse During Pregnancy: Severity and Frequency of Injuries and Associated Entry Into Prenatal Care.' *Journal of the American Medical Society* 267(23):3176-3178/

Merchant, Kathleen and Kurz, Kathleen. 1993. 'Women's Nutrition Through the Life Cycle: Social and Biological Vulnerabilities.' In *The Health of Women: A Global Perspective*. Marge Koblinsky, Judith Timyan and Jill Gay (eds). Boulder, Co.:Westview Press. pp. 63-90.

Miedzian, Myriam. 1991. *Boys will be Boys: Breaking the Link Between Masculinity and Violence*. New York: Doubleday.

Mohamud, Asha. (1991) 'Medical and Cultural Aspects of Female Circumcision in Somalia and Recent Efforts for Eradication.' Paper presented at the 18th Annual NCIH International Health Conference, Arlington, VA.

Mollica, Richard and Son, Linda. (1989) 'Cultural Dimensions in the Evaluation and Treatment of Sexual Trauma: An Overview.' *Psychiatric Clinics of North America* 12(2):363-379.

Perwz, Amelia Marques. (1990) 'Aproximacion Diagnostica a Las Violaciones de Mujeres en Los Distritos de Panama y San Miguelito.' Centro Para El Desarrollo de la Mujer, Universidad de Panama.

Portugal, Ana Maria (1988) 'Cronica de una Violacion Provocada?' *Revista Mujer/Fempress* 'Contraviolencia.' Santiago, Chile: FEM-PRESS-ILET.

PROFAMILIA. 1990. *Encuestra de Prevalencia, Demografia y Salud*. Bogata: Columbia.

Raikes. Alanagh. 1990. *Pregnancy, Birthing and Family Planning in Keyna: Changing Patterns of Behaviour: A Health Utilization Study in Kissi District*. Copenhagen: Centre for Development Research.

Ramaanamma, Hamid. (1990) 'Female Foeticide and Infanticide: A Silent Violence.' in *Violence Against Women*. Edited by Sushman Sood. Jaipur, India: Arihant Publishers.

Ramirez Rodriguez, Juan Carlos and Uribe Vazquez, Griselda. (forth-coming). 'Mujer y violencia: un hecho cotidiano.' *Salad Publica de Mexico*. Cuernavaca: Instituto Nacional de Salud Public.

Rao-Gupta, Geeta. 1993 Personal Communication. Washington D.C., International Centre for Research on Women.

Rao, Vijayendra and Bloch, Francis. 1993(b). 'Wife-beating, Its Causes and Its Implication for Nutrition Allocations to Children: An

Economic and Anthropological Case Study of A Rural South Indian Community.' Draft Research Report prepared for the World Bank Poverty and Human Resource Division, Washington D.C.

Sanday, Peggy Reeves. (1981) 'The Socio-cultural Context of Rape: A Cross Cultural Study.' *Journal of Social Issues* 37(4):5-27.

Schei, Berit and Bakketeig L.S. 1989. 'Gynecological Impact of Sexual and Physical Abuse by Spouse: A Study of a random sample of Norwegian Women.' *British Journal of Obstetrics and Gynecoology* 96: 1379-1383.

Shim, Young-Hee. (1992) 'Sexual Violence against Women in Korea: A Victimization Survey of Seoul Women.' Paper presented at the conference on 'International Perspectives: Crime, Justice and Public Order.' St. Petersburg, Russia, June 21-27.

Stark, E.; Flitcraft, A.; Zuckerman, B.; Grey, A.; Robinson, J. and W. Frazier. (1981) *Wife Abuse in the Medical Setting: An Introduction for Health Personnel.* Monograph #7. Washington, D.C.: Office of Domestic Violence.

Swiss, Shana and Giller, J.E. (1993) 'Rape as a Crime of War.' *Journal of the American Medical Association* 270(5):612-615.

Toft, S. (1986) (ed) *Domestic Violence in Papua New Guinea.* Law Reform Commission Occasional Paper No. 19, Port Moresby, Papua New Guinea.

Toubia, Nahid. 1993. *Female Genital Mutilation: A Call for Global Action.* Available from Women, Ink. 777 United Nations Plaza, New York.

Uglade, Juan Gerardo. (1988) 'Sindrome de la Mujer Agredida,' In *Mujer* no.5. San Jose, Costa Rica: Cefemina.

Vasquez, R. y Tamayo, G. (1989) *Violencia y Legalidad* Lima:Concytec.

World Bank. (1993) *World Development Report 1993: Investing in Health.* New York: Oxford University Press.

Zierler, Sally; Feingold, Lisa; Laufer, Deborah; Velentgas, Priscilla; Kantrowitz-Gordon, Ira; Mayer, Kenneth. (1991) 'Adult Survivors of Childood Sexual Abuse and Subsequent Rish of HIV Infection' *American Journal of Public Health,* 81(5):572-575.

6

Women's economic rights

Women have less access to power, wealth and resources, and are less likely to own land or property. In most cases they have inferior status both legally and culturally. They have less access to education and training, and to paid employment.

Gender and Development, Oxfam's policy for its programme, May 1993

Perhaps the most obvious link between any of the five different issues discussed at the WLP Conference is the one that exists between macro-economic policy and political participation. Women generally have no say in macro-economic decisions because they have no say in political decisions. SAPs and other macro-economic policies designed in the North are continuing to change women's lives for the worse, and the measures implemented to ameliorate the social effects of these policies are not designed from the point of view of poor women.

Definitions of poverty which confine themselves to economic statistics invite equally narrow solutions, which focus on facilitating access to resources, and participation in a paid labour force, as ends in themselves. Whereas men's economic status is usually defined in positive terms, including their labour force participation, and what they possess, women's economic status is most often defined in terms of what they lack.

In the paper included in this chapter, *Gender, Poverty and Structural Adjustment*, Jeanine Anderson examines macro-economic policy from a gender perspective, arguing that 'structural adjustment must be viewed in a context where political democracy and economic modernisation form two legs of a global development project.' Structural adjustment policies, despite the rhetoric of their proponents, have largely depended on a lack of genuine democracy; 'democratisation is sacrificed in favour of economic modernisation. This situation should be reversed.' Therefore, women must think not only about economic change but about political change.

Women, poverty, and politics: making the links

Compared to the men in their social groups, women are less able to obtain and control resources, and work harder for less, or no, financial remuneration. The gender imbalance in the recognition and enforcement of economic rights can be seen in women's lack of income or property ownership, or participation in decision-making bodies. Recognising and enforcing women's economic rights[1] enables them to benefit fairly from their labour by gaining control over their own income; to contribute to economic decisions within the family, community and in wider society; and to speak out and take action against policies and practices that ignore the rights of others, or damage the physical or social environment.

The economic status of women is even lower when the negative effects of unpaid labour are included. Official statistics do not count much of their work since this is unremunerated and therefore goes unrecognised and uncounted. The old adage 'time is money' never had such relevance as it does to the 'invisible' and unremunerated work by women, which denies them the time and extra energy to participate in other aspects of economic, social, and political life. Subsistence agriculture, work in the informal sector, and reproductive work — social and biological reproduction — all contribute to the public economy but there is no consistent method to account for them. Economic poverty was defined by the WLP Asia Regional Meeting in Jakarta, Indonesia as: 'a lack of access to and control over resources. These resources are capital, credit, land and property, knowledge and skills, tools of production, information concerning and control over market mechanisms'.[2]

In the past, the focus of most economic development work with women has been to attempt to create means of generating income outside of, and in some cases in spite of, existing power relationships. Development interventions have concerned themselves with the challenge of providing more resources for women and their families, rather than in helping women to change the discriminatory structures which determine how resources are distributed.

By defining poverty afresh, in terms of control as well as access, economic, social, and political relationships can be placed at the centre of an analysis of women's economic rights. In order to establish women's economic rights, it is necessary to understand women's position within these complex relationships; and, where opportunities for development intervention exist, they should aim not only to reduce absolute levels of poverty in the short term by meeting women's practical needs, but to create the conditions whereby women can obtain and gain control over a wide range of economic resources. Awareness of economic rights has often been linked to women's assertion of other, interconnected rights:

the right to freedom of movement, to social and political participation, and to self-expression. Women's disadvantaged economic status is caused by, and in turn perpetuates, the worldwide view of women as subordinate to men in cultural, socio-economic, and political terms.

The changing macro-economic background

Early in the Conference at the plenary concerned with 'Linking the Personal to the Global', representatives from working groups reported on the development issues each group had identified as important in making such links. Dianna Melrose (Director, Policy Department, Oxfam UK/I) asserted on behalf of her group that, everywhere in the world, 'market forces are overriding the needs of women, the needs of children, the needs of men, the needs of communities. People are being thrown on the scrap-heap of unemployment, they are not being valued for their intrinsic capacities and worth, and it is women who bear the brunt of that process.' Such recognition of the linkages between market-oriented economic development policies and their effects on women at the grassroots is a first step in creating an agenda for action.

Participants at the Conference discussed international economic institutions, such as the World Trade Organisation (WTO, which has replaced the GATT), the impact of structural adjustment programmes (SAPs),[3] export-oriented industrialisation, the 'rolling-back' of the state, and the activities of transnational corporations (TNCs). Changes in the world economic order have consequences at both macro- and micro-level. However, different regions of the world are affected very differently, and as a result national and regional organisations have different concerns. For example, as described by the WLP Latin America/Caribbean Region Meeting, held in Santiago, economic conditions in the Latin American and Caribbean countries vary widely: 'In Brazil, the struggle is for better salaries and conditions of employment for women; in the Caribbean and Chile, which are more integrated and increasingly dependent on transnational capitalism, the issues are the exploitation of cheap female labour through the *maquiladoras* and seasonal employment; in Peru there is very little opportunity for employment at all, and emphasis is on survival strategies.'[4]

In addition to these regional variations, the new economic order affects women differently according to their class and other aspects of their identity. Participants discussed the policies of WTO, many of which may spell catastrophe for those women who work in small-scale production in agriculture and manufacturing. The introduction of SAPs

has contributed to the 'feminisation of poverty', as social services are cut and the pressure on women to work harder with fewer resources is increased. As Jeanine Anderson's paper states, cuts in social services as part of SAPs packages have put many women out of paid work and at the same time have increased their responsibility to care for the ill, and provide education, at home. More and more Southern women living in poverty are being forced into migrancy, unregulated work in the 'shadow economy' and into selling their bodies as a sexual commodity. Meanwhile, women whose position in society allows them to take advantage of the so-called 'free market' may benefit in some respects from the measures.[5]

Working on economic rights

Nalu Faria Silva (Sempreviva Organozacao Feminista, Brazil) told the Conference that 'when an agency says that they are going to carry out international co-operation work in order to eliminate poverty, nobody questions it, because everybody agrees that poverty and hunger are totally unacceptable.' She went on to point out that the subordination of women is also unacceptable, and must be seen as such by development agencies: 'Hierarchical gender relations are part of the process of the creation of hunger, although this is still not part of the analysis of most people. ... If we have a pattern based on oppression, exploitation and agenda concentration, and which exploits through discrimination more than half the population, ... this domination creates hunger, authoritarianism, and violence.' Thus development agencies concerned with poverty must be explicit about the need to eliminate the subordination of women.

The Women's Economic Rights working group at the Conference concluded that international funding agencies, local development NGOs, and women's organisations, need a greater capacity for gender-based economic analysis and action. They also need new methods and criteria for measuring economic success, and the impact of development activity. In the view of the working group, the activities of local development NGOs and international funding agencies are increasingly mediated by the policies of multilateral financial institutions, which are tending to draw local economies more and more into the orbit of the international economy. Such policies were questioned in terms of women's lack of participation in decision-making, and of the distressing and disabling impact they have had on the lives of women in particular. Lobbying for change must therefore be seen to be as much a part of development as local project-funding.

After a role-play, the Women's Economic Rights working group discussed how different development agencies deal with the needs of grassroots women. Some take a welfare approach and try to improve economic conditions without addressing women's strategic economic interests. Others, aware of the need to tackle macro-economic factors, have no strategy for combining their campaigning and lobbying for longer-term structural change with the pressing daily need of women to earn money. Participants felt that such agencies are creating barriers for themselves by seeing economic development in terms of a dilemma, rather than an opportunity to address a whole issue.

A dual strategy is necessary, of working with women living in poverty to address practical needs, and using experience gained in this way to strengthen campaigns to redress discrimination in the wider economic situation. Mariam Dem (Programme Officer, Oxfam UK/I, Senegal) stated that it should not be a question of 'one or the other', but of working at both the micro- and the macro-level. Organisations working at the grassroots level can link in a strategic alliance with those involved in analysis, campaigning and lobbying at national and international level. As Mariam Dem said, 'it is often said that we want to work with the 'poorest of the poor'. I think it is important to know that working with the poorest people also requires working with an élite that is able to carry out an analysis, ... to commit themselves to be an accompaniment, ... working together with the greater population to achieve change.'

Morena Herrera (Mujeres por la Dignidad y la Vida, El Salvador) added: 'it is important that we should stop thinking only on a small scale ... very little economic analysis and research is carried out either by the agencies or by the women's movement. I think it would be important, for instance, to support economic research and economic training processes coming from women that would allow us to start thinking on a larger scale, to launch initiatives that would release us from a mere survival and from the margins of the economy. How can we achieve economic power in any other way? I think we could start by reaffirming our economic knowledge in order to put together proposals which link micro and macro issues in the economic field'. There is, therefore, a critical need for economic analysis that not only takes into consideration local economic development, but also the rapidly changing macro-economic environment, the effects of which are felt in the life of both rural and urban communities.

Income-generation projects: a feminist critique

It is a healthy step for development practitioners to consider the drawbacks of income-generating projects since, for many years, these

projects have been unquestioningly accepted as beneficial for women. There are many success stories related to small-scale income-generation projects for women. Many of these have evolved or have been planned to encompass a wider range of activities and development issues. Certainly, Oxfam UK/I's own record can attest to this. The overwhelming evidence that women are more reliable as partners in economic development projects — in the sense that they are better at paying back loans, and spend more than men on the health and education of the family — is a strong motivation for development agencies to target women for these types of projects.

However, as a result of their reputation for honesty and efficiency, women have tended to be relegated to small-scale income-generation projects, with funders paying less attention to the worth of their potential involvement in other development work. Some conference participants expressed concern over the apparent marginalisation of women which occurs when income-generating projects are implemented in isolation from wider economic issues. By failing to recognise the economic importance of women's labour in the national economy, and restricting the scope of economic development for women by restricting them to small-scale income-generation projects, the economic development of the whole country is limited. This was vividly expressed by one working group participant from Africa who exclaimed: 'Raising chickens! That's all we ever hear about. How can you develop an economy by raising chickens?' Such questions have resonance in countries where the economy is changing rapidly; and where decision-making is shifting away from local control, and thereby even further from the possibility of control by women. Small-scale economic projects are of real value when they are part of a wider and longer-term process that addresses other factors, especially gender relations, and as such can contribute to a sustainable programme for economic development and gender equity.

It is crucial to emphasise the link between economic and political decision-making. As the example of raising chickens illustrates, the economic interests of a group of women may be interpreted on their behalf by a local NGO or an international funding agency working without a gender perspective. In such cases, needs tend to get expressed in one-dimensional terms, such as 'lack of credit'. Lack of credit may be a significant factor; but it is also likely to be bound up with other forms of discrimination against women. It should be recognised that all practical interventions have a strategic effect:[6] small-scale income-generating projects and credit schemes need to form part of a strategy for development that has the transformation of gender relations as its ultimate goal.

For example, in Bangladesh, as elsewhere, various forms of credit schemes are used as a device for the empowerment of women through

enhancing their participation in the cash economy. But, as Rina Roy (Project Officer, Oxfam UK/I, Bangladesh) pointed out, the links between economic participation and empowerment are not straightforward: 'participation in a credit scheme alone does not ensure a woman's independence in decision-making.' In Rina Roy's view, the subordination of women must be addressed explicitly as an issue if economic participation is to lead to empowerment in other spheres: 'These women are under double pressure. When they get credit, they can't use it because they have to give it to their husband or another male family member. But they have an obligation to repay it to the project officers who come weekly to collect it. Sometimes they cannot pay the instalment because [they have] not been repaid by the husband or whoever. So [a woman] is under pressure from the officers and ... from the family. Before, she was only working at the homestead ... now she has another burden, of pressure from society, from the family, from the officials, from everywhere.'

Income-generation projects recognise women's potential for economic independence, but do not establish it as a right. Sometimes, as Rina Roy explained, projects promoting women's economic participation may have the effect of increasing their oppression, because their economic contribution represents a threat to their menfolk: 'This is more than just extra responsibility, sometimes it results in violence. Sometimes the husband punishes the wife when she asks to have the money returned to her. Sometimes he tortures her, sometimes he divorces her; many things happen because of this.'

If it is planned without an understanding of the social and political context, an income-generation project can cause more problems than it solves. It is therefore essential that projects promoting women's economic participation are designed — or at the very least informed — by the insights of the women project partners themselves, so that women's subordinate social status and existing responsibilities are taken into consideration. Where violence occurs as a result of women's participation, women will need support, which should be built into the project design.

There are other pitfalls; poorly-designed income-generating projects do not address imbalances in male and female workloads and they make little impact on the mainstream economy. A project which may appear to be successful may in fact be subsidised by the extra, unremunerated work of its participants. Mini Bedi (Field Representative, Community Aid Abroad Australia, India) spoke of her observations of income-generation projects for women. She witnessed women working longer hours because of the additional activity, and not gaining recognition for their strength and their unbearable workload.

Making money is only one aspect of achieving economic empowerment, and it may have costs in terms of women's time and health. In response to the plenary report of the Women's Economic Rights working group, Mini Bedi stated, 'because women have to manage families, … they feel the stresses of poverty more and more. Yet, whenever women's projects are organised, they demand more work … because they need more money. But what does that really do for the women involved? In one project, we looked at women who were earning additional income from an income-generation project. To get it, they had to work for 16 to 18 hours a day.'

Income-generation projects for women can perhaps only claim to be a catalyst for change in gender relations in that they establish an alternative economic framework within which women can work collectively in the short term, and on which they can build for the longer term. If the project can provide a support structure for women, their improved earning capacity may be accompanied by a change in gender power relations, and may lead to real economic progress. This progress is more likely to come about if both women and men are prepared for the adjustments.

Frustration at the 'ghettoisation' of women in the small-scale informal sector comes at a time when economies are changing rapidly. According to Oxfam staff attending the Africa Regional Meeting in Harare, in preparation for the Conference, '[t]here is a need to support women's projects which enable them to participate in the mainstream ...'[7] This is one way in which income-generation projects can have a place in a wider programme for increasing women's economic resources.

Those income-generating projects which do achieve genuine change are conceived as long-term in nature, in the experience of Samagra Bikash Parishad (SBP), one of Oxfam's partner NGOs in India. A case study of SBP's work describes how this programme combined income-generation with addressing all aspects of women's subordination. After more than ten years, the result has hardly been an overnight revolution, but 'there have been visible positive changes at home. The husbands and male family members have shown concern in extending the co-operation in sharing the household work They also help in buying the raw material. Men have started to realise what women are capable of and now most of the women have their moral support.'[8]

Similarly, at the Asia Regional Meeting, held in Jakarta, participants were in agreement that from their experience, 'a key element of income-generating projects aimed at redressing economic injustice towards women is parallel activity designed to strengthen the decision-making power of women, even in the family'. They emphasised 'the importance of linkages between economic empowerment and political empowerment.'[9]

Without political power, women have no chance of influencing the macro-economic policies that determine the conditions under which they must work locally.

Development agencies and economic rights

Working to improve the economic rights of women is a challenge, not only to communities themselves, but to the community of development agencies: funders, field offices, and partner NGOs. As discussed above, improving the economic rights of women means challenging the social and political, as well as the economic, status quo. Some development agencies — funders and partner NGOs — see this as an insurmountable barrier and relegate women to unchallenging and conformist projects, whereas others take the long road and work slowly, aware that change comes through a process of participation rather than a series of short-term projects.

In short, the key is to see income-generation projects as part of a longer process of raising consciousness, and acquiring skills and resources, rather than ends in themselves. However, the short-term, practical benefits of such initiatives must not be forgotten. Income-generating projects which allow women to work within the home are particularly useful where women are obliged by custom to remain in seclusion. According to the women in the SBP programme, 'the single most important achievement of their work has been their mobility and their ability to break the chain of social taboos.'[10] Income-generating projects can sometimes make the difference between survival and disaster.

Income-generating projects also offer a potential entry into wider markets, and a basis for training, skills development, and confidence building, which can extend to other aspects of life, and provide opportunities for personal and organisational development. According to Morena Herrera, 'we have to consider how we women can benefit from the effects of development, not only as beneficiaries of these projects, but also as actors and as proposal-makers to put forward an alternative development plan that takes us into account, as women.'

Economic interventions designed to foster empowerment must be evaluated by methods which take into account the process of transform-ation. The contributions made by lobbying, networking, and public education are not always immediately tangible, but their long-term effects can lead to more sustained development because they aim to change not just the conditions but the system that determines the conditions.

In Jeanine Anderson's view, funding agencies such as Oxfam, critical as they are of the effects of SAPs on women in particular, should also

consider their responsibilities to support the growth of democracy, through training and institution-building. The WLP demonstrates that Northern funding agencies can work with their partners in the South and their supporters in the North, to contribute to a better understanding and analysis of the factors that inhibit development. The fiftieth anniversary of the Bretton Woods Institutions (the IMF and World Bank) and UN meetings such as the World Summit on Social Development and the World Conference on Women provide opportunities to promote a closer linking of constituencies.

At the Conference there was a clear call for new and better means of exchanging information. Information travelling between partners in development tends to flow northwards; very little flows the other way. At the Africa Regional Meeting in Harare[11] it was stated that, although communities are fighting the effects of macro-economic policies, such as SAPs, they have little understanding of why these policies have been imposed and what their overall effects are. This was echoed at the Conference, where it was felt that local NGOs, supported by funding agencies, have a role to play in explaining economic policies to the people with whom they work, to foster a local analysis, and thereby provide a catalyst for change: 'The Oxfam policy department should work with women on research and lobbying [about the effects of] the structural adjustment programmes, and use ... existing African [research], as well as support women's initiatives ... and give them information, so that they can prepare [for] the structural adjustment programme [to] come to their countries.'

In the present context of SAPs, the barriers to the decision-making fora are insurmountable for most women's organisations. Jeanine Anderson makes clear in her article that, in her view, a growing body of research on structural adjustment has shown that it is not working, and must change. Women's organisations, therefore, should be organising for a 'share of decision-making in defining just which regulatory functions are to be retained by new, post-adjustment national states'. Participants concurred with Jeanine Anderson's message: working at the local level on women's immediate economic needs is necessary, but insufficient in itself to effect women's empowerment: this demands not only commitment to interventions which have an express goal of empowerment, but, on a world level, change in macro-economic policies. Only through participation in the entire political process can women begin to influence macro-economic policies.

• Gender, poverty, and structural adjustment

Jeanine Anderson

Introduction

This paper seeks to lay out the major issues involved in structural adjustment programmes that have, among their many other effects, important impacts on gender relations, women's poverty, and the possibility of advancing the cause of gender equity in the developing world.

The term 'structural adjustment' came into the world's vocabulary in the mid- 1980s. Structural adjustment programmes (SAPs) were conceived as packages of transitional measures for redirecting the economies of countries that had not realised the high hopes for development prevalent a decade before. These programmes are intended to facilitate a conversion to economies that are outer-directed and export-led, governed by the market with minimal planning and regulation. Labour markets are to be flexible and unregulated. SAPs have been applied in developing countries of Asia, Africa and Latin America and in the former socialist 'Second World'.

Men and women occupy different niches in the economies of all nations; they bear different relations to society's central institutions; they are treated differently under the law; and they operate under different structures of incentives and constraints. Inevitably, then, they have been differently affected by SAPs, just as they were differently affected by the development strategies and economic policies that preceded them.

Backdrop: the feminisation of poverty

Structural adjustment is only the latest of a succession of development strategies that have crossed the world's stage in the past four decades. Earlier strategies pursued such varied goals as industrialisation, redistribution, population control, investment in human capital, the satisfaction of basic needs, and equity. Women's needs and gender equity were given short shrift in most of these efforts, yet there have also been well-designed and well-managed, gender-sensitive development projects. None has been enough to curb a worldwide process of feminisation of poverty. Poverty is becoming progressively more female

in absolute and relative terms: that is, increasing numbers of women are poor, and an increasing proportion of the poor are women rather than men.

The trend is global, but there are important differences in the causes that lie behind the feminisation of poverty in the industrialised countries, the developing countries of the South, and the former socialist countries. Some of the factors the developing countries share with other regions are labour markets segregated by gender, job discrimination, lower wages for women, and the unequal burden of housework. In addition there are growing numbers of solo female-headed households, men's paternal obligations have become progressively easier to evade, or difficult to fulfil, and the elderly poor are on the increase, with women predominant among them. A factor specific to developing countries is the concentration of women in agriculture, especially subsistence agriculture, while male cultivators are drawn into commercial crops; this causes women to lose their husbands' assistance in subsistence tasks and providing for the family. In many countries women have lesser legal rights, while social norms restrict their movements outside the home.

An immediate consequence of the application of SAPs has been to make the poor poorer everywhere (Lubeck 1992; Ugarteche 1992). The defenders of structural adjustment insist that this situation will last only until the economies in question have effectively applied the programme and the benefits of the new model begin to disseminate throughout society, while an increase in poverty was fated to occur independent of the measures. Whatever the merits of predictions about the future, it must be accepted that structural adjustment has contributed heavily to the absolute impoverishment of women around the world. Can it also be blamed for women's relatively greater impoverishment as compared to men? That is to say, do SAPs have features that, however dire their effects on the male population, are even worse for women?

Such would appear to be the case. There are factors inherent in the logic of SAPs that reinforce the disadvantages women already experience relative to men, and that create new pressures. In the following sections, four such problem areas will be examined.

Export economies and the distribution of poverty

Boserup (1970), over two decades ago, sought to discover the reasons why women had not benefited to the same extent as men from development programmes and projects in the Third World. She discovered interesting differences in the geographical distribution of men and women. In Africa, where women predominate in subsistence agriculture, men were likely to leave the village for work in cities and

mining communities; in Asia and other regions of plough agriculture, it was women who migrated. Women seemed either to be consigned to the backwaters of the rural subsistence economy or to act as shock troops in opening new and risky areas of economic activity (as they did in the Industrial Revolution in Europe).

The migration of vast numbers of persons within countries and across national borders is one of the more prominent facts of the modern world. These are persons fleeing from poverty in one place and looking for economic opportunity in another. The proportion of women to men among migrant groups tells important truths about the different choices that are available to women and men. In recent years, for example, export processing zones[12] have been attracting female migrants to cities and factory towns. SAPs encourage this movement insofar as they stimulate production for the export market and create conditions in which the availability of cheap female labour for industrial activities itself becomes a comparative advantage.

A more important effect of SAPs on patterns of migration, however, is likely to be an intensification of the process that concerned Boserup: the emptying of the countryside of men, with women and children left behind. In Peru's over 150 provinces, the proportion of women to men varies widely, but, in general, as provinces are poorer their populations are more heavily female (Anderson 1993). Male migrants go to areas of rapid economic growth: regional commercial centres, and the coca growing zones of the Amazon basin. The major cities, meanwhile, also concentrate women and the poor. In Peru, as in Boserup's Africa, women are left in stagnant areas of the countryside, in small towns whose economic base is the female activity of petty trade in agricultural products, and, more recently, in the shanties and tenements of the largest cities.

Resolving women's poverty, then, means addressing the geographical distribution of poverty and the problem of unequal investment in different regions of developing countries. Structural adjustment is unlikely to lead to any such result, given its emphasis on market forces and comparative advantage. In some African countries a strategy of 'backward linkages' has been proposed to tie rural development more closely to urban industrialisation. But since the ties connect through commercial agricultural products, women are unlikely to be beneficiaries.

The family in poverty under structural adjustment

The dissemination of SAPs reflects the ascendency of neo-liberal economic thought in organisations such as the World Bank and the International Monetary Fund (IMF). Other interpretations of the

economic problems of the developing world and former socialist countries have strong arguments in their favour, however. One with particular relevance to the question of gender and poverty is the so-called institutionalist school. This places emphasis on the web of institutions that organise relations, including economic relations, in diverse social groups, sub-cultures, and nations. Lubeck (1992:526) summarises the issues:

Institutionalists argue that producers often choose to allocate resources — land, labour, and credit — for the reproduction of groups (i.e. households, lineages, Islamic brotherhoods, or cultural associations) precisely because these diversified investments guard against environmental risk, market uncertainties, and the political instability associated with planning in a way that assures that they recover a small surplus at the very least. These behaviours reproduce an insurance-like network of moral obligation at the expense of greater surpluses earned by specialised, profit-maximising strategies.

In other parts of the world (Lubeck writes of Africa), the institutions in question may involve extended families, groupings of urban migrants with the same province of origin, churches, or the institutions associated with the urban informal sector: sellers' associations, solidarity groups, and self-defense organisations. An important point made by the institutionalists is that most human institutions are multi-purpose; that is, they serve material, social, cultural, and spiritual ends that are almost impossible to separate.

The importance of social institutions probably increases under conditions of structural adjustment. Structural adjustment creates a situation of enormous turbulence in social and economic systems (typically in political systems as well, though this may be a somewhat delayed reaction). Many have argued that the response of the poor in situations of turbulence or insecurity is to fall back on established relationships and proven strategies for obtaining the necessities of life. Figueroa (1990) has shown this to be the case, for example, for Peru.

The family is the first institution called upon to serve as a cushion in times of trouble. Any possible competitors leave. The State, which from the point of view of the poor was never particularly generous or reliable, disappears. Markets are unproven and apparently adverse; that, at least, is what the daily experience of the poor would seem to tell them. The family, then, is obliged to increase and diversify its functions, regressing, in a sense, to its multiple role in pre-modern society. There is no little irony in the fact that this should be one outcome of the drive to modernise traditional economies.

This situation has special implications for women. It seems indisputable that the family determines women's opportunities and

well-being more than it does men's. Yet the family tends to be not only undemocratic and unjust, when measured by a standard of gender equity (Okin 1989), but also tends to be protected from critical examination by the armour of social ideology. How can the question be raised of authoritarian decision-making when men, finding themselves unemployed, are forced to recruit family labour in their struggle to get by with an informal business? How can there be talk of redressing the balance in the sexual division of labour when men (and women) are forced to raise to inhuman levels the total time they devote to income-generating activities?

Structural adjustment strengthens the defensive potential of the family and primary institutions, such as neighbourhood networks and other mechanisms that tend to be loosely grouped in discussions of the 'survival strategies' of the poor. This does not mean that the family and these other institutions have been strengthened as such, or that they have been made more equitable. Migration within country and across borders, encouraged, as we have seen, under structural adjustment, breaks up extended families and local communities. In this process the system of checks and balances — embodied in gossip, in the authority of persons such as marriage godparents, in traditional sanctions — that helps to prevent family violence and other abuses, is lost. Male migrants to the cities may establish new families and 'forget' their responsibilities towards children left behind in the village.

Certainly structural adjustment — like the development strategies that preceded it — offers women no relief from the traditional division of household labour. The Western origins of both these 'packages' probably weigh heavily in this result: the gender stereotypes applied to housework that characterise Western societies are associated with modernity and prestige. But the arguments of Marxist feminists (see, for example, several of the authors in Collins and Gimenez 1990) concerning the functionality under capitalism of women's free labour in servicing the members of the family gain particular force under the new conditions. The intensification of housework is another phrase that has become current in connection with SAPs. With less cash available, families (i.e. women) must provide themselves with daily services in clothes and shoe repair, producing and processing foods, that they might earlier have bought on the market.

Democracy and the problem of public services

The fate of public services and the state's role in provision of infrastructure and sanitation under structural adjustment is a crucial issue, especially from a gender perspective. Women typically form the

link between the family and health services, education, housing, social security, and other welfare-related programmes whether public or private. Women distribute the household budget — in time and labour power as well as money — for the purchase of services and for such indirect costs as transportation to health posts and meetings with teachers. This occurs as a 'natural' extension of women's role in cooking, cleaning, clothing, and emotional maintenance of the family, in a majority of the world's cultures. It places women in a structural position of being those most interested in the level of service provision and in the way services operate.

SAPs have been imposed in countries where the state has difficulty in providing the minimal services that have for decades been understood to be an inherent function of the state in the Western democracies. Government deficits are large, taxation is weak, and social services and infrastructure are often financed through loans and donations. In most cases there is inadequate coverage of basic services, their quality is poor, and the problem of equity in access to public services is unresolved.

Measures were undoubtedly necessary to bring the public service sector in line with the real needs and demands of the population and to put its finances on a sounder footing; yet, whatever their problems, state-provided social services — especially public education and the public health system — form the core of the regime's legitimacy in many countries. Structural adjustment removes that source of legitimacy and further weakens an already weak state. Many developing countries were just beginning to build an effective public administration, to construct networks of services that were their only presence in remote areas, and to establish mechanisms for citizen participation and redress. For many of their citizens, the state's withdrawal from the provision of services and welfare means that the state has also withdrawn from the political relationship between state and citizen. The political loyalty of the citizen is thereby lost.

Spending on defence also tends to be high and wasteful in many Third World countries. Such spending, and the military values it fosters, is usually not a gender interest of women. Ironically, expenditures on defence and internal security may have risen as a direct consequence of SAPs, because of the need to maintain order in the face of protests (Herbst 1990). However, there are now signs of growing pressure from the World Bank and IMF to cut military spending.

The fact that SAPs are designed in centres of power outside the borders of the countries that apply them, only worsens the problem of weak states and state administration. The level of participation of local government employees, consultants and planners may vary, but, in most cases, the state is placed in a role of executing policies developed

elsewhere, subject to the periodic visits from inspection teams that wield more power than national parliaments.

These processes are taking place at a time when the central objectives of the international women's movement are empowerment, and promoting women's effective participation in political systems that have traditionally excluded them. The assumption behind these struggles is that the systems in question are democratic: not ideal democratic systems, perhaps, but working democracies with minimal elements of representation, due process, and the capacity to enforce policies in favour of social equity.

If women's emergence on the political scene hinges on the consolidation of democratic forms of government, a crucial question arises with respect to the implications of structural adjustment for this second great invitation being put forward to the Second and Third Worlds by the central countries. This is the invitation to political democracy. The democratic model as we know it includes the recognition of ample social rights, a fact that has not lost its relevance in the industrialised countries despite years of Reaganism and Thatcherism.

All observers agree in recognising that structural adjustment has placed enormous obstacles in the path of the spread and consolidation of democracy. This occurs, among other reasons, because of the widening gap between the rich and the poor; because of the frequent need for repression to impose the programme; because of the privations suffered by the poor and the middle classes; and because the reduction of state services causes confusion and mistrust. The context, then, is hardly promising for women's debut as new political actors.

Women organising together forms an essential part of gaining access to the political system. Under present conditions, formal organisations such as political action groups, labour unions, market co-operatives, or neighbourhood associations have little opportunity to prosper. Some authors (March and Taqqu 1986) have suggested that women's organisations can be especially fluid and informal yet still be effective as sources of political initiative and self-defence. Two important issues remain to be resolved: how to move from informal organisations to large-scale alliances in a world of ever greater concentrations of power; and to whom claims are to be addressed. A central challenge for the women's movement in this connection is to ensure a share of decision-making in defining just which regulatory functions are to be retained by new, post-adjustment national states.

Girls and boys in a libertarian world

Poor families distribute scarce resources among family members according to gender and age. Not enough is known about the logic of the decisions made in different cultural groups (including decisions to abandon certain members). The evidence suggests, however, that, under conditions of scarcity, girls enjoy fewer of most families' resources than boys. Boys tend to receive more education than girls, they are often better fed, and they are more frequent users of health services. Under structural adjustment, families' resources shrink and the relative costs of health, education, and child care rise. Lesser investment in the capacities of girls means perpetuating the disadvantages of women into the next generation.

The limiting case of discrimination against girls is the selective survival of male infants and children. Amartya Sen (1990) has made dramatic calculations of the numbers of girls and women that are 'missing' in countries of Asia where female infanticide and negligence in the care of female infants and children are widely practised. In addition to the cultural importance of male heirs, such practices are driven by economic considerations in poor families where, in the absence of effective means of birth control, the costs of raising each child must be carefully weighed against future returns. Scheper-Hughes (1992), writing about infant and child death in the north-east region of Brazil, does not find evidence of sex differences in survival but does register the emotional costs for mothers of reproductive 'strategies' involving high numbers of children born and high numbers of children that die.

Poor families respond to a drop in income by putting more of their members to work. Thus, child labour has returned with force under structural adjustment. The children's labour market tends to reproduce the gender division of the adult labour market. Boys tend to work at jobs that take them out on the street or into workshops and small factories, that imply movement, dealing with the public, adaptability, and variety. Girls tend to work close by members of their families or under the supervision of other adults, as happens in their most frequent occupation, domestic service. They have fewer opportunities to deal with strangers, take initiatives, or practice a variety of skills. Large numbers of young girls are left at home to do household maintenance tasks while their parents and male siblings work outside. The opportunities for stimulation, for gaining life experience, and for informal education, are vastly different in the gender-differentiated settings of children's work. Once again, girls acquire lesser skills and capacities.

Are there opportunities for women?

In the face of the evidence of negative effects on women of structural adjustment, one struggles to locate some saving benefits. These, if any, must lie in the opportunities that structural adjustment creates for diverse actors to move into new economic niches. On the economic playing-board, the hands are being dealt anew. It might be hypothesised that the advantages men formerly enjoyed, using their political power to reinforce their access to jobs and incomes, have been neutralised by the unleashing of the market.

One possibility is that women will move into the jobs vacated by men in the public service. Public employment has lost prestige, salary levels are appallingly low, and public office no longer means being able to distribute patronage or exercise significant power. The public service threatens to go the way of other occupations — schoolteaching, waitressing, or medicine in the former Soviet Union — that made a historical shift from predominantly male to predominantly female. It remains to be seen whether a feminised public administration will prove more susceptible to the demands of women, at least in the restricted areas that still remain under the control of the State.

A second new economic niche that women may be able to exploit lies in the small business activities so actively being encouraged as part of the structural adjustment package. There is reason to believe that the entrepreneurial roles assumed by women help to explain the success of the economic model pursued by the Asian 'tigers' — that small group of countries that have developed economically so rapidly over recent decades. Here, not only are family (including children) businesses common, but women are frequent heads of enterprises. As to gender roles, the Asian family firm makes an interesting contrast with the typical family firm in Latin America, where men — sons, nephews, godsons, and in-married sons-in-law — tend to be the vehicle of expansion (Lomnitz and Pérez-Lizaur 1987). The case demonstrates once again the importance of institutional and cultural factors in the behaviour of economic systems.

Women everywhere are care specialists. Women care for children, the elderly, the sick and incapacitated in the family; many low-prestige female occupations such as hairdressing and house cleaning involve maintenance and personal services; and women managers and professionals are concentrated in care-taking activities such as nursing, social work, education, and child care. If this is so, it is reasonable to suppose that throwing open the doors to a new scale and variety of private services might create entrepreneurial and employment opportunities for women, opportunities where they might have a

comparative advantage derived from their socialisation, gendered education, and female life- experience.

In this connection, it is worth recalling the all-too-frequent effects of many development projects that displaced women from occupational niches in the provision of services. Schemes to organise free mass vaccination, voluntary community health-promoters, pre-school education for poor children based on an unpaid labour force, often entered into unfair competition with poor women who were generating income by giving injections and medical advice to neighbours, as birth attendants, or running informal child-care centres in their homes. Even when women were left undisturbed in their petty service activities, they were rarely recipients of credit, which was reserved for 'productive' activities.

In theory, structural adjustment will return these small-scale service providers to work and put the volunteers out of business. For those who have watched with alarm the proliferation of women's unpaid work in large-scale development projects, or even as part of the social compensation packages in SAPs, the new trend is a vindication (Barrig 1990). Community health promoters, cooks in community kitchens, and child- care workers — these women may be poised to seize the opportunity for pursuing these same activities in the private sector.

Nonetheless, for this to occur, several conditions will have to be met. First, women will have to perceive the opportunities, something that flies against the ideology of self-denial and community service that sustained them over the years of voluntary work. Second, though the volunteer projects were often large-scale and administratively complex, poor women's managerial functions in them were defined as non-work and usually did not imply any special training. It is likely, nonetheless, that the women who participated in such activities have indeed learned leadership, managerial, and administrative skills. Yet exactly how far these skills will carry them is not clear. The new private services sector is likely to attract investors and entrepreneurs with considerable capital and experience. Unless women obtain training and credit for establishing new businesses in this area, they may not be able to compete.

Implications for development efforts

As one part of the world spins off in a post-modernist mosaic of non-comparable differences and cultural particularities, the rest succumbs to a relentless, standard recipe for development. SAPs allow little room for national differences in social institutions or cultural values, including national differences in gender systems. An immediate need, then, is for

agencies of international co-operation to encourage the production of knowledge about, and analyses of, the different institutional contexts in developing countries and the necessity for designing strategies for economic development that take these differences into account. Enough time has passed to show that SAPs are not working to the same degree in all the countries of the world; many observers suspect that in some countries they are not working at all. Standardisation may make the task of the World Bank easier, but it goes against the reality of a resurgence of ethnic and national identities and the permanent presence of a rich mix of peoples in human societies.

This paper has argued that structural adjustment must be viewed in a context where political democracy and economic modernisation form two legs of a global development project. All the nations of the world have a vested interest in this project, especially insofar as universal democratic government holds the promise of a world free of armed conflict. Under SAPs, democratisation is sacrificed in favour of economic modernisation. This situation should be reversed. The expansion of democracy is in women's particular interest: it holds out the hope that women may become full participants in the decisions that affect their lives, and that they may use the political system to promote gender equity and justice. Women have cause for taking the initiative in swinging the balance back to democratisation in the debate about development and in the distribution of resources at the level of governments, multilateral agencies, and agencies of international co-operation. The challenge is finding ways that it might be done.

References

Anderson, J. (1993), 'La feminización de la pobreza en el Perú'. unpublished working paper, Lima, Peru, Taller de Políticas y Desarrollo Social.

Barrig, M. (1990), 'Quejas y contentamientos: historia de una política social, los municipios y la organización femenina en Lima', in *Movimientos sociales: elementos para una relectura*, Lima, DESCO.

Boserup, E. (1970) *Women's Role in Economic Development*, New York, St. Martin's Press.

Collins, J. and M. Gimenez, editors (1990) *Work without Wages. Domestic Labor and Self-Employment within Capitalism*, State University of New York Press.

Figueroa, A. (1990), 'De la distribución de la crisis a la crisis de la distribución: Perú, 1975-1990', working paper No. 96, Lima, Peru, Catholic University of Peru.

Herbst, J. (1990), 'The structural adjustment of politics in Africa', *World Development* 18:949-58.

Kardam, N. (1991) *Bringing Women In: Women's Issues in International Development Programmes*, Boulder & London, Lynne Rienner Publishers.

Lomnitz, L. A. and M. Perez-Lizaur (1987) *A Mexican Elite Family 1820-1980*, Princeton University Press.

Lubeck, P. (1992), 'The Crisis of African Development: Conflicting Interpretations and Resolutions', *Annual Review of Sociology* 18:519-540.

March, K. and R. Taqqu (1986), *Women's Informal Associations in Developing Countries: Catalysts for Change?*, Boulder & London, Westview Press.

Okin, S. M. (1989) *Justice, Gender, and the Family*, Basic Books.

Scheper-Hughes, N. (1992) *Death without Weeping: The Violence of Everyday Life in Brazil*, University of California Press.

Sen, A. (1990), 'More than 100 Million Women Are Missing', *New York Review of Books*, December 20:61-66.

Ugarteche, O. (1992), 'El impacto de la deuda externa y las políticas de ajuste estructurales sobre la niñez en América latina', unpublished report to the Latin American Save the Children network.

7

Environment and sustainable livelihoods

As the twentieth century closes, feminism is faced with two challenges: on the one hand there is the challenge posed by ecological disruption which threatens the very basis of life on this planet: on the other, there is a constant need to respond to, and transform, the patriarchal categories of definition and analysis that we have inherited.

Vandana Shiva, *Close to Home*, 1994[1]

In recent years 'sustainable development' has emerged as a phrase which suggests everything that is seen as good and reasonable about development projects: environmentally benign and socially beneficial, not just for the present generation but to those of the future. A definition of sustainable development used by Oxfam is that 'which meets the needs of the present without compromising the ability of future generations to meet their own needs'.[2]

In her paper written for the WLP Conference, *Gender, Environment, and Sustainable Development*, Vandana Shiva goes back to the colonial roots of 'development' and provides an analysis of the stages of European imperialism, linked to the petroleum industry, transnationals, world trade agreements, the environment, and feminist activism. Vandana Shiva questions the contemporary use of words such as 'free' and 'development'. Central to the analysis of this paper is the idea that the language of colonialism, adapted for current trends, is still with us and that local communities and women need to challenge its use and take back meanings for themselves.

Participants at the WLP Conference discussed the lack of recognition by development professionals of the gradual process of evolution and change, which is a feature of all societies. This lack of recognition of non-interventional, day-to-day 'development' tends to lead to a false

emphasis on the importance of Northern interventions. The Environ-ment working group agreed that 'development cannot be brought in from outside.' Concepts of development which are familiar to communities under different terminology are mystified by development jargon and the short-term fads of the development 'industry'. Mariam Dem (Oxfam UK/I, Senegal) spoke for many at the Conference when she said that 'there is a kind of fashion as far as all these concepts are concerned: sustainable development [is one of these], for instance ... we do not check with [our partners] ... to find out what they include in that concept ... it is not obvious that the understanding of the concept is shared by people from the North and the different constituencies with whom we work in the South.'

In the absence of other sources of information, Southern organisations may take their definition of environmental sustainable development from their funder, which in turn might get it from a second level, for example a multi-lateral organisation. The resulting definition of sustainable development may be totally out of context in the community.

As Wanjiru Kihoro (ABANTU for Development, UK) pointed out, 'that ... is why there are at times accusations of imposition from the North — whether it's environment, whether it's gender — simply because we may be calling things by different names, because of our different understandings. ... There is a failure in communication among the different constituencies.'

Defining sustainability

In the past, the women and men who are the objects of development projects are not the ones who have determined development theory or practice. Usually, so-called 'beneficiaries' are the last to know the real agenda. Participants at the Conference asserted many times in different contexts that the process of development must come from inside the community. Further, the Environment working group considered that, in light of the concept of sustainability, development 'can only be sustainable when its "beneficiaries" take responsibility for it'. Although cultural and linguistic constraints may undoubtedly be a factor in inhibiting a shared understanding of concepts such as environment and sustainability, it may also be asked if the problem was more one of an unwillingness, on the part of the development practitioners, to let the community begin the defining process.

There is a need for a clear mutual understanding of what is meant by basic terms such as 'sustainability', 'environment', and 'development'. In practice, these terms are in danger of meaning all things to all people.

117

For example, 'sustainable' is a subjective term that is open to interpretation; different understandings of the term may cause disagreement. The fact that the nature of sustainability is defined by the context means that an industrialist's perspective on sustainability is likely to differ radically from that of a peasant farmer. The term 'environment' also attracts different interpretations. A scientific definition of the environment focuses on natural phenomena and their limits of use. A wider interpretation of the term focuses on the interaction of living beings with their surroundings, and puts the forces which mediate this interaction at the centre. Social and economic structures, politics, customs, culture and the legal system are as much a part of the environment as trees and the water supply, because these factors determine how global resources will be used, at what rate and for which purpose. These factors form the link in debates concerning environment and sustainable livelihoods, and it is with this perspective that development agencies work on environmental issues.

The Environment working group warned that sustainable development projects which focus on the physical environment without considering social relations may risk using project partners as tools to deliver an environmental goal, while ignoring the human cost involved. The Conference plenary concluded that socio-economic factors, including gender relations, cannot be merely tacked on to projects for the 'environment', and that all development work should logically ensure sustainability. There can be no sustainability, globally or locally, until inequalities are removed.

While language and culture present barriers, these are not insurmountable. Information, perspectives, and analyses should be shared, particularly in addressing environmental issues which have implications for every aspect of life and livelihoods. Communication gaps between women's organisations, feminist organisations ,and other grassroots organisations ,need to be closed.

Global inequalities

Mariam Dem (Oxfam UK/I, Senegal), on behalf of the working group on environment, echoed Southern indignation voiced in 1993 at the Earth Summit in Rio, Brazil, about the fact that there are huge disparities between the North and the South in terms of resource use and consumption. 'if funding agencies, local NGOs, and feminist organisations working for change ... ,are to provide support, they have to be able to accept that interaction is necessary; and that some of their practices [need] to be questioned. They have to be modest enough to

recognise the values of others and to create an interaction.' However, Mariam Dem pointed out that it is essential to recognise that these disparities also exist 'within the countries of the South, between grassroots populations which find themselves at a particular level and the élite whose conditions in terms of living, knowledge and capacities are far more developed ...'.

The case study used by the working group on Environment contained many of the elements of the problems facing grassroots communities and local NGOs today. It illustrated how different concepts of 'environment' and 'sustainable development' are held by different interest groups, and how economically and socially powerful groups are able to dominate. For example, while the question of rights to use of, and control over, land, is a key issue for gender and development practitioners worldwide, the difference which exists between use of land, and control over it, is often still glossed over. While the concept of 'management of resources' has entered the language and practice of development, discussion of the issue of who actually controls resources tends to be avoided. It is frequently assumed that existing arrangements of usage and control must be mutually beneficial to all who belong to the unit under scrutiny; yet the myth of co-operation all too often conceals conflicting claims over land and crops, between women who have worked the land and who use it to support their family, and the men of the same family who hold the land rights.

Control of resources, as a concept, tends to be more widely recognised — although not necessarily easier to resolve — when it is viewed in terms of a power struggle between parties who are perceived as having inherently opposing interests: for example, a wealthy landowner and a community of peasant farmers. However, when the power struggle is between protagonists who are perceived as naturally co-operative — for example, within a community, or between marital partners — control of the resource is less likely to be accepted as a development issue. It is crucial to recognise the difference between unquestioning respect for 'traditional' social structures, and critical understanding, which respects culture while recognising the need to support change from within it.

Global relationships

Macro-economic decisions made at an international level are having severe consequences for the socio-economic as well as the natural environment. During the process of 'Linking the Regional to the Global', Rajamma Gomathy, (Project Officer, Oxfam UK/I, Bangalore) pointed out that 'commercialisation of agriculture is practised according to the

119

needs of the multinationals, such that women's workload increases and women are more disadvantaged because there is no food for eating in the house: there is production only for the market.' Women are unable to reverse or improve conditions because, even nationally, they are very far removed from the decision-making arena.

In her paper Vandana Shiva asserts: 'The main challenge of our times is to reinvent freedom in an era of free trade, to reinvent decentralised and democratic decision-making in the context of globalisation, and to reinvent justice and sustainability in a period of deregulated commerce.' She sees the present phase of 'free trade' as having the same effect on women as the first colonial phase: loss of ownership and control. The intervening 'development' gave women a disproportionate burden of pollution. Resources have been privatised in foreign ownership and removed for distant markets. Their relationship with the local environment has been broken, and 'non-sustainability is the result. Women bear the costs of this non-sustainability.' As common property rights, which guaranteed women status as equal partners or even as managers, have been replaced by private ownership, poor women have lost their customary rights to resources.

The Environment role-play identified how rural people and the rural environment are drawn into, and affected by, the global political economy, through agri-business and industrialisation, which are increasingly reaching areas previously characterised by small-scale primary production and limited local markets. Here, women farmers working at a subsistence level may be adversely affected by policies which replace the cultivation of food for local consumption with cash crops, raise the cost of food, and lead to intensive migration, destruction of the soil, and pollution of the water supply. Yet, these farmers may not be automatically helped by, for example, projects for water conservation and agro-forestry, unless these projects are designed also to meet their development needs, recognising the root causes of the deterioration of the environment.

Because the commercialisation of agriculture may increase women's workload in cultivating cash crops, they will have less time to give to growing food for the household and for local sale. If they try to make up the balance from time previously spent in other activities, it is likely that the short time left to them for rest will be eroded. In the report of the Environment working group to the Conference plenary, Mariam Dem stressed that 'if we are to create sustainability in what we do, in development, by providing support to improve livelihoods, by trying to tackle health issues, by trying to provide education support, and so on, it is important to know what the situation is in regard to all these elements which are related to the environments in which we work ... It is

extremely important when working to achieve sustainable development to be able to carry out an analysis of [the] context; and … to link it with the situation of the actors involved'.

Recognising different roles

Mariam Dem reported for the working group that, during the role-play, they noted that 'beyond the natural environment are different actors, who interact with their natural environment … it was important to determine what [each person's] reality was, [and] define more precisely the various roles, … to know the situation. We realised that what often happens is that when we [funding agencies] want to intervene in a particular environment, we get there with our ideas, our approach and our strategy, without taking into consideration the reality that is already there.'

Each of the main actors in the role play took on some stereotypical, but not unrealistic characteristics. For example:

- Women farmers were seen as wanting to meet the basic needs of families and they want to continue to do this; to protect their livelihoods; have a voice in decision-making; and have access to and control of good local land and resources. They want information to try to protect their diminishing interests.
- Local NGOs were seen as sharing the aim of helping the local community, although this motive might mask another agenda, such as the personal ambition of the project leader. As in every organisation, survival of the organisation often becomes a motive itself in seeking funding.
- The funding agency was seen as wanting to help the local community, and choosing to do this by supporting the NGO. Believing that their idea of sustainable development projects are the best solution, many funding agencies might prioritise funding as many as possible, and promoting their particular conception of sustainable development.
- Governments were seen as wanting to raise national revenue, and improve their national and international standing. One way to do this is to build a political power base, through the promotion of industrialisation and agribusiness. The population may be manipulated to meet these ends.

Some of these goals overlap, while others are contradictory. Yet all actors are in a position to contribute to the development of the country and the community. The capacity for each development constituency to act independently in its own interest reflects the relative power of each. Grassroots women have little power, while NGOs are able to manoeuvre

between the financial power of the international funding agencies and the political power of the government.

Sustainable development as a process

The concept of sustainability presents a real challenge to mainstream development practice. If development is to be sustainable, the approach to it cannot be short term or *ad hoc*. Currently, development interventions are typically project-based. If one project is followed by another with perhaps another objective, there will be no sustainability.

In the working group on Environment and Sustainable Livelihoods, one participant remarked that assessing the complexity of a situation into which development funding is introduced 'needs more time than money'. This was echoed during a Conference plenary discussion by Wanjiru Kihoro, who criticised Northern development agencies for their short-termism, and the fact that they often appear to place more emphasis on funding than on the development process itself: 'The aid agency comes with resources ... and seems to think that is the most important thing about development. In my view it is not ... communities ... have had ... a much longer life than the agencies ... There is very little time within a project to go into the whole history of how people have been struggling, and how gender relations have been played out in the community. When the agency comes with its current concerns — whether it is 'environment' this year and 'gender' the next, they forget that the people have been going on in their struggles, and they don't link up with those struggles.'

In her turn, Mariam Dem asserted that organisations such as Oxfam and other funding organisations that have field offices in the South, as well as staff based in the North, should 'consider sustainability from a human resources perspective: human resources which are put forward to facilitate the effective implementation of these so-called sustainable development programmes. For example, we often have expatriate staff. No sooner have they understood the situation, than they have to return to their own countries. We know that even if we have the money or the knowledge [which comes from living in one kind of environment] ..., we can benefit from other types of knowledge coming from other contexts ... sustainable development can only be, and must be, presented in terms of global relationships. We have to [also] be able to link micro and macro issues. Sustainability must also be considered with this in mind.'

Funding agencies may want to take a participatory approach, and want to fund sustainability, but often their own practice seems to contradict this. For example, local NGOs, who are often obliged to obtain

funding from more than one source, face an added administrative and managerial burden which new or inexperienced organisations find difficult. The Southern Women's Meeting identified this as a serious issue. As Fatumata Sow (APAC, Senegal) said at the Conference plenary: 'we ask the funding agencies to harmonise their funding, evaluation and impact analysis criteria and rules and so that their evaluation coincides with the agendas of NGOs and national partners. In our eyes, this is extremely important: to take into account the life cycle and evolution of organisations and projects.'

The Environment working group's role-play highlighted the tendency of NGOs to rely on information from the international agencies, rather than carrying out participatory research at community level. Lack of consultation with alternative networks for information and support can mean that decisions on the sort of interventions to finance are 'funding-led' (funds are allocated for types of intervention which are predetermined by the funding agency). This reduces the chance of development initiatives being designed by Southern partners. In the role-play, funder preference for 'environmental' projects led to an unnecessary displacement of an existing health project.

Finally, sustainability applies to the structure of funding itself and the way in which this is administered, as well as to the work on the ground. This has implications for funding phases and staffing of field offices; for example, in terms of funding phases, longer lead times are necessary to assure that all variables have been considered, not just by the NGO, but by the community participants. Mariam Dem stated, 'funding agencies don't mind taking a participatory approach, [and] don't mind trying to understand the situation, but they must face this constraint: either they don't have enough time, or they don't have enough money. ... Maybe they could maximise this time and this money through a different type of intervention'.

Where do we go now?

Despite the failure of development planners to take political, economic, and social relations into account as a holistic whole when they plan interventions, sustainable development can only succeed when these links are made. The concept of sustainability offers a profound challenge to everyone involved in development work to think about what it really means for their work, and the way they are doing it.

Vandana Shiva stresses the importance of local action on environmental sustainability, describing how women can and do take collective action in situations which threaten their livelihoods and the

health and safety of their families. In so doing, she makes a direct link between the often unregulated activities of transnational corporations, environmental pollution, and child health. Yet, as the Environment working group asserted, in conventional project-based development planning, these may be treated as competing criteria for project funding.

WLP Conference participants would agree that this is a false dichotomy. A healthy environment and sustainable resource management are interdependent with human health and well-being. It is by making these connections, and acting on them in the design and implementation of development interventions, that control over the development process will begin to be restored to, and sustained by, Southern communities.

• Gender, environment, and sustainable development

Vandana Shiva

Introduction

A significant trend over the past five centuries has been the change in the use and ownership of natural resources. Utilisation patterns have increasingly shifted from local use for basic needs to non-local use for industrial and commercial objectives. Ownership patterns have similarly shifted from ownership as commons to private property in resources as commodities.

The implications for sustainability arise from the fact that as resources are diverted to meet distant market needs, their relationship with local ecosystems and local communities is broken. Resources are extracted with indifference to ecological limits and non-sustainability is the result. Women disproportionately bear the costs of this non-sustainability.

While commons and local use rights include women as equal partners, and sometimes even as the primary managers, forms of private property bring about women's exclusion from ownership and control of natural resources.

The three phrases of resource appropriation

This process of natural resource appropriation and the shift from the local community ownership and control to non-local state or corporate ownership and control has had both a continuity and discontinuity over the past 500 years.

Phase I: Colonisation

In the first phase the process of appropriation was through colonisation of non-European land and people by European powers. The Papal bull Dum Diversas of 1492 granted to the Portuguese, and the warrant the Spanish Pope, Borgia Alexander VI, granted to Ferdinand and Isabella before Columbus set sail, authorised the European nobility to attack,conquer and subdue pagans and other unbelievers who were

125

inimical to Christ; to capture their gods and their territories, to reduce their persons to perpetual slavery, and to transfer their lands and properties to the European monarchs.

The idea that 'wild' 'primitive' men must be tamed or exterminated and their resources appropriated and improved was not restricted to the Spanish colonisation of South America. It drove the white settlers from England during the take over of North America as well. The royal charters that sanctioned the first journey out of England used, in fact, practically the same language as the one used by Spanish and Portuguese monarchs. The charter Henry VII granted to John Cabot and his sons in 1482, for example, licensed the sea-farers to occupy and set up the king's banners and ensigns, 'in any town, city, castle, island or main land whatsoever, newly found by them', anywhere in the eastern, western and northern sea,' belonging to heathens and infidels in whatsoever part of the world placed, which before this time were unknown to all Christians.' The charter empowered them, 'to conquer, occupy and possess all such places', the main condition being that they would give to the king the fifth part of the whole capital gained in every voyage of their enterprise. A little later, the Englishman, Humphry Gilbert's, letters patent empowered him 'to search out remote heathen and barbarous lands not occupied by Christian princes'. The locations of these lands were of course properly vague, but the cultural assumptions were plain. Such remote lands belonged by right to the True Faith to such Christian princes as would first discover them, and not to the native inhabitants themselves.[3]

Land was the central resource in the first phase of natural resource appropriation through colonisation. But land alone was not productive. Its productivity was linked with biodiversity and what Crosby has called 'biological imperialism'. Most staples of the world were first domesticated in the Americas by native Americans — maize, potato, and tomato, along with pumpkin, peanuts, and cassava/manioc. This colonisation of biodiversity has become even more important in the late twentieth century as we shall see later.

Phase II : Development

The second phase of natural resource appropriation can be identified with the 'development' paradigm. As Third World countries gained independence during the mid-twentieth century, they did not decolonise at the level of natural resource utilisation and control. On the contrary, the appropriation of land, forests, and rivers from local community use and ownership was accelerated with the 'development' ideology which became the reason for the newly independent nation states. Multilateral

development banks, and bilateral aid, were essential ingredients for the alienation of resources from local communities.

If 'development' was the central ideology of this phrase of resource appropriation, oil was the central resource for technological transformation. The paradigm was one of substitutability of all natural resources by petroleum-derived products — fertilisers, pesticides, materials, fibres. The environmental impact of this petrochemical-centred development era showed up in terms of destruction of renewable natural resources and also in the form of toxic pollution.

The impact was sensed and responded to by women in local communities, in the North and in the South. In Nigeria, women attacked oil industry installations and personnel throughout the 1980s. Women do most of the peasant farming, and the oil-based industrialisation superimposed on this local political economy a new regime which dispossessed women of farmland. In the 1984 Ogharefe uprising, women seized control of a US corporation's production site, threw off their clothes and, with this curse, won their demands for financial compensation for pollution and alienation of land. In the 1986 Elepan women's uprising, women shut down the whole area of the region's oil industry.[4]

In industrialised countries too, local women have led struggles against toxic pollution. These women, often ridiculed as 'hysterical housewives', have put health and survival at the heart of the environmental agenda. The impact of toxic chemicals came to the forefront with the 1978-1980 struggle at Love Canal where 900 families fought for and won relocation after they had discovered that their neighbourhood was built next to 21,000 tons of toxic wastes. Lois Gibbs led this community struggle. Since then, a new social justice movement, led almost exclusively by women, has arisen in the United States, The Movement for Social Justice, which includes the people who have suffered most — the women and children, the poor, and people of colour. It is no accident that toxic dumps, incinerators, and other dangerous facilities are placed in poor, rural areas in the industrialised countries, or in Third World countries. Clearly class, race, and ethnicity in a community are driving factors in site selection. And pollution has gender-differentiated effects, in that its impact is carried more heavily by women. Penny Newman, of the Citizens' Clearing House for Hazardous Wastes has called it the 'feminisation of pollution'.[5]

Phase III : Free Trade

We are now entering the third phrase of resource appropriation — the 'free trade' era, symbolised by forced and coercive liberalisation of

structural adjustment imposed by the IMF and World Bank, and turned into a global regime through the Uruguay Round of GATT. The world is finally split into two classes of homeless — the privileged homeless who owe allegiance to no country but own the world as property, and the dispossessed homeless, who live in refugee camps, resettlement colonies, and reserves. If 'development' created development refugees, free trade will create its own GATT refugees, especially in the field of agriculture.

Agriculture and related activities are the most important source of livelihood for Third World women. 'Free-trade' in agriculture, as construed in GATT terms, aims to create freedom for transnational corporations (TNCs) to invest, produce and trade in agricultural commodities without restriction, regulation or responsibility. This freedom for agribusiness is based on the denial of freedom to rural women to produce, process, and consume food according to the local environmental, economic, and cultural needs. What GATT aims to achieve is the replacement of women and other subsistence producers by TNCs as the main providers of food. Behind the obfuscation of such terms as 'market access', 'domestic support', 'sanitary and phytosanitary measures', and 'intellectual property rights' in the final draft of the GATT agreement, is a raw restructuring of power around food: taking it away from people and concentrating it in the hands of a small number of agro-industrial interests. The conflict is not between farmers of the North and those of the South, but between small farmers everywhere and multinationals. It is no surprise that the bulk of US, Japanese, and European farmers are also opposed to the proposed GATT reforms, because these reforms are meant to drive small farmers out of business.

In the Third World, most small farmers are women, even though their role has remained invisible and has been neglected in official agriculture development programmes. By focusing on international trade in food, GATT policies serve to further marginalise the household and domestic food economies in which women play a significant role. Further, since GATT is a self-executing treaty, it will automatically lead to the setting up of a Multilateral Trade Organisation (MTO) which, with World Bank and IMF, will form the centre of world governance.

Women and food production

The negative impact of GATT will be greater on Third World women because they play a major role in food production and processing, even though this fact has remained invisible and neglected. In India, for example, agriculture employs 70 per cent of the working population, and about 84 per cent of all economically active women.

GATT policies that encourage free export and import of agricultural products translate into policies for the destruction of small farmers' local food production capacities. By locating food in the domain of international trade, these policies dislocate its production in the household and community. Policies being imposed under 'market access' and 'domestic support' on the agriculture agreement are basically policies that allow TNCs to displace the small producer. Under 'market access' is thus an instrument for the conversion of the Third World's subsistence production of food into a 'market' for TNCs. Similarly, by relating domestic policy to international markets through clauses on domestic support, GATT facilitates the shifting of subsidies from poor producers and consumers to big agribusinesses.

The displacement of women and other small peasants from agricultural production will also have a serious impact on food consumption since peasants' access to food is through participation in its production. As TNCs dump subsidised surpluses on the Third World, peasants are driven out of food production into famine. A conservative assessment of the impact of so-called liberalisation on food consumption indicates that in India, by the year 2000, there will be 5.6 per cent more hungry people than would have been the case if free trade in agriculture were not introduced. Free trade will lead to 26.2 per cent reduction in human consumption of agricultural produce. The growth of free trade thus implies the growth of hunger.

The growth of TNC profits takes place at the cost of people's food needs being met. Since women have been responsible for food production and provisioning, the decline in food availability has a direct impact on them. Control over food is thus increasingly taken out of the hands of Third World women and put in the hands of Northern TNCs. The concentration of markets, trade, and power in the hands of a few TNCs makes competition by small farmers in the Third World impossible. US grain exports account for 76 per cent of world agricultural trade. In 1921, 36 firms accounted for 85 per cent of US wheat exports. By the end of the 1970s just six companies: Cargill, Continental Grain, Luis Dreyfus, Bunge, Andre & Co, and Mitsui/Cook exported 85 per cent of all US wheat, 95 per cent of its corn, and 80 per cent of its sorghum. These same companies were handling 90 per cent of the EC's trade in wheat and corn, and 90 per cent of Australia's sorghum exports. Between them, Cargill, the largest private corporation in the US, and Continental Grain, the third largest, control 25 per cent of the market.

Intellectual property rights and ownership of seeds

Intellectual Property Rights (IPR) are another instrument in the GATT agreement which will dispossess rural women of their power, control, and knowledge. IPRs in GATT and other international platforms aim to take seed out of peasant women's custody and make it the private property of TNCs. By adding 'trade related' to IPRs, GATT has forced issues of the ownership of genetic resources and life forms on to the agenda of international trade through Trade-Related Intellectual Property Rights (TRIPs). At the conceptual level, TRIPs are restrictive, being by definition weighted in favour of transnational corporations, and against citizens in general, and particularly Third World peasants and forest-dwellers. People everywhere innovate and create. In fact, the poorest have to be the most innovative, since they have to create their means of survival while it is daily threatened. Women have been important innovators and protectors of seeds and genetic resources.

Article 27 on patentable matter is a clear indication that national decisions made on grounds of public interest are overruled. Article 27 (1) states that 'patents shall be available for any inventions, whether products or processes, in all fields of technology, provided that they are new, involve an inventive step, and are capable of industrial application.' This nullifies the exclusions built into national patent laws for the protection of the public and the national interest. For example, in the Patent Act of India, 1970, methods of agriculture and horticulture were excluded, and were not patentable; whereas the TRIPs text includes these as patentable. Under the Indian Patent Act, only process patents can be granted to food, medicines, drugs, and chemical products, but under the MTO, the Third World will have to grant product patents also in this area. Article 27 calls for a review of the scope of patentability and subject matter of patents four years after signing the text. Within an MTO with no democratic structure, however, such a review will only be used by MNCs to expand the domain of their monopoly control. The worldwide movement against patents on life has rejected TRIPs in GATT, while Sustainable Agriculture movements and biodiversity convention movements have expressed concern about the universalisation of patent regimes. Article 27 (3) states that 'parties shall provide for the protection of plant varieties either by patents or by an effective in generis system or by any combination thereof.'

Under the impact of this enforcement, farmers will not be allowed to save their own seed. The International Convention of the Union for the Protection of New Varieties of Plants (UPOV) had maintained farmers' rights to save seed, but in March 1991 this clause was removed. The new clause in UPOV (and TRIPs) can be used to enforce royalty payments on

farmers if they save their own seed. With the stronger intellectual property rights regime being conceived under MTO, the transfer of extra funds as royalty payments from the poor to the rich countries would exacerbate the current Third World debt crisis tenfold. This is ironical, since most plant diversity originates in the Third World, and seeds and plant materials that today are under the control of the industrialised world, were originally taken freely from the farmers to whom they will now be sold back as patented material. As a result, seed companies will reap monopoly profits, while the genius of Third World farmers will go unrewarded and they will be banned from saving and using their own seeds.

IPRs in the area of seeds and plant material are in any case not easy to demarcate, since the genetic resources used by multinational corporations for claiming patents are the product of centuries of innovation and selection by Third World farmers, especially women. The UN Food and Agriculture Organisation (FAO) has recognised these contributions in the form of 'Farmers' Rights'; and the Biodiversity Convention signed at the 1992 Earth Summit also recognises them, and accepts the need to make IPRs subservient to the objectives of biodiversity conservation.

In addition to loss of control over genetic resources is a new threat of loss of control over ownership of land. As banks become privatised and contract farming is introduced, the farmer will risk losing his or her land. Protection of rights to land, water and genetic resources are central to the freedom of farmers. GATT, however, defines legal protection only in terms of the interests of the corporate sector and freedom of TNCs. Whose rights to resources need protection from the viewpoint of sustainability and justice? This question will move centre stage as farmers' and environmental movements begin to address the emerging control over natural resources by global interests for global profits.

Local control over natural resources is an essential precondition for farmers' freedom. But free trade which, as we have seen, implies a relocation of control over natural resources for farmers and Third World governments to global institutions, has serious environmental consequences. Corporations use land, water, and genetic resources in non-renewable, non-sustainable ways, being mainly concerned to maximise profits rather than to conserve local resources. Local laws and regulations for limiting environmental degradation will be treated as barriers to free trade. Local communities' democratic decisions on resource conservation are thus excluded by GATT. The GATT draft by Dunkel requires that central governments adopt measures to ensure that state governments comply with GATT rules, which further reduces farmers' influence in decision-making. Thus farmers' organisations will

be weakened, as will state legislators and parliament: all power will be concentrated in the hands of GATT and TNCs.

The freedom that TNCs are claiming through intellectual property rights protection in the GATT agreement on TRIPs is the freedom that European colonisers have claimed since 1492 when Columbus set precedence in treating the licence to conquer non-European peoples as a natural right of European men. The land titles issued by the Pope through European kings and queens were the first patents. Charters and patents issued to merchant adventurers were authorisations to 'discover, find, search out and view such remote heathen and barbarous lands, countries and territories and actually possessed of any Christian prince or people'. The colonisers' freedom was built on the slavery and subjugation of the people with original rights to the land. This violent take-over was rendered 'natural' by defining the colonised people into nature, thus denying them their humanity and freedom.

The implication of a world-view that assumes the possession of an intellect to be limited to only one class of human beings is that they are entitled to claim all products of intellectual labour as their private property, even when they have appropriated it from others — the Third World. Intellectual property rights and patents on life are the ultimate expression of capitalist patriarchy's impulse to control all that is living and free.

GATT is the platform where capitalist patriarchy's notion of freedom as the unrestrained right of men with economic power to own, control and destroy life is articulated as 'free-trade'. But for the Third World, and for women, freedom has different meanings. In what seems the remote domain of international trade, these different meanings of freedom are a focus of contest and conflict. Free trade in food and agriculture is the concrete location of the most fundamental ethical and economic issues of human existence of the present times. It is here that Third World women have a unique contribution to make, because in their daily lives they embody the three colonisations on which modern patriarchy is based; the colonisation of nature, of women, and of the Third World.

Looking within: gender and working culture

Because gender relations are dynamic, Oxfam's vision and policy cannot be static; adjustments and changes may be required over time.
Gender and Development, Oxfam's Policy for its Programme, May 1993

A genuine and growing commitment to a gender perspective on development is evident in Oxfam UK/I. Support and resourcing for the three-year WLP testified to this. Yet staff in Oxfam UK/I field offices and NGO partners, working in comparative isolation, often lack the support necessary for effective implementation of Oxfam's Gender Policy, including the introduction of new ways of working with grassroots communities and project partners. This chapter looks at the implications of taking on a gender policy for the internal structure and work culture of Oxfam UK/I and, implicitly, for other organisations.

Regional perspectives on gender

Despite the universality of the basic assumptions of a gender and development policy, important differences between countries and cultures mean that procedures for implementation will vary. Staff will need a range of support in their programme work, and also in the development of gender awareness in human resource issues. Participants at the Conference felt that the Gender Team should reassess the regional divisions in its training and advisory work, bearing in mind that cultural context often brings countries closer than geographical proximity — Yemen and Sudan, for example, are culturally closer than Yemen and its neighbour Lebanon. A more reciprocal relationship between the Gender Team and the Field Offices would lead to a better

analysis and understanding within the Gender Team of specific conditions in the field.

Many field officers are Southern women who are well placed to assess the potential for work on gender issues in their region. It was suggested at the Conference that regional reference groups should be set up to meet periodically in order to discuss and share ideas and problems relating to the implementation of Oxfam's Gender Policy. These regional groups could also develop region-specific approaches to training on gender issues, and the monitoring and evaluation of projects from a gender perspective.

Resistance within the organisation

Although working for change is an aim of their programme work, many NGOs are resistant to changes imposed on them from outside. While supporting challenges to 'traditional culture' may be a central focus of their development activities, 'gender issues' may be associated with radical feminism and perceived as a threat to the status quo, and an imposition of Northern culture. Women, as well as men, may feel some antagonism, since they share the values of their social system; even where women or men may see the value of gender analysis in exposing unequal power relations in their society, they may have too little power in their organisations to carry the work through.

Gender identity is a part of everyone's life, and this gives us all a personal perspective on gender which we may not be able to leave at the office door. The feminist assertion that the 'personal is political' can equally be used as an argument against integrating a gender analysis into work (Kabeer 1995). Resistance is not likely to be overcome by a policy statement alone, but the existence of such a statement means that staff are obliged to acknowledge gender issues in their professional activities. The pragmatic view is that this is very much better than nothing.

However, while official adoption of a gender policy means that it becomes part of the responsibility of all staff, resistance may actually increase precisely because the initiative is being imposed from above. 'Gender' becomes one of a series of top-down policy initiatives, coming from head office (for Oxfam, others include basic rights, sustainable development, and multiculturalism), which, while not fundamentally incompatible, may appear to be unco-ordinated, and to add to workloads. This lack of co-ordination can be confusing and frustrating for field staff, and for project partners, who are far removed from the policy-making process.

Gender and working culture

If organisations recognise the importance of an analysis of gender relations in their development work, they must apply the same analysis to the working culture of their own organisation. Gender-aware employment policies should go hand-in-hand with programme work that recognises the centrality of gender analysis. However, women are generally under-represented in positions of power, and Oxfam is no exception to this. Dianna Melrose (Oxfam UK/I, Policy Director) reported to the Conference on behalf of a working group looking at the issue of placing women in policy-making roles in funding agencies: 'We were very struck by how under-represented women are in power structures at every level within Oxfam UK/I, where I am the sole woman on the Overseas Management Team. Sadly, we have no women on the Corporate Management Team, although we tried very hard to recruit women. … It was very depressing to see how few women applied, there was about one in 40 for many of the jobs, … although men with very few qualifications had not thought twice about applying. We women, however, limit ourselves, we underestimate ourselves, we think we have to be perfect to appllly for a job.'

The view of men as main breadwinners for their families, which is rooted in Western culture, and the notion of the family wage,[1] coupled with women's reproductive role, combine to give women the lower-paid and lower status jobs in the public sphere. Many of these jobs are concerned with a servicing role, and therefore fit gender norms more easily than high-paid, high-status, executive roles.

Although women may underestimate themselves when applying for jobs, they may also know from experience that the effort of making a job application may not be worthwhile; in organisations which have a bias towards employing men, a woman's application must be outstandingly good to be accepted over one from a man.

The dearth of female applicants for high-level or even middle-level posts underlines the problem that, in general, bureaucratic working cultures value qualities and characteristics which are not promoted in the socialisation of women. Although some women find it possible to conform to this style of behaviour in the workplace – and some may excel at this – others reject the pressure to do so, in favour of a working culture which places greater value on diversity, participation, consensus-buil;ding, and a holistic view of issues and context, as well as the different taents and vulnerabilities of the individual women and men in the workplace.

Employees as carers

In a working culture which ignores women's and men's responsibilities for their families, women — and the increasing numbers of men who are primary carers — cannot hope to compete on equal terms with men who have a wife or partner who provides most of the family care. The overtime and irregular hours often expected of people working in higher grades are other reasons why women are under-represented in high-level posts. People who are primary carers for children or the elderly are simply not able to commit themselves to a culture of work which would encroach greatly on their time outside the office. Dianna Melrose pointed out that her work is often carried out 'at the cost of my personal life and time with my kids. So I live, as I think we all do, that dynamic between the demands of our workload, ... and feeling that as a mother you want to be part of your children's life, and not miss their childhood.'

This is a common experience for many staff, particularly in fields of work to which they have a high personal and political commitment. The work often takes over at the expense of family life, of involvement in their own community, and of gaining valuable knowledge and perspectives from non-work activities.

In addition to being damaging for women in terms of lessening their employment opportunities, such working cultures also fail to recognise the right of men to take a responsible part in domestic life and to care for their children, and perpetuate their role as primary breadwinner. Such a system operates on the explicit or tacit assumption that an unpaid, invisible 'wife' — or a paid domestic worker — is available to perform the work necessary to nurture the family.

An important recommendation from the working group on Oxfam management culture at the Conference was that Oxfam UK/I should offer a childcare allowance to staff in the field and in the UK; although it is acknowledged that this is still only a partial solution.

The move to a 'flexible' working culture

Oxfam UK/I is currently examining the implications for equal opportunities of the rise of a 'flexible' working culture. This is characterised by the use of short-term contracts which either ignore or reduce the employer's responsibility for payments for pensions or maternity leave. Short-term contracts enable the employer to 'contract in' workers for brief periods of time when the office is busy, or for specialised tasks, but the resulting insecurity for employees means that those with family responsibilities, or who would like to have children,

are less likely to apply. This discriminates against women and older people.

The implementation of a gender policy, which encourages a holistic view of the productive and reproductive responsibilities of both women and men, creates an opportunity to change this punishing work ethic within an organisation, and find new ways of getting the necessary work done well and creatively without sacrificing the personal life of staff, or depending on the unpaid labour of a spouse. Sylvia Borren (Dd Beuk, The Netherlands), suggested that 'the culture of Oxfam UK/I should be feminised'; standards for working time should not be set that oblige or encourage employees to neglect their family responsibilities, and prevent them from leading more balanced lives.

Short-term contracts also hinder the ability of organisations to learn lessons from their experience. The fact that all programme staff in field offices are on short-term contracts means a steep learning curve on policies which are unfamiliar. It seems that as soon as staff learn the 'language' of concepts and familiarity with the culture in which they work, they leave. This is at odds with Oxfam UK/I's commitment to staff development and institutional learning, and Oxfam UK/I is thus examining the issue of short-term contracts very carefully. For expatriates working in the field for only one or two years, work on gender issues can be blocked by a lack of local knowledge and cultural understanding. Mariam Dem (Oxfam UK/I, Senegal) spoke of this when reporting on the Environment and Sustainable Livelihoods working group. Such lack of continuity is a hindrance to the development process, particularly where the funder wants to work with women or another particularly isolated section of the community. Unfortunately, in some special circumstances, such as emergency situations, such contracts may be unavoidable.

If feminising the working culture is possible, why does this so rarely happen? Perhaps because, while many would subscribe to the vision as a counsel of perfection, it is simply not considered to be feasible. Discouraging employees from working long hours would seem at first sight to be counter-productive. However, there are clear benefits: an end to stress and overwork, and a more fulfilled life for the workforce, results in better quality work in the time allotted. Organisations should recognise the positive effects of an energetic workforce which feels valued and is not permanently fatigued.

In order to help women who are juggling paid and unpaid productive work with domestic chores, resource management, and the responsibilities of caring for children and other members of the family, gender-sensitive development work requires a different, and more flexible, approach. It must go beyond the assumption that if women's present needs as carers are taken into consideration their problems will

be solved. Ultimately, the fundamental imbalance of male and female workloads must be addressed.

The Conference was reminded that discrimination on grounds of sex is not only an issue for head office, where organisation-wide trends in employment patterns may be monitored, but that such discrimination also exists in the field offices, where female field officers have a limited amount of power to implement Oxfam's Gender Policy. According to Mariam Dem: 'It is very important for management to know that, given the position of women in field offices, they have a very important role to play. It is not obvious, in work around gender issues, or in the realisation of recommendations issued from this meeting, that women, even if they have the will, can have the last word on how far we can go. It is very important for management to take this into account and to look at what procedures they can offer as far as field work is concerned.'

Gender and multiculturalism

By questioning the culture of the organisation, rather than taking it as an invisible, 'given' factor, Oxfam's Gender Policy provides the opportunity to look at other forms of discrimination which militate against certain groups being adequately represented in Oxfam's structure. Participants at the Conference urged management not only to remember Oxfam's commitment to improve the situation of women, but also to ensure that women, ethnic minorities, and other under-represented groups are represented throughout the organisation. According to Dianna Melrose: 'We want to see Asian women, African women, Latin American and Caribbean women represented in our power and decision-making structures — that is the aspiration.'

Language and translation were seen as important issues at the Conference. The working group on Oxfam management culture stated that 'Oxfam UK/I must try to use a language in its work which does not marginalise and intimidate through unnecessary use of jargon … or complex language which hampers, rather than helps, comprehension.' A further point raised by the working group was that exchange visits should be organised between the field and Oxfam head office, to give better insights into aspects of Oxfam UK/I's work.

Work, violence, and sexual harassment

The culture of an organisation can also create a tendency for acts of harassment and aggression between staff to be hidden, or even to go

unrecognised as an issue by those involved. According to Hilary Coulby (Oxfam UK/I, Philippines), 'we have to look to our own behaviour within Oxfam as an institution before we are in a position to preach to anybody else ... Violence and sexual harassment happen within [charitable] organisations.'

Sexual harassment, and even violence, certainly exist to some degree in most organisations, including development agencies. Many agencies, including Oxfam UK/I, have policies to address this problem, but the question remains of how workable these are in reality. Women are reluctant to complain for fear of losing their job or promotion prospects, of being publicly embarrassed, or accused of provoking the harassment themselves. The professed and implicit aims of humanitarian organisations and the charity sector may mean that sexual harassment is the more unexpected, and this may influence women's unwillingness to draw attention to its existence. Employees may not recognise it as a problem that they have the right to address.

If violence is accepted as a development issue, there are obvious implications for funding agencies. They must do more than make pious statements for the benefit of other people, and must address the issue of violence and harassment very seriously within their own organisations. Such critical self-analysis is not easy. Women — and male — employees need to know that they are protected from sexual harassment by the terms of their employment, and that they can take steps against the perpetrators through agreed organisational procedures.

The first step in tackling the problem is to talk about it; this can only happen if employees know they can rely on the fairness of formally agreed procedures. One Conference participant stated that 'the reality for many of the women here [at the conference] is that they will go back to isolated locations where they are a minority, and where they are not necessarily protected ... There is a lack of confidence that the organisation has the will to deal with these issues, and many of them are still not taken up.'

The frankness with which this problem was discussed at the conference suggests that development organisations which have a male and female staff — both funding agencies such as Oxfam, and partner organisations — are increasingly taking this first step of recognising sexual harassment within their institutions and programmes.

Who is responsible for implementing a gender policy?

Before a gender and development policy is accepted as a part of the mainstream work of an organisation, the responsibility for promoting

gender issues tends to fall on a small number of specialists. Dianna Melrose described the time and energy it takes to get a policy accepted and implemented, and the cost to staff which this pioneering work involves: 'I have been working with the Gender Team, and have seen what an enormous task they have. Where do they begin, given the scale of the task of mainstreaming gender in Oxfam UK/I? How do they prioritise between different demands?' Implementing Oxfam UK/I's gender policy is now the responsibility of management, while the Gender Team is charged with providing support for the process.

Moving on from this, Ernst Ligteringen (Asia Area Director, Oxfam UK/I) stated that implementing the Gender Policy requires Oxfam UK/I to look to all members of staff, in all aspects of their work; considerable responsibility for shaping the programme exists beyond senior management: 'the field [is] where the bulk of the decisions are taken, where the projects are. It is in the field where Country Representatives, with the project and programme officers, make the decisions.'

Gender training within organisations

Within an organisation, gender-awareness training should involve all levels of staff; one conference participant recommended allocating time 'for training at regional meetings which involve head office as well as staff from the region'. A number of other ways in which training could be integrated into the organisation's work were suggested. These included:

- introductory training on gender-awareness, including staffing issues, for all staff, should be followed by a training session designed for specific areas of work;

- men might benefit from training by other men;

- gender training should not only focus on the conceptual tools needed to perform a gender analysis, but on the shift in personal attitudes which is implicit in working with a gender perspective;

- methods of research, monitoring, and evaluation which are designed for use in the field — such as participatory rural appraisal (PRA) — which themselves draw on feminist research methods, can be appropriated and adapted for use in gender training;

- gender training may be carried out in the context of current work, or may focus on a specific issue; it may often be a catalyst for other forms of training or education.

Conclusion

To sum up, the working culture within Oxfam UK/I is in need of reform, starting by challenging a culture of overwork and instability, which discriminates against women and men during the years in which they have primary responsibility for caring for a family, and against everyone who wishes to have a role in their community. People who have their personal options curtailed by their employer are also limited in their ability to approach their development work with a well-rounded view of life. To have added so-called flexible ways of working, which undermine equal opportunities, onto an existing culture of strain and overwork, would have meant that Oxfam UK/I ran the risk of violating the principles of the gender policy, as well as the organisational commitment to capacity-building and staff development. Consequently, the emphasis in human resource management throughout the organisation is firmly on career development and retaining staff.

Ernst Ligteringen called for investment in training to change the culture of Oxfam UK/I from within, 'changing the management culture, making a positive investment in training, focused on women, … to enhance women's capacity and women's experience in management'. His use of the concept of investment is significant because it signals a long-term and strategic view, that envisages a process of consensual change rather than change by decree, and an acknowledgement that this is change for the better.

9

Working with partners

The introduction of gender as a category of analysis, as a political tool, makes the strengthening of women's groups even more necessary ... In the experience of many women, some projects have taken 'gender' as an element of their work without actually changing what they do, as a mere modern cover with old contents, thus reinforcing ancient social roles ... Working with women, through women's organisations, requires a new perspective on gender — often work with women is developed, but there is no empowerment; and this can be a perpetuation of traditional activities that neither empower them nor provide them with changes in their own lives.

Betania Avila (SOS-CORPO, Brazil)

Penny Plowman (Oxfam UK/I, South Africa) said that, early in 1994, the South Africa Rural Women's Movement was undecided if 'it should continue to work with women's groups or enter the mainstream by beginning to work with mixed organisations'. Many funding agencies, including Oxfam UK/I, are coming from the other direction; having in the past worked with mixed organisations, many of which reflect the conventional power structures within their culture by being headed by men, Oxfam is now examining the alternative strategy of increasing work with women's organisations which have an agenda for change.

This chapter explores the role of a gender policy in encouraging organisations to think hard about their choice of partners, and ways of working. It goes on to consider how Oxfam UK/I is looking beyond its traditional role of funding agency; in recent years, in a search for new ways of working, it has encouraged participation through planning, joint North-South advocacy, and capacity-building.

Choosing partners

In choosing development partners, funding agencies have three options: to work with organisations that are gender-blind and view development programmes as a neutral intervention; to work with groups that are gender-aware and want their projects to take on the particular needs of women; or to work with groups that have the political goal of transforming gender relations.[1]

Defining women's organisations

The term 'women's organisation' covers a variety of groups. Many conventional women's organisations, founded with the aim of increasing the welfare of their members through practical means such as cookery or small-scale income-generation projects, take an uncritical approach to the existing development model. At the other end of the spectrum, explicitly 'feminist' organisations tend to begin with a critique of society and of development, and set out to challenge conventional structures. Speaking from her experience of Oxfam UK/I's work with NGOs in several countries, Eugenia Piza-López (Gender Team, Oxfam UK/I) is convinced that 'the cutting edge of the critique of … patriarchal societies … is coming from organised women's groups. Whether it is a critical analysis of religious practices or a critical analysis of development models, I believe it is there where … a consensus [can be built in which] we can move together. We must identify how we work with women's organisations because they have told us that they don't only want funding, they want a relationship of constructive dialogue.'

A great deal of discussion at the WLP Conference, and many recommendations, focused on the need for more resources for women — in the form of funding and non-financial resources — to be channelled through women's organisations who have a feminist agenda of women's empowerment. Betania Avila asserts that women's groups which have an empowerment goal need to develop, not only to create employment, but also to become 'critical subjects towards other projects'. One key concern raised by the working group was that, at Field Office level, explicitly feminist organisations were rejected in favour of organisations which promote the practical welfare of women without addressing the underlying causes of their need for support.

If Oxfam UK/I fails to see the links between feminist issues and development, and restricts its work to conventional women's organisations which lack an empowerment perspective, and mixed NGOs that are not gender-aware, it will miss crucial development

opportunities. It is all too easy for NGO partners to avoid the real challenge of gender analysis by introducing purely nominal changes. Faizun Zackariya (Oxfam UK/I in Sri Lanka), gave the example of several rehabilitation groups 'set up with no long-term vision, simply a short-term agenda to provide food, shelter and clothing — men were in charge. This pattern is prevalent. Then, foreign agencies like Oxfam UK/I go in and ask why these organisations have no female appointees, and so token women are duly appointed in order to secure funding, but they have no decision-making power.'

Working with women's organisations

The organisations that work with women and for women with an agenda of empowerment are currently underfunded, in comparison to traditional 'welfare' women's organisations, mixed-sex or male-dominated equivalents. Supporting organisations committed to women's empowerment will increase the resources devoted to helping women to acquire the knowledge, skills, and confidence to enable them to change mainstream development and their continuing subordination to men.

However, even if Oxfam UK/I decides to prioritise work with women's organisations, feminist or not, it must also be aware that, not only are there differences among these organisations, but in some areas there is no women's movement with which to work. Although this may make the work more difficult, it does not represent an absolute barrier. For example, Galuh Wandita (Oxfam UK/I, Indonesia) believes that in countries such as Indonesia, where there is almost no popular movement, 'Oxfam can play a role to "jump start" ... to help programmes develop a feminist perspective. This is a long, "non-productive" process working with women and women's organisations. It includes trips abroad so they can visit feminist and women's organisations.'

Sonia Vásquez (Oxfam UK/I, Caribbean) explained that although women's organisations are not evenly spread in the Caribbean region, Oxfam UK/I can and does develop good working relations where this is possible: 'in Haiti, women's organisations are few, but elsewhere in the region [the proportion of women's organisations to mixed or men-only organisations] can be as high as 50 per cent ... and in some places we have improved relations with feminist organisations.' Elsi Bravo (Oxfam UK/I, Peru) reported 'we have found that women organising against the economic crisis have been the most dynamic. In cities, funding is 60 per cent for women's organisations. But in the rural areas it is only 50 per cent, because here Oxfam UK/I works mainly with NGOs run by men'.

Oxfam UK/I can also use its contacts to create linkages between different interest groups. Rina Roy (Oxfam UK/I, Bangladesh) said that, in Bangladesh, Oxfam UK/I works 'mainly in rural areas where there are women's organisations, whereas feminist organisations tend to be in the cities, although they are now trying to go to the rural grassroots. Oxfam UK/I in Bangladesh relates mainly to the grassroots, but also to women's trade unions, and now in preparation for Beijing, to feminist organisations.'

Oxfam UK/I does not have a specific policy of supporting such links, but some field offices have built up a working relationship with both women's and feminist organisations, and are creating alliances between them. On the whole, Oxfam UK/I prefers to work with larger and established NGOs, which already have a base, an infrastructure, and local contacts, for logistical reasons; whereas many women's and feminist organisations are small. There might also be legal problems in helping small groups; for example in India a group must be registered with the government before it can receive funds. Political barriers also exist. Rajamma Gomathy (Oxfam UK/I, India) said she 'would like to work more with feminist organisations, but Indian feminists see Oxfam UK/I as a foreign agency and now even I am [seen as] an outsider, although I have been an active feminist for over ten years'.

Ultimately, as Elsi Bravo said, Oxfam UK/I's programme should allow its partners the freedom to determine their own priorities, among them the 'different demands by women in different countries. They need to have opportunities for support where they are, even as abused women or within the issue of the "disappeared".'[2] Funding agencies have to decide how they will work with women's organisations to provide this support.

Working with men

There is still a great deal more work to be done by Oxfam UK/I, its partners, and other funding agencies, to develop new ways of working with men's and mixed organisations, both to further an empowerment agenda for women and to ensure male acceptance of this through working with men. Alda Facio (ILANUD, Costa Rica) expressed a concern that the responsibility for gender work seems to have been put solely on women: 'The introduction of gender is very important [for development work] but not so that only women need to be present.'

Male resistance – from a raised fist in the privacy of the home, to legal suppression of women's rights at national level – means that many women worldwide pay a heavy price for their attempts to achieve self-

determination. Working with men is essential if women's empowerment is to succeed as a sustainable option. Sara Longwe (Longwe Clarke and Associates, Zambia) reminded the Conference that 'radical women who take a front line on political issues make themselves vulnerable. This is where the transparency with policies is very important, because if you are going to get women involved then you will have to think of personal and professional risks as well, because you are making these women vulnerable.' The long-term view taken by Esther Tegre (Oxfam UK/I, Burkina Faso)is that 'if no change occurs in men, any gains by women can be only cosmetic'.

Raising women's consciousness of their right to lead their lives free from the fear of domestic violence may actually aggravate the immediate dangers facing the women; if an abused woman makes the decision to fight back, she may ultimately need both medical and legal assistance to realise a life free from violence. As Sara Longwe said, 'if you have a policy which moves your people, and moves you into radicalism, you must also plan support.'

Organisational solutions for work with men

Sonia Vásquez gave a specific example of Oxfam UK/I working with existing organisations in the Caribbean region, where Oxfam UK/I has 'a programme to encourage mixed organisations to look at gender. We got feminist organisations to facilitate this by providing the mixed NGOs with analytical tools, a questionnaire based on concrete issues. We think there is a need for an integrated strategy, a need for training for institution building of women's organisations using feminist organisa-tions, and a need for supporting women's organisations relating to mixed.' Rina Roy added to this, '... and also to give training to men'.

Some mixed NGOs have created a small programme for women, within their overall programme of work. This usually isolates women and inhibits discussions of issues of gender and development within the organisation. Such a split also creates difficulties for Oxfam UK/I, as the two sections of the NGO often think along very different lines, although it is administered as one. The confusion holds back real progress. One working group participant advised that to assist the process 'alliances must be built between like-minded groups to engage with male structures. Women must not allow themselves to get onto a sub-committee on the sidelines.'

Working on gender with men brings issues of identity to the fore. There are constraints on field office staff who undertake gender work as it is often viewed as a 'soft option' or 'something to do with women' —

and undervalued in field offices. According to Penny Plowman's experience in South Africa, a typical male attitude is: 'We understand this problem of gender but this is the women's problem, they must pull up their socks and work hard on it.' A demonstrated commitment to gender-awareness training for all field staff, and additional resources for field staff working on gender issues, would help to raise the perceived value of this work.

Gender training should also be carried out by men and for men; not only towards an explicit goal of gender equity through focusing on women's subordination, but also with the object of exploring issues of male gender identity, which affect many social classes and groups of men adversely. In some cases, participants at the Conference thought that training methods that 'show mixed groups the difference between men's and women's lives' would make gender relevant to whole communities; 'where possible, it is better to work with a mixed group'. They felt that responsibility for enacting gender-sensitive work should be shared between women and men Field Officers, and men should be integrated into the Gender Team at head office.

Problems may arise when men take up the cause of women without understanding that they themselves must change, in their analysis and in their actions. For example, Penny Plowman spoke of 'educated men in South Africa, often returned exiles, [who] have adopted the jargon of gender-sensitivity, and are now speaking on behalf of women at conferences and other public fora. Although both groups think they are speaking the same language, this is where the similarity ends. Male and female understandings of gender are completely different.' Gender may also be taken up as a fad, to further reputations and careers. Penny Plowman gave the example of a rural women's organisation that went on a march to lobby for a water project, which was successful; 'but men, who the women had asked for technical assistance, took all the credit'.

Transparency and support

In order to ensure that there is real change and not just a shift in terminology which disguises the same old 'top-down' development style, funding agencies must recognise that new opportunities, created by more dynamic ways of working, also bring new responsibilities. As Helen O'Connell (One World Action, UK) stated: 'If we are serious about participation, and if we, as donor agencies, want to assist in some way, then we need to take on board the need to be a lot more honest and transparent about how we make our decisions. If we don't want to fund women's organisations, we should say why not — let's have an open

discussion about it so that we all know what we are talking about.'

Hilary Coulby (Oxfam UK/I, Philippines) asked for greater transparency between Oxfam UK/I and its project partners: 'greater transparency with women's organisations … is going to be necessary, and we are going to have to work out exactly how to do this. … [women's organisations at the WLP Conference] have demanded consistency in terms of minimum standards for funding criteria and guidelines'. However, there are obstacles in the way. In Hilary Coulby's view, this is 'because there is a very uneven way in which gender work is implemented on the ground and in programmes, which is very much to do with people's personal interests, whether they are men or women, and whether they are interested in gender issues at all … We have not established those guidelines and criteria in any serious way.'

According to Ernst Ligteringen (Asia Area Director, Oxfam UK/I), 'if we want to work with our counterparts [in linking, advocacy, and capacity building] we will have to achieve much greater levels of transparency, clear on what we are trying to achieve and clear on what project partners are trying to achieve. We will have to come to negotiated, jointly-understood, objectives. In this sense I think it is very important that we are absolutely clear on our Gender Policy. We have it, it is also in our organisational strategic plan, [working on] gender [issues] is not negotiable. Let that be clear in our dialogue with our project partners.'

However heartening this may sound for the many who have worked long and hard to place gender issues on the agenda of international funding agencies, there remains an issue to be resolved: if Oxfam UK/I will not fund projects or organisations unless they work within the framework of a policy on gender and development, what happens to existing programmes which do not integrate a gender perspective?

Ernst Ligteringen pointed out that field officers working with project partners will have to make some very hard decisions about whether to stop funding the work if it does not conform to Oxfam's Gender Policy. Cutting off funding is an extreme measure, and if Oxfam UK/I is really committed to developing a relationship with its partner organisations based on what Ernst Ligteringen described as 'negotiated, jointly-understood objectives', partners in the South will need to understand why a gender perspective is now seen as an essential pre-condition for funding, and how policy decisions are made in funding agencies.

Field officers are known to potential partner organisations, and thus, an organisational decision on funding criteria has a personal dimension. Ernst Ligteringen pointed out that 'that is where the hard side of the choices come. And that is, for each manager at each level, where you know it is going to hurt if you cut [funding].' The report of the Southern Women's Organisations working group took a similar view: 'Changes

are difficult … but we think that if there really is a will, and if there really is a possibility for the creation of spaces where other voices can be taken into account, we have to follow things through; and perhaps we must not be afraid to bring about drastic changes when they prove necessary.'

This last point was echoed by Dianna Melrose (Policy Director, Oxfam UK/I), who stated that some currently-funded work cannot be given a gender perspective because it is 'fundamentally against women's strategic interests'. In her view, this is the work that we should 'say we are going to stop funding'.

To take the example of how one field office deals with gender-blind proposals, Oxfam UK/I South Africa now sends back applications with no gender policy or which lack a 50 per cent female staffing. But this system would not work in areas where there is little gender sensitivity.

It is counter-productive for a funding body to impose conditionality which may harm the very women whom they wish to help, therefore central management should also recognise the need for flexibility in the regions, and the Gender Policy should acknowledge this need. Joyce Umbima (FEMNET, Kenya) acknowledged the support of Oxfam UK/I to women's organisations, particularly in Africa, but she also wants the organisation to 'recognise the fact that we are not all at the same level of understanding of gender issues and gender concerns. So, as you take the hard line of making sure that you slaughter those projects that are gender-blind, take into consideration the people that they are helping, their level of understanding, and where they are. Cutting support to any project should be with a human face.'

In making this appeal, Joyce Umbima touched on a principle of the gender analysis of development: development is a process that should enable people and communities to develop their capacity to decide the direction their lives will take. The point of a gender and development policy is not just to fund women's projects and organisations; ultimately it involves all of society in a process of change.

Women's organisations at the WLP Conference were critical of unwillingness on the part of funding agencies to take measures when programme activities go against the guidelines set up for gender-sensitive development. Hilary Coulby pointed out that while 'you are also saying that the funding agency should be lobbied where these are violated, … that of course requires a very particular type of organisation. We will need to be much more open, and to set up a process which will ensure that you have the information to lobby us with.'

Integrating gender into existing work

Work on gender issues is still seen by some as competing with other activities, rather than as an essential component of all development work, and as a key to making all interventions more efficient in reaching the poorest of the poor. This view was expressed by Ernst Ligteringen, who told the Conference that 'if we want to invest more in gender-related work, we will have to find, at all the different levels where we hold budgets, what we will do less of'.

Responding to this implication that 'gender' is somehow separate from the rest of 'development', Alda Facio countered that 'it is not a matter of "either we do emergency work or we do gender work". We can do emergency work from a gender perspective. We can distribute food with a gender-sensitive methodology ... I am worried that you said "doing less of something", because that starts making us compete for resources.' This view was enthusiastically endorsed by other participants. Speaking 'from a management perspective in the field', Rebecca Buell (Oxfam UK/I, Central America) said that she wanted to support what Alda Facio had said: 'There is often a lot of confusion about what it means to integrate gender into development practice ... We need to integrate a gender analysis into all the work, the result of which is a firm institutional commitment to affirmative action for women in funding, in hiring, and in involvement in international fora at all levels.'

However, for gender-specific concerns, for example work to combat violence against women as a barrier to development and a human rights abuse, there may, as Ernst Ligteringen suggested, be competing priorities. Rebecca Buell referred to the problem of priority-setting in a competitive environment, and gave the example of her own office, 'where we are in the process of setting priorities for the next year, and where gender work will be seen as one of several initiatives within Oxfam UK/I. We have a whole series of new initiatives ... concerned with basic rights, sustainable development, and a number of management issues. I would make a very strong request to the managers who are going back to Oxfam House, ... that participation and the definition of those initiatives comes from a gender perspective, and that there is an affirmative action requirement for the inclusion of women ... in those processes throughout.'

The working group on policy implementation also concluded that there was a sense that funds available for work on women's gender concerns are smaller than for other issues, such as environment. In the short term, what does a regional manager do if commitments are already made but there is an onus to begin work from a gender perspective? Where will funding come from for more work specifically with women,

and more support, such as training, for field staff? These are some of the practical tensions that management and field staff have to face together. Mariam Dem (Oxfam UK/I, Senegal) asked if, 'given that resources are already defined and ear-marked, for a particular period, ... what other resources can be made available for the extra work that will have to be carried out? Budgets are already agreed, and priorities are already set, so have management planned for other resources, other possibilities to seek resources, for the gender work that has to be done?'

Choosing a suitable pace of change

Drawing on their own experience, Oxfam staff at the Conference identified the need for specific procedures, but they agreed that Oxfam UK/I should support regionally-appropriate strategies for implementation because gender relations and strategic needs differ across regions. Cultural and religious constraints on work with women are a major factor in some areas. Such barriers to communication with women are not insurmountable, but it takes time to overcome them. Yameema Mitha (Oxfam UK/I Pakistan) described the way she and her husband work in partnership in a conservative rural area: 'We work through the established and accepted cultural system. That is, through the men first. Once my husband has a good relationship with village men, I also begin to work with them. Then, after the men have met me, we can ask to meet the men's wives.'

With care and diplomacy such tactics are routes to working with women successfully, even where they live in seclusion. But how can this slow, painstaking work, which relies upon relationships of trust with people who may oppose the principles on which Oxfam's gender policy is founded, be reconciled with a demand by partners for more openness on the part of funding agencies about their policies? A sound and workable gender policy provides the foundation for radical practice at every level. The policy cannot be implemented without a very clear understanding between funders and partners about the consequences of a gender analysis.

Communicating with the grassroots

Once having raised the issue of gender, a development agency must support field officers and deal with their needs. Gender is not a concept that should be introduced without back-up. Gender is, as Kanchan Sinha (Oxfam UK/I, India) said, 'a social issue'. It must be dealt with in every

aspect of life. Facilitating linking and an exchange of information and learning materials is a valuable service to small, under-funded organisations, for whom the cost of postage is a real barrier to communications.

Responding to the Latin America regional report, which identified the need to share materials on a regional basis, Alda Facio pointed out that while 'it is important that materials are shared between Oxfam UK/I offices, partners and women's organisations, ... this assumes that postage costs could be absorbed in operational budgets. It is sometimes very difficult for women's organisations to carry out systematic mailings, especially to remote places, so maybe a lot of Latin American documents could be channelled from Oxfam UK/I offices. Those centres that have been systematically collecting literature for several years should be involved in this.' Other regions could operate similar information exchange systems, if direct costs such as postage and copying were covered.

How do funding agencies listen to the grassroots? It is frequently said that women's roles in society are 'invisible'. Although the lack of value given to women's work as carers causes much of this 'invisibility', the way in which funding agencies relate to their projects compounds the problem. As Eugenia Piza-López said in the plenary on communications, women 'do have a very active and visible role but they don't have visibility in the structures that determine the location of resources'. Nor, apparently, do they have visibility in the minds of the people who organise field visits. If they are not looked for, they will not be seen.

Nynoshca Fecunda (De Beuk, the Netherlands) reminded the Conference that 'sometimes we arrive thinking that the local people are not articulate. Also, the timing of our visits ... is not well thought out, so we are always in a hurry and do not have time to take up [ideas and information] from the community. As a result, we only meet the community half-way. ... That is why, most of the time, [funding agencies] miss the women. Sometimes, if you are a woman you are invisible, so a mouthpiece rather than the women's voice is heard.'

Even where women are clearly visible, communication can be hampered by a lack of appropriate skills and information. Lajana Manandhar (Oxfam UK/I, Nepal) said that in Nepal, Oxfam UK/I was not able 'to support as many women's organisations as we would like, because of a lack of information and communication on skills development in the grassroots where there are autonomous women's organisations (such as mothers' groups) who have raised their own money'. This is a case where Oxfam UK/I could provide non-funding support by being a channel for communications.

The existence of departments — in academic institutions and development agencies — which specialise in gender issues is helpful in

providing a resource for women's development organisations, and a forum for learning and research. Funding is needed to run such departments, whose very existence may be precarious. The report from the Global Meeting of Southern Women's Organisations requested that 'funding agencies ... put at the disposal of their gender and development departments funds that will allow them to support networking and solidarity work, co-ordination of research, and exchanges of information and survey findings'.

In their work, specialist gender departments should emphasise the importance of facilitating the formation of South-South relationships. In this respect, the report from the Global Meeting of Southern Women's Organisations also stated that 'Oxfam UK/I can do a lot more, and can do it better. ... We were saddened to observe that it is only through a meeting such as this that we are able to find out what is happening, that we are able to have these exchanges. Other than this meeting, there are practically no other possibilities for us to do so. ... We believe that we must go much further in this direction.'

Other non-funding support was requested by the Southern women's organisations who urged Oxfam UK/I to translate its resources to serve non-English-speaking communities: 'given the problems related to communication and involvement of the people, consider having the documents related to projects written in the local and regional languages, and ensure that general policy and orientation documents are translated into those languages, so as to make them accessible to NGOs and local communities. We ask for the translation costs involved to be funded.' Without such services, the people with the most to gain from communication will continue to be the least able to communicate.

Training and education for empowerment

Gender training is a means of raising women's and men's consciousness of the way in which gender identity affects every aspect of people's lives. In a world of gender-based discrimination, consciousness-raising is a prerequisite for gender-fair practice and for policy development. Gender training provides the conceptual tools needed to effect the change in power relations that is its ultimate purpose. Because gender training covers such a wide spectrum of development work, from planning to implementation at the grassroots, it must be designed to address the particular needs, knowledge, and perspectives of participants in the training.[3]

Regional approaches to gender training were reviewed at the Conference. In some areas, Oxfam networks have already developed as an

information exchange on training and other gender and development issues. Action for Gender Relations in Asia (AGRA) began as a single network and now has two branches, in South Asia and South-East Asia. Training tends to take place within the context of a specific theme, such as conflict.

Gender training with partners

In some regions, for example Mali, partner NGOs have little or no knowledge of gender analysis as a development approach, and although field officers are committed to promoting gender issues, they lack knowledge of training techniques. The problem is further compounded by the fact that much training is still initiated in the North.

This practice distorts the reality of Southern women's resistance to gender oppression; although the terms used by development agencies may come from the North, the concept of discrimination against women is known across cultures. Participants at the Conference pointed out how essential it is to recognise that, although the basis of discrimination against women is the same throughout the world, the characteristics vary. There is a need to understand the particular contexts in which development agencies work on gender issues, and tailor policies and training accordingly.

In support of these points, Rosalinda Namises (National Education Legal Assistance Centre, Namibia) spoke of her own experience: 'When we in the South first heard about gender, it was not introduced from our side. It was introduced from the North, and we were called to come to the North to study. And after studying we went back and did gender training. We encountered a lot of problems; there were a lot of questions that we couldn't answer. For instance, there was the whole question of custom, culture, and tradition, and how to deal with those in terms of the new concept of gender. And there we were: we were stuck, how should we answer?'

The irony of this is that an underlying aim of gender-awareness is to strengthen women's ability to direct their own work and lives, and not to accept unquestioningly what is handed to them. Gender-awareness training cannot rely on universal models; it needs to be orientated to specific conditions. As Rosalinda Namises observed: 'For me, it was clear that if we had defined gender in our own context, we would have been better able to answer the questions. And only after some time now, after we have been faced with different questions, different experiences, and different exposures, we are now able a little to answer those questions. But I think more needs to be done.'

Other forms of training for women's empowerment

In addition to gender training, development funders, partner NGOs, and women's organisations can all benefit from other kinds of training devised to assist women and men to overcome socially-derived barriers to effective communication, and participation in public life. Gender-awareness training for both women and men, and training for women's personal development, should go hand-in-hand. Training in assertiveness, public speaking, languages, and negotiating skills are invaluable for individuals in communicating their views and needs in settings where they lack confidence.

The Southern Women's Meeting in Thailand stated that 'it is important that the training of women, particularly in the field of project-making techniques, fund-raising and negotiation, be given much greater consideration as far as funding is concerned. We also believe that women's involvement in making decisions which affect them must not just be mentioned on paper, but must be translated effectively in practice; this also ensures that local skills are used for setting up curricula and training.' For all staff, work on equal opportunities policies is a necessary accompaniment to training on gender issues.

Sonia Vásquez emphasised the value of bringing in a new perspective: 'We discussed training in Oxfam UK/I with feminist organisations and contracted one to do it, and we have worked with others ... to inform our work. We do not have the old prejudices that feminist organisations are only theoretical. They are helpful in planning and design. Similar work has taken place elsewhere; for instance, in Latin America, Oxfam UK/I has found that, by working with women's organisations, staff can be educated and informed on women's issues, and in South Asia both women's and feminist organisations were used to develop staff perspectives. In the Caribbean, many feminists have begun to work with the grassroots, with mutually beneficial results.

Oxfam UK/I support for capacity building and leadership still tends to be through mixed organisations, partly because there are more of them, and partly because of existing contacts. This can present problems in trying to work with women with a strategy for gender equality. For example, Sonia Vásquez explained that 'in Haiti our team say they do not work with women because they do not have appropriate women's organisations. But they have been running leadership training for peasant organisations, with the result that more men are in leadership roles, although many women are members. This is due to the structure of training which takes place away from home in two-week blocks.' Such arrangements discriminate against working women, and in their place we 'need training that privileges women. Space should be provided for

small women's organisations, where there are not strong organisations to provide facilities for training.'

Non-funding support for the women's movement

Taking on a gender policy obliges development practitioners to find alternative ways of working with partner NGOs. Continuing to rely on conventional methods that have been used for decades of working with and through men, will mean that women, having different demands, will miss out on opportunities and be pushed back even further.

During the WLP Conference non-funding support was mentioned as a way Oxfam UK/I could support new autonomous organisations. Non-funding support such as training and facilitating links requires time and skills. Whether it is administered directly by funding agencies, consultants, or through partner NGOs, this valuable way of working needs to be investigated further. Joyce Umbima said: 'We must identify how we work with [women's organisations] because they have said they don't only want funding … We both want a relationship of constructive dialogue.' An example of this 'constructive dialogue' is the work of the Dutch non-governmental funding agency, Novib, which brought together representatives of feminist networks that it supports, to develop indicators for evaluation of projects.

Culture — song, drama, and dance — is often seen as a peripheral aspect of development, yet it provides considerable scope and opportunity to promote gender-awareness among project partners. Popular materials should be developed for use with project partners, through co-operation between the Gender Team and appropriate field offices.

In mixed organisations, large and small, men often carry authority by virtue of their social status rather than any inherent or acquired ability. Women, whose upbringing may discourage them from challenging male authority, find this assumption of gender and class superiority difficult to deal with. Mariam Dem identifies this as one reason why consciousness-raising for women on gender and other related issues, such as class, caste, and disability, is so important: 'We women want to be active in change, and I think that nothing will change unless we women change from within.'

Although formal education can contain positive messages about gender equity, generally this is not the case in either North or South. Melka Eisa Ali (Oxfam UK/I) pointed out that 'education is very important, … especially for illiterate women to learn to read and write. But … in many countries the instruments that NGOs are using to teach

women and young children to read are those that reinforce patriarchal values. And when we have studied these and said "look, these are reinforcing the idea that the women is subservient", they say "oh but this is reality, we can't use literacy programmes to change reality".'

Having recognised the drawbacks of education which is biased towards maintaining, not challenging, gender relations, it must be stressed that education can in itself be a stepping-stone to empowerment and development. The WLP Declaration from Southern Women's Organisations recognises this, and demands 'funding for formal and non-formal education for girls and women, and training to enable better analysis of their own needs'.

Output-oriented development

Used in isolation, output-oriented management goals, expressed in terms of project delivery, inhibit development based on a longer-term process of learning and empowerment. Without denying the need for accountability and efficient use of resources, questions are being raised about the application of these criteria to the exclusion of others. According to Sara Longwe: 'We should not ask ourselves what is incorrect about the technical perspective, but rather what is missing from it; we should not seek to contradict the explanations it provides, but rather look for the gender problems which it cannot explain.'[4]

Sara Longwe explored the attitude of many Northern governmental development agencies: 'their language is technical, technical in the sense that they say they are dealing with pure development, they are not dealing with "issues". They think their stand is non-ideological, and neutral. They are only interested in bringing resources so that we can "develop". They go further by adopting frameworks or strategies which will deal with welfare issues, and with "efficiency". To some extent, they think that our underdevelopment is due to a lack of resources, to not using our resources effectively and efficiently; and therefore women, since they do most of the work, are not using the resources properly... This line is still being followed in spite of many volumes of research which show otherwise.'

For the poorest, meeting day-to-day needs is a priority, and projects which seek to satisfy these immediate material needs can also be part of a strategy to move beyond them. This is already the goal of many development projects. Unfortunately, the time allocated to achieve success is generally far too short. As Juliana Kadzinga, of the Danish development agency MS, observed at the WLP conference: 'funding agencies do not realise that a long process has to be gone through in leading up to a specific

project. The time needed before a project even starts might be three times as long as is currently allocated for the project itself. No wonder so many collapse.' Her account of the work of MS in Zimbabwe described some typical drawbacks inherent in project funding. Funding needs to be radically re-structured, and support a process which starts with planning together with project partners, well before the project commences, so that a shared commitment to the work is generated through the process of building a shared development agenda.

Making the micro-macro links

Despite the existence of an established, and growing, body of research on methods of data collection, monitoring, and evaluation which are driven by the 'beneficiaries' of development themselves, information continues to flow much more easily from North to South, from academics to practitioners, and from policy-makers to field offices and partner organisations. Feeding information and analysis from Southern perspectives into the structures of Northern funding agencies should be seen as part of the process of development. In this way, good and bad practice can be explored and lessons learnt. The benefits of this process are two-fold; on the one hand, people on the receiving end of funding for development are empowered to assess their activities, criticise aspects of the project which may be misconceived, and have their views heard by the funder. On the other hand, this bottom-up process should add to the body of knowledge and expertise held by the organisation and improve the quality of the programme.

In this process, the approach for funders should be to facilitate communications rather than to intervene. The role for Oxfam UK/I in projects like the WLP and the South-South Environment Linking Project is that of agent, creating an environment in which links between development partners at all levels within a specific issue area can be formed.

This non-interventionist, modest role is significant for organisations which work on gender issues, since the value of empirical knowledge and the need to listen to the voices of women are central tenets of feminist research practice. Listening to the views and needs of women's organisa-tions with an empowerment agenda is, thus, an essential part of effective implementation of a gender and development policy.

Women's organisations can link up with feminist organisations, and with other social movements. A challenge of this style of working is to turn tensions between these groups into a creative dialogue. Initiating links between different sorts of women's organisations is also a means of

bringing grassroots concerns into decision-making areas of a funding agency, and to share information and analyses of development.

Alliances among organisations can generate a strong new movement for a particular cause. Morena Herrera (Mujeres por la Dignidad y la Vida) said that in Latin America, where traditional social movements have been weakened, 'there is a wide-reaching women's movement, of which feminism is one aspect. The international women's movement, the feminist movement, have come together to analyse the region's economic crisis. They have found the diversity of this to be enriching and creative.' A major focus for the Latin American movement is the need to find a response to structural adjustment policies, at local, national, and regional levels. In so doing, 'grassroots women's organisations are moving away from seeing themselves in a welfare assistance role and more as a movement forging new global policies and strategies'.

Women's organisations are often disregarded for taking an overly parochial view, and for not addressing 'high-level' issues. A common prejudice is that women are poor candidates for activity which involves linking with others to form broad-based coalitions; they tend to lead over-committed lives, and may be restricted by culture or circumstance from travelling or participating in public life. However, women manage to overcome these restrictions; many coalitions, networks, and alliances between organisations have been very successful. Organisations representing civil movements, including women's organisations, have been able to lobby international gatherings, forming caucuses around particular issues, and have hosted parallel NGO gatherings which are a stimulus to the formal meetings from which grassroots groups may be excluded.

With very few resources, collectively, women's organisations have been active on a broad range of economic and social issues, and this experience has a developmental element. For example, Betania Avila said that in Latin America, 'the regional, national, and international practice of these organisations has made it possible to integrate women into international contexts which have traditionally been the sphere in which men alone participated'.

Working with organisations and coalitions offers enormous potential for moving local concerns outward and upward to other levels of decision-making. For example, it is never easy to raise a new idea or a contentious issue when it is likely to be, or feared to be, met with scepticism or hostility. A joint presentation which demonstrates wide support, is likely to be more convincing. The parties to the alliance have an opportunity to work through their position, to be better prepared, and to learn from each other.

Women's organisations, particularly from the grassroots, need such strategies of coalition-building if their point of view is to be influential. In

practice, however, few organisations can afford to do this preparatory work in addition to the work they are funded to do (if they are funded at all). Individuals in small organisations, unused to the politics of agenda-setting and coalition-building, may lack the skills to carry out such preparation.

But who pays for this unaccounted time? In the past, Oxfam UK/I staff have not had sufficient time allocated for this non-funding support, nor has it been written into their objectives. Oxfam UK/I is now putting resources into strengthening Southern advocacy — through communications officers, through funding a new Southern Advocacy post in the organisation's Policy Department, and through requiring field officers to give time and resources to advocacy as a central activity.

As discussed earlier, the project-oriented accounting structure of development funding agencies is not very sympathetic to deviations from narrow project objectives. A well-written report, good statistics, and a project that is up-and-running, are impressive. This is understandable, as within the system they are the only real measure of the funds having been well spent. However, if 'scaling-up' were to be written into project plans this would become part of the reporting process. Scaling-up is an aspect of institution-building and strengthening capacity, which are measurable, as they include consultation, planning, research and analysis, and skills training, and therefore fundable.

Ideas and information need to be channelled from the grassroots to other levels, and back again. The grassroots cannot be expected to maintain those channels of communication on their own, and higher-level decision-makers need to have thorough knowledge of grassroots conditions and perspectives. This principle applies nationally, as well as to North-South relations between funder and partner. In speaking of the importance of learning from each other, Sara Longwe said that 'NGOs may be mainly from the élite but we need these linkages between the rural and the urban, the 'ordinary' woman and the so-called élite woman. We have to open each other's eyes to … gender-awareness from our own perspectives.' In this light, there is a legitimate role for organisations which have a commitment, and resources, to act as intermediaries in this process.

Linking and networking

Linking between stakeholders in development in the North and South, is a method of working which is increasingly being adopted by Northern NGOs in an attempt to break through communication barriers. Women's organisations are agents for change, and their capacity is enhanced by

links with like-minded organisations, both feminist and mainstream, regionally and globally. Links need not be permanent, and they need not be all-encompassing. They can be part of a short-term strategy to reach a particular goal, or a long-term strategy for information exchange.

For Oxfam UK/I, the funding of two linking projects — the Women's Linking Project and the South-South Environment Linking Project — signalled the start of a way of working that remains in general untried by the large Northern development NGOs. However, for many smaller NGOs working on gender issues in the North and South, North-South linking has long been an important way of developing policy, and for building international solidarity. South-South linking, unmediated and uncensored by Northern funders or by head office, is also an essential means of capacity building in the South. Funding is needed to facilitate such networking.

Similarly, funding support for project partners' participation in international fora is essential to bring a strong and representative Southern voice to meetings that are generally dominated by the North and by governments. Yet such support must be more than the price of a round trip ticket. International fora take place, more often than not, after a continuous chain of smaller preparatory meetings. Attendance at all the meetings in the process is necessary if participants are to influence the outcome. Support also needs to be provided for the time and resources for study, and to discuss issues locally in advance, so as to be able to contribute with knowledge and authority at the larger regional and international meetings.

Constraints on new ways of working

In developing the new ways of working described above, Northern development NGOs are trying not only to increase efficacy, but also to achieve clarity on the way funding policy is determined, and resources are allocated. But changing ways of working takes time. The frustration of this process was acknowledged by Ernst Ligteringen: 'Oxfam UK/I is a large organisation. We work in over 70 countries, and if we want to change our ways of working please appreciate that this will take some time.'

Time is not the only constraint. In the field, many development practitioners would like to work in more innovative ways; however, if they are to be enabled to do so, standard project planning and accounting practice must become more flexible. These are not easy adjustments to make. From a practical perspective, the funding agency itself may be restricted by conditions imposed by its source of funding. In addition,

demands made on funding agencies are increasing every year, and their income cannot keep pace. If a process-oriented, long-term development initiative is slow to show results, there may be considerable pressure from funders to discontinue it, or to change the terms of reference. Such difficulties are a symptom of the very complex system of funding and co-funding into which most of the major Northern funding NGOs, large and small, are linked.

For most funding NGOs, simply opting out of the system means cutting back on projects funded by major sources such as government. Few would be willing to cut themselves off from sources of sorely-needed funding, in the absence of a viable alternative. The process of questioning the assumptions underlying conventional, short-term, project-focused development practice, is itself a lengthy one. New development goals are needed, and new methods for monitoring and evaluation, so that results are not measured merely in terms of quantity — of chickens raised or baskets woven. More flexible approaches to development work are not necessarily less exacting than output-oriented models, but they require evaluation criteria which measure quality and sustainability.

10

Power and partnership

Gender inequality is the subject of a strong North-South patriarchal alliance. Here, the problem is to break this existing bond, and to replace it with a North-South sisterhood of alliance to pursue objectives of gender equality.
Sara Hlupekile Longwe, 'Breaking the patriarchal alliance: governments, bilaterals and NGOs', *Focus on Gender* 2:3, October 1994

At the WLP conference many Southern women expressed frustration at the lack of progress made by development funding agencies — governmental and non-governmental — in creating a climate of change for women. Sara Longwe has said that the powerful and influential governmental agencies in particular have ignored gender issues, and have ignored human rights.

Together, women in the South and North are having to confront what, in her keynote address at the Conference, Sara Longwe described as a 'global patriarchal bond':[1] a shared understanding among men of their superior place in society, and a tacit commitment to maintaining this state of affairs. At the Conference, women spoke about the many levels on which discrimination against women exists; the unjust power of the state, of society and culture, of husbands and brothers, and of male colleagues, as a barrier to the personal, social, political, and economic development of women. They also criticised the unequal power relationship inherent in the funding of development activities, between funder and recipient. Questions of power between funders and recipients are often avoided by funding agencies, and by many recipient NGOs, who would prefer a peaceful, unchallenging, funding relationship.

Realising women's power

Although there is a great deal spoken and written about the common bonds between women — sometimes at the cost of recognising the differences between them — most have not moved en masse beyond a negative awareness of the fact that *women lack power* in a patriarchal world. Only a few groups of women have yet moved from an understanding of gender relations and a common experience of subordination, to *an assertion of shared power which sets out to challenge the situation*. As Mini Bedi (Community Aid Abroad Australia, India) stated at the Conference, 'wherever women have shown strength, we never say, "this woman was strong"; we say, "the man was weak". This is very depressing.'

Recognising our strength and inner resources begins with personal development. Women's organisations that recognise and build on women's sense of their individual strengths can provide a conduit to channel these strengths to community-wide development. The role of such organisations was frequently discussed throughout the WLP conference. Neelam Gohre (Stree Aadhar Kendra, India), reported for the Southern Women's Organisations working group that 'the women's movements of South and North play an important part in women registering all forms of discrimination in the struggle for survival and in strengthening women's power. We have been able to challenge the established definitions of power because the women's movement has asked a question about whether the personal is political.'

Support for women's movements is a first step in the process of changing the power structures in which women occupy the lower strata. Funding agencies that commit themselves to such support are contributing to the redefinition of norms for women's participation, a process that inevitably includes their own organisations.

Providing alternative power bases

Participants at the five Regional Meetings, which formed the second stage of the Women's Linking Project, called for the strengthening of women's organisations in the economy, and their capacity for analysis for action. They unanimously saw the need for building women's organisations as a counter to the existing power bases which oppress and exclude them, and as a prerequisite for women's full participation in development.

Throughout the WLP conference, participants testified to the fact that, despite the multitude of development programmes, reports, and

evaluations, there has been no significant improvement in the overall status of women. According to Neelam Gohre, the regional and global meetings all observed 'violence against women within the family and within society is increasing, religious fundamentalism and communal violence is entering mainstream politics and women are becoming more and more powerless, the number of women headed households is also increasing, ... and ... there has been no considerable change in the status of women'.

Representing the Africa region, Fatumata Sow (APAC, Senegal) read a statement from the Southern Women's Organisations, which said that funders should raise their support for women's organisations but they 'must express this increase in hard figures so that it can be monitored'. Moreover, funders should 'commit themselves to release most of, or at least a large part of, their funds to benefit women's organisations'. At the same time funders need to recognise that many of these organisations are still embryonic and may be organised differently from mainstream NGOs. Criteria for choosing partners that do not take this into account compound the inequalities and disadvantages.

The statement went on to make a number of specific requests of funding agencies, the first of which was 'to take into account the needs expressed by the women themselves, even if these needs do not necessarily correspond to the needs identified in the agencies' own agendas. We also urge these agencies to support innovative programmes and projects which are able to bring about significant and important changes in women's lives.'

This demand reminded participants of the earlier statement made by Neelam Gohre that 'in many countries people are ready to pay money, they are ready to give money to "charity", but not for women's rights. If somebody has an income-generation project, they want to use sewing machines but they don't want women to know about legal rights. So "funds" may be a label for certain issues, but funds are not a label for empowerment because in our own countries many people feel that if women become more aware, we will challenge religion, we will challenge family, we will challenge patriarchal relations, so they want to divert all the funds to "charity" and not to empowerment. Therefore, funding for the people's own agenda is also important.'

Although there are variations from region to region, and from community to community, the general trend is the same. By understanding the local in relation to the global, women can seek collective action for change. Nevertheless, there have been calls for support for a regional base in order to focus more clearly on specific conditions.

Strengthening Southern research capacity

In addition to working with women at the community level, development research and analysis also needs to be decentralised. In order to shift the development perspective away from the North, where institutions for development research and education are concentrated, support must be given to the South to build capacity for this work. Strong Southern institutions need well-qualified staff. Commenting on the need to restore dwindling post-graduate study grants for women, Colletah Chitsike of Oxfam in Zimbabwe said that 'this is not élitism; we are only asking for the same tools and training as you in the West have'. New gender and development frameworks are being developed in the South, to challenge the conventional welfare model of socio-economic development coming from the North.

The South Asia and Middle East Regional Meeting recommended a gender and development institute for Asia to give opportunity for women activists and academics, and to encourage permanent national as well as wider South-South networks. This meeting observed that 'many people are dominated by Western ideologies, and the women's movement may get isolated within our own countries if we do not think deeply through our own histories and through our own countries. Development of future leaders, bringing women up within women's and mixed organisations, through training and project management is also important.'

Support for regional education and research facilities for women would produce new models for development by enabling a region-specific gender analysis of development. As Neelam Gohre said, 'it is our duty, our priority, to have indicators for the empowerment of women and how it can be reflected within our work and within our projects. This will require evaluation of the specific situation of women in each country because although we are discussing on a global platform, country to country, region to region, there may be specificities of the issues which otherwise may be missed.'

In addition to contributing to cultural, political, and economic research, such institutes could undertake gender training and project management for development NGOs, and create opportunities for political participation by promoting inter-sectoral dialogue and debate involving women working at all levels of education, formal and non-formal. Regional institutes for gender and development could form a crucial element in a broad-based process of education and training for women to enable better analysis of their own needs.

Asserting power at international fora

Unlike the development establishment, which sees international fora as the pinnacle of activities within a given issue area, women's movements throughout the world see these events as merely one aspect of linking. International information exchange and policy debate are part of the strategy for strengthening women's organisations. International conferences have a valuable role within the context of an international organisation, such as Oxfam UK/I, or as a forum for discussing major issues such as reproductive rights or structural adjustment.

Such conferences can be alienating for individuals when participation is dominated by larger or more powerful groups. The link between personal experience and the global setting, and the importance of identity, was highlighted by Neelam Gohre: 'the development of the individual woman as a person, strengthening her skills potential and knowledge, her self-confidence, self-image, assertiveness, particularly in mixed groups, can be shared in a smaller group where we feel empowered. But ... when we came to the global conference, ... I sometimes felt disempowered ... we have to analyse which specific situations disempower women. To achieve all this, we recognise the need to develop our own frameworks, and promote existing models for analysis and not rely solely on Western models.'

Developing regional networks is a way of supporting and creating space for participation by smaller interest groups. Participants from every region acknowledged the value of such networks as a way of giving time and space for people to express themselves and to seek their own alliances within a shared context.

While large or global meetings are useful for sharing information or for consolidating a collective position, smaller fora at a local and regional level can help women from the same, or neighbouring, cultures to acquire confidence and self-esteem, both individually and collectively, and to develop an assertiveness which can be carried over into mixed groups, and larger and international meetings, or which can continue to be used with greater effect locally.

Redefining partnership

This notion of partnership between women — within countries and regions, and, at larger fora, between South and North — throws new light on the use of the term by Northern development NGOs. A gender analysis, concerned with power relations and change, provides a framework for questioning the work of development funding agencies

more deeply. It also suggests different ways of working between funders and their NGO partners.

The difficulty of finding an acceptable way of referring to the relationship of funder and recipient reflects the unease which characterises the power relations between the two. 'Recipient' sounds passive; 'beneficiary' even more so. However, moving to the terminology of 'partnership' is only a cosmetic change if the power relations between the 'partners' remains unexplored and fundamentally unequal. WLP conference participants questioned the very use of the term 'partner' to describe the relationship between a Northern funder and a recipient NGO in the South.

Juliana Kadzinga (MS, Zimbabwe), pointed out the fundamental imbalance in the relationship between a funder and a recipient of funds: 'We demand that our partners from the South be transparent with their policies, but they [are not able] to make demands on their 'partners' in the North ... this issue really needs to be followed up strongly ... How can we talk of 'partnerships' and 'power-sharing' when we don't allow partners from the South to get into our systems, and make us accountable for what we say?'

From time to time, funding agencies that work with NGO 'partners' re-examine the relationship, and their approach to development practice. The WLP Conference was, in some respects, an evaluation of Oxfam UK/I's work with gender and development; and Southern partners were involved in its planning from an early stage. Partners have a crucial role to play in evaluating the effectiveness of funders' policies and practice. If they are to do so, however, they need to know what it is they are evaluating, to understand what motivates a particular funding agency, and how it makes its decisions.

It is not disputed that Southern NGOs which receive funding must be accountable to their funders. Partners are not asking to run the funding agencies, but would simply like to know which policies are being implemented, which are not, why these choices have been made, and how they can contribute usefully to the policy-making process. Juliana Kadzinga also pointed out that there is an issue of reciprocity at stake; the communities in Zimbabwe with whom she works want to feel that they are able to observe the etiquette of their culture by giving something back to the Danish community which funds development activities. The political, legal, and cultural differences among countries of the North are not always apparent to partners or field staff in the South. Yet the political and legal framework is an important factor in formulating and implementing agency policy on many issues; and this framework reflects the culture of the country which guides policy in a particular direction. A lack of knowledge of these basic differences — between a

British and a Dutch funder, for example — and their implications for the agencies' work, can cause confusion and misunderstandings on the part of NGO partners, and also field staff.

A better understanding by Southern partners of Northern funding agencies would help to sharpen their criticism of development and give it a more potent focus. If Northern funding agencies are serious about 'partnership' and consultation, they have an obligation to contribute to a better understanding of their own ideological roots and operational structure, so that their partners and field staff appreciate the fundamental ethics behind the work — not just what the latest policy is.

Fatumata Sow (APAC, Senegal) told the WLP Conference that 'we believe that there are in fact unequal relationships that for us make talking about partnerships a little illusory. This partnership must be built, it must be designed and conceptualised, so that it is actually put into practice … it is important that funding organisations involve their NGO partners in the making, implementation and evaluation of projects and programmes through a participatory process'.

Challenging the 'patriarchal partnership'

In her keynote speech Sara Longwe spoke about the entrenched alliance of Northern and Southern men that has, in her view, ensured that official development assistance from the North has ignored gender issues and women's human rights.[2] 'This patriarchal resistance is not only in the executive air-conditioned board-rooms in the North. It is also in our own villages, as we have heard during this conference.'

Development organisations, in the North and the South, collude — openly or implicitly — to keep issues of gender off their agendas: 'bilateral agencies, the recipients of the so-called aid, the implementers of such aid, and the so-called target groups, are all busy constructing road-blocks for resisting gender issues as part of the developmental processes'. Where there are gender and development policies, 'these have been made under duress because of the pressure that comes from the North, where our sisters have at least a bit of access to the decision-makers'.

In general, Southern government departments and many NGOs 'are in an alliance with the North, and they are not interested in [gender], so we end up with projects that just scratch the surface through welfare'. To perform this limited work, very meagre resources are spread too thinly. Sara Longwe told the Conference of the 'roadblocks' established by the alliance of Southern and Northern governments and organisations. Neither side is willing to put conditionality on assuring resources for

'gender issues, and for bringing about the just world we here are dreaming of. However, they are willing to put conditionality on … plural politics, and on drugs. They won't give you any more money because you are involved in drug trafficking, but they will not put an embargo on regimes that carry out violence against women.'

NGOs as catalysts for change

Sara Longwe believes NGOs have the potential to be catalysts for action to break this patriarchal bond, beginning with action in the North. 'With the NGOs as the first catalyst in the North, we can rely on alliances. It is because they have some autonomy [that] they are able to put into practice some of their radicalness, some of their gender awareness. It is also because they have access to policy-makers, and to other bilateral agencies.' Official development aid, which has been so steadfastly gender-blind, is tax-payers' money; Northern advocates could apply pressure for better use of these funds. Women in the North have spoken out, Sara Longwe acknowledges, 'and have won some of those battles to reduce gender disparities'.

However, Sara Longwe also asserted that women in the South also have 'some sort of relative autonomy' by the very fact of their lack of funding; in this light, their marginalisation by male-dominated government and organisational structures gives them freedom to think and act creatively, and to form new alliances outside the conventional fora. In Sara Longwe's view, a strength of women's organisations in the South is to 'work very closely with the grassroots, both in the urban and in the rural areas'. Thus, a chain of alliances stretches between women, from the few involved in national decision-making in North and South, to those working in Northern NGOs which advocate women's empowerment, to Southern women's organisations, to the grassroots.

Building alliances across barriers of identity

To counter the effects of tacit alliances within established power structures, which seek to maintain the status quo, women must themselves form alliances at all levels. As Sara Longwe put it, 'we can adopt all sorts of strategies: to accept, to collude, or to have a focused challenge, built on alliances, to the patriarchal bond with the aim of empowerment. There are ways of linking with North and South …. What we need is to be very concrete and at the same time very broad based. … Basically, the patriarchal bond is both in the North and in the South and

it is about ignoring gender issues; that is why it is so strong.'

The process of building trust between women, and forging strong alliances, calls for openness with each other, recognising shared goals and refusing to be divided by the differences which inevitably exist: differences based on factors such as ethnicity, class, and disability. In a world where there is fierce competition over limited resources, we must try to think strategically about how those resources can best reach those who need them most.

Women in the North have already made considerable legal, social, and material advances for themselves. A small number of women in the North have also contributed to gains by women in the South by helping to push women's issues onto the development agenda. More recently, there has been a reaction among Southern women to the Northern-dominated theory and practice of development, and women's studies. Southern women have asserted not only their personal experience of the issues, but also their strong analysis which has historically been marginalised by academia.

Too often, practice and theory are seen as separate from each other; however, many practitioners are often theorists, and vice versa. Theory and practice cannot exist in isolation from the other. Organisations, publications, and information networks, which provide opportunities to share Southern experience and analysis of the development 'industry' from a gender perspective, are necessary if development agencies are to learn lessons from existing work and research and improve their analysis and practice.

One of the most important factors in advancing the gender and development debate in the North has been the presence of a small number of Southern women activists based in the North. Generally excluded from consultation, and resisting use as 'tokens' of the South, some have formed autonomous organisations to try to influence the policies and practice of development organisations. They have a special role to play in building alliances between the South and the North, and between women's organisations on specific issues. They are able to combine their knowledge and perspectives of the South with an understanding of how the decision-making system in the North works, to produce an original critique.

Ending the North-South divide

Alliances and networks in the North and South have greater relevance now than ever before, in the era of globalisation of the economy, the post-colonial imposition of Western-style representative democratic systems

upon the South, and the spread of North Atlantic cultural mores through the global media. Oxfam's Women's Linking Project was a path breaking initiative by a large funding NGO to create direct links between women's organisations and campaigns in the North and the South in a way that was also meant to change policies in the North. According to the Southern women's organisations working group: 'Lobbying work on gender-awareness, policy-making — both at macro and micro levels — is a fundamental aspect, given that the changes expected in the South must also take place in the North; because if these changes do not occur in both hemispheres, there cannot be any major changes or notable improvement for women.'

The 'feminisation of poverty' is taking place in both the South and the North, and links between women's labour in different parts of the world have never been so direct. Privatisation of public services, on which women depend so heavily and which employ so many women, is central to the policies of conservative governments in the North and South, and of the multilateral financial institutions, which determine the economic policies of indebted countries of the South.

The globalisation of production has drawn many women into paid but insecure employment. More women are working for a wage now than ever before; yet employment is often short-term or seasonal, unregulated, and in unsafe conditions, paid at piece-work rates rather than by regular salary; and collective action through trade unions is often banned.

These changes in patterns of employment are taking place simultaneously in the South and the North. Women in different countries and regions are effectively competing against each other for work, often for the same transnational employer, who can move to where production is most profitable. In some industries, women in different parts of the world are part of the same production process: manufacturing components in three or four countries, assembling them in another, selling the final product in another. This chain links women as workers and as consumers, as it divides them through regional competition for business.

Although Northern NGOs have had some success in raising radical development issues — such as challenges to the policies of the World Bank and the IMF — with the general public, and in official fora, few of them have chosen to align themselves directly with what the women's movement in the South is saying about these issues. One notable exception is WIDE (Network, Women in Development Europe) which works in alliance with women's organisations in the North and the South.

One WLP Conference participant made the request that: 'Oxfam UK/I policy department should work with women on research and lobbying on Structural Adjustment Programmes (SAPs) and use existing African alternatives, as well as support women's initiatives … They must

look at countries that are not at present implementing SAPs, and give them information so that they can prepare once SAPs come to their countries.' This kind of joint work, using the resources of the North to support the experience of the South, and analysis from both North and South, is vitally important.

The Conference was concerned about the interaction between Northern funders, their NGO partners in the South, and women's organisations. As well as looking at how these work together for policy implementation in the field, there was also an interest in how these three actors in development could use their respective knowledge, analysis, and communication skills to long-term effect. For example, campaigning in the North for a change in the Northern and international economic policies that are harmful to the South, tends to be kept separate from mainstream development activities in the South. The working group on Women's Economic Rights felt strongly that 'there is great potential in the next two years for the three actors to work together. There is the fiftieth anniversary of the Bretton Woods institutions, there is the Social Summit, there is Beijing 1995, the Fourth UN Women's Conference — women's economic rights are central to all three of those debates ... The resources and the lobbying skills of the international funding agencies, the micro-level experience of the field officers and the local NGOs, and the feminist analysis of the women's organisations could combine into a powerful lobby for change.'

In the view of Devaki Jain, a feminist activist, development economist, and founder of the DAWN network, consumers must assert their power, and fulfil their moral obligation, to lobby for fair conditions of employment and pay for producers.[3] The vast quantity of Southern-produced goods that are marketed in the North makes this lobbying a global issue, which demands an awareness of the history of colonial and post-colonial economic exploitation of the South. Devaki Jain points out how women in the North have the capacity to organise politically to challenge the policies and activities of powerful Northern governments, institutions, and TNCs that are responsible for these worsening conditions in the South as well as in the North.

Conference participants emphasised that research in the North and the South should be complementary, and should emphasise the interdependence of the economics of individuals, communities, nations and regions. Northern-based NGOs have a responsibility to educate people in the North to feel effective and long-term solidarity with the South, which goes beyond making charitable donations. For 20 years Oxfam UK/I has been involved in carrying out research for public education, liaison with trade unions, and lobbying of government.

Devaki Jain's work puts a challenge to women to face up to the fact

that, despite the talk of a worldwide agenda, there is more division than unity: 'we are so fragmented, and so self-conscious about plunging into any commitment, so territorial, and most of all, so suspicious of each other'. If women united globally to demand better conditions from the corporations which pit them against each other, solidarity could achieve what competition cannot. Differences must be recognised, but not allowed to become barriers to working on the basis of similarities. 'If Northern and Southern women understood their similar experience of economic injustice as two friends, we could really resist it.' This is not to deny relative power within the world economy, but rather to recognise its existence and to work in partnership to challenge and change it.

Women's organisations in the North have co-operated to put pressure on decision-making bodies. Oxfam UK/I has conveyed their views in representations to the government through the National Alliance of Women's Organisations' Gender and Development Network, and also through EUROSTEP (European Solidarity Towards the Equal Participation of People).[4] In May 1993, a workshop was held to develop common strategies for integrating gender-fair policies and practice into the programmes of EUROSTEP member agencies, within their own organisations, and in their work with women in poor communities of the South. Oxfam UK/I published a report of this workshop[5] for a wider readership.

These actions are slowly influencing the policies of NGOs such as Oxfam UK/I, and government departments responsible for development assistance. Some have given only quiet support to these initiatives but gradually more agencies are changing their perspective.

Five challenges

Five challenges were issued by the working group of Southern women's organisations, to international NGOs, to stimulate the construction of stronger alliances between women:

• To determine or set a higher quota for women's organisations and women's activities, projects and also [gender-aware] work with mixed groups.

• To compile information on international, national and regional policies that affect women. Our voicelessness sometimes arises because we are not aware of the policies of our own governments, or of funding agencies; they may only tell us a fraction of their agenda. So, we would like you to be the source of this information so we can independently get information on which policies have been agreed.

- To recognise that women's organisations should be able to monitor the projects of international NGOs, with the aim of stimulating cross-regional learning about development approaches in particular contexts.

- To resource women's organisations to implement strategies by building up their organisational structures.

- To be accountable regarding policies such as Oxfam UK/I's Gender Policy.

On this last point, one participant asserted: 'Funding agencies must demonstrate [through] their assistance that they are committed to [such policies], and their projects must demonstrate their willingness to break the patriarchal bond. When they analyse … discriminatory practices or laws, they should not say, 'oh, no, we are not going to touch this one'. We would like those gender policies to be comprehensive, to take into account all gender relations that affect women's empowerment. You cannot give power, you cannot empower somebody — one has to empower oneself; that is what you have to facilitate … we would like to see the funder NGOs facilitate this empowerment of women in their programmes.'

Southern women are asking for the mechanisms to monitor 'what they are doing in our region or country, we can set this against the meaning of this policy, and see if there is a contradiction. If there is a contradiction, that is the chance to tell them that "your intentions are good, but your actions are contrary". … That would be one way in which the funding agencies can be made accountable.'

Speaking as an Oxfam UK/I field officer in the South, Mariam Dem (Oxfam UK/I, Senegal) added to this that she 'would just like women in the South to have, within the recommendations [Southern women have made], a commitment to work together with Oxfam UK/I's field offices. I think that it would be a pity if, after this Conference, each one of us was to go back to their own programmes and own concerns. So I think it is very important for women's organisations represented here to return to their countries and to be able to work closely with field offices. Not only in terms of how they can benefit from Oxfam UK/I, but also in terms of what they can bring to Oxfam UK/I.'

Mariam Dem echoed Sara Longwe's view that 'it is important that we have common structures, which are flexible, which can be informal, so as to ensure the monitoring of the recommendations which will be issued at the end of this conference. [So] all women's organisations from the South represented here and all of Oxfam UK/I's field offices should be able to find a space to see how far the recommendations are put into practice and how to ensure that they are.'

11

Conclusion

Gender means doing things differently.
 Candida March (Women's Linking Project, Oxfam UK/I)

Among development funding agencies, international work continues all
too often to have a North-North or a North-South flow. The WLP
Conference continued the South-South and South-North direction of the
Women's Linking Project. As links develop within the women's
movement — South-South and South-North — new priorities will
emerge and new demands will be made on the organisations which fund
development in the South. Southern NGOs and field offices will begin to
relate differently, to each other, and to head office. This change in
relations, in combination with a gender analysis of development, has the
potential to change funding agencies in profound ways.

 Eugenia Piza-López (Gender Team, Oxfam UK/I) told the WLP
Conference: 'This is a ... revolutionary process. There is a need to look at
things we can do now, and things we have to move to progressively ...
our sisters from Southern organisations help us through this, in changing
an organisation which works in such extremely different countries,
cultures, languages, and working styles — all with different assump-
tions and different perspectives of what is gender.'

 The WLP conference addressed a number of specific issues: economic
rights, health and reproductive rights, social and political participation,
environment and sustainable development, and violence. All of these
were analysed in terms of eliminating oppressive relationships,
exploring how each issue is affected by the gender identity of women
and men, and how this gender identity is cross-cut by other factors which
determine position in society, including class, age, ethnicity, and
disability. Development initiatives which take these issues into account
will not only stand a better chance of giving practical help to people who

are most needy, but may also change the marginalised status of groups who experience discrimination against them. In this way, development can be seen not only as a matter of socio-economics but as a way to maximise human potential.

At the Conference, Oxfam UK/I was asked to co-operate with other NGOs and with other funding agencies, regionally and at international level. This raised questions about linkages, in terms of communication, co-operation, and transparency. Small organisations, including many women's organisations, are frequently entrapped in a mesh of competing demands by the different funders with whom they have dealings. A call for greater transparency in the relationship between funders and recipients is a challenge for development interventions at all levels and in all regions.

The Conference asked a great deal of Oxfam UK/I, but none of the requests was more important than to continue lobbying and advocacy in the North, in order to address structural injustice in economic and political relations. This is fundamental to forging deep and long-lasting change. Advocacy depends on the formation and maintenance of effective networks, through many different methods of communication, to ensure that information and analysis can be shared and debated. Active networks — South-South and South-North — are a vital component in implementing gender-fair development, and challenge the conventional North-South flow of information. Such networks form part of a strategy for capacity building in Southern women's organisations; a strong and united women's movement is essential if the locus of analysis and decision-making is to move from the North to the South.

That Oxfam UK/I remains committed to its gender and development policy, and is considering the full implications of this policy for both its programme work and its relations with staff within Oxfam UK/I and its partner organisations, was reaffirmed by Oxfam UK/I managers attending the Conference. There was general consensus that working with a gender perspective means a new way of working, emphasising solidarity, iterative learning, and transparency between headquarters, field offices, partner NGOs, and Southern women's organisations. The spirit of the commitment needed to put policy into practice was captured by Ernst Ligteringen's phrase: 'gender is not negotiable', applied to project partners as well as to Oxfam UK/I.

Important points were made about staffing and recruitment criteria, and conditions of employment in Oxfam UK/I. Positive action — making sure that more women move up into management positions — is important, but there is also a need to recruit gender-sensitive people, train staff to be gender sensitive, and provide support for those working in difficult areas. In short, time-honoured bureaucratic working culture

must change, and new market-driven personnel policies should not be taken on unquestioningly in the meantime. In particular, the move towards insecure and short-term employment should be profoundly questioned in the light of Oxfam's commitment to equal opportunities and the organisational Gender Policy. Participants at the WLP Conference asked Oxfam UK/I to bring the gender dimension into its organisation in a number of ways: to work through its own management structure to put its gender intent into action within the organisation, and to make sure that gender specialists, such as Oxfam UK/I's Gender Team have the resources to continue their work.

Guidelines are needed for working with colleagues and partners who are antagonistic towards the idea of changing gender relations to support the empowerment of women, or who think that these issues are not their concern or responsibility. Another way of working is needed to provide support for those who are enthusiastic about the principles of gender equity, but who need help in determining how to go about it in development activities. New ways of planning, monitoring, and evaluating gender and development work must be used to allow funders, and the Southern organisations with whom they work, to assess the effects of development interventions, in specific national conditions and culture. Overall, there is a need to build new development practice based on better and more open communications between the field staff and head office so that each understands the perspectives, constraints, and strengths of the other.

Oxfam UK/I staff in the regions are looking to the Gender Team for support in implementing the policy. The Gender Team has a key role in relating to other organisations, relationships which can also help the team in developing its work further and thereby developing the work of the whole organisation. It is also a resource and a focal point for Oxfam UK/I staff and partner organisations, while the organisational gender policy is being implemented by line managers. Assistance and advice can be sought from the Gender Team during the implementation process, and materials and information can be collected and distributed to forge an iterative process of learning. The future capacity and direction of the Gender Team will be determined by the level of support it has within Oxfam UK/I, which is a question of choices and priorities for the organisation. The Gender Team must also set its own priorities and strategies for its work within the organisation and beyond, drawing in as well as challenging the gender-sceptics.

Regional reports

Three reports from regional working groups were presented at the close of the conference. Their aim was to offer ideas, and recommenda-tions for action by Oxfam UK/I head office, within the context of the regions. While the reports were united on main issues, it is clear that a gender and development analysis does not follow a set formula. To be effective in helping to create the conditions for development, a gender perspective should shape many aspects of work: sharing information, research, analysis, the development of methodologies to turn analysis into action, and new procedures and criteria for evaluation.

There were recommendations for lobbying in the direction of the World Bank and IMF. The Africa meeting urged non-governmental funding agencies to work with 'African women on research and lobbying on structural adjustment programmes. They should also build on alternatives proposed by Africans and to support lobbying, information and awareness-raising initiatives by African women on this issue.' The report stressed Africa's need for education, training and capacity building, but it also recommended an audit of Oxfam's work on gender in Africa within three years.

All the groups called for support for women's organisations and feminist organisations in developing Oxfam UK/I's work. The Asia and Middle East meeting reiterated its 'intention to make Oxfam UK/I in Asia and in the Middle East more transparent to women's and feminist organisations, and Oxfam UK/I partners, and the need to institutionalise — whether by using existing structures or by exploring new ones — the links with women's organisations in order to further the gender issues raised in this conference'.

A number of specific points regarding such links were raised, particularly concerning international fora, which need to be informed by the perspectives of the women's movement on economic policy and the development of democracy. However, as the Latin American Report emphasised, while international fora such as the Social Development Summit and the UN Conference on Women are significant events, they should be seen as stages in a continuous process. Opportunities offered by the events themselves can only be taken full advantage of if there is adequate preparation and follow-up. The Latin American report pointed out that 'it is important that, in every country, support is given to initiatives in which women's organisations formulate proposals to go to [fora such as] Beijing. At the same time, there is a need to build mechanisms through which those same women can monitor the implementation of these policies by governments. In other words, there must be a pre- and post-Beijing vision.' In the absence of this kind of understanding of

international events, there is a risk that the impetus to development will be side-tracked by the same major international events which are supposed to hasten it. Participants were aware that there are still many occasions when women are unrepresented in international fora. The WLP Conference itself was a case in point; it was noted with regret that, not every country, region or interest group was represented there. There are similar gaps within the regions in which Oxfam UK/I works.

Women's movements in all regions are pushing against the boundaries of conventional definitions of development, and are setting political priorities in terms of the immediate and strategic interests of communities in their locality. More work on forging regional perspectives was called for at the WLP Conference, and the likelihood of tensions and differences within regions was recognised. Profound changes such as those discussed at the WLP Conference will not work unless the organisation's staff understand them fully, and are able to share in the strategy for their implementation. Oxfam UK/I works through NGOs, a practice which brings limitations as well as benefits. Their integrity, as well as current funding agreements, must be respected. Oxfam UK/I is a large organisation and management does not rely on top-down decision-making, instead respecting the knowledge and expertise of field officers, and relying on their commitment to the aims of the organisation. Consistent minimum criteria for funding, which are sensitive to different contexts, guidelines for working with different kinds of organisations, and effective methods of monitoring and evaluation are needed. Procedures are needed when implementation fails or is blocked, and budgetary constraints — in terms of absolute funds available and in the funders's ability to allocate them — were mentioned by a number of speakers from head office and the field.

Although statements from management and staff were reassuring, there was still a sense of impatience among some participants, perhaps based on a fear that, after the Conference ended, all the good intentions would be forgotten. Participants wanted to be sure that their efforts were not wasted, that management was listening, and that changes would be made. How soon is it possible to expect changes? Eugenia Piza-López believes that although Oxfam UK/I 'is patriarchal in its roots and in its style, it is not unable to change'.

Nevertheless, this process of change is ambitious. As Eugenia Piza-López pointed out, a realistic assessment is needed of what can be done now and how progressive change can occur, since Oxfam UK/I is 'an organisation which works in many countries with extremely different cultures, languages and working styles, and with different assumptions of what gender is ... [this requires] not only an allocation of resources, but also a capacity to understand how best to change an organisation.'

Endnotes

1 Introduction

1 There are numerous sources of information and inspiration on this subject, in particular see: Macdonald, Mandy (Ed) (1994) *Gender Planning in Development Agencies: Meeting the Challenge*. Oxfam Publications.

2 'Women to Women: Worldwide Linking for Development', Oxfam Publicity, Dimza Pityana, 1992.

3 Culture, one of the original five issues, came to be seen as a special issue, cross-cutting all others, therefore a commitment was made to ensure it was addressed in all discussions at the WLP Conference. This paper, 'Thinking about 'culture': some programme pointers', by Seble Dawit and Abena PA Busia, was published in Oxfam's journal, *Gender and Development*, Vol 3 Issue 1, 1995.

4 From interviews with the visitors, a book, *Dedicated Lives*, was published giving their personal accounts of work with women at the grassroots.

5 The Declaration from Southern Women's Organisations is included in this book as an Appendix.

6 Maria Suarez Toro, one of the conference facilitators, has written a full explanation of the conference methodology and its progress, including comments from the evaluation. See: `Treading New Paths' in *Focus on Gender*, Vol 2, No 3, 1994.

7 ibid

2 Issues and perspectives

1 Longwe, Sara Hlupekile (1994) 'Breaking the patriarchal alliance' in *Focus on Gender* Vol2, No3, October 1994.

2 For a discussion of working with men on gender issues, see: White, Sarah, 'Making men an issue: gender planning for 'the other half'' in Macdonald, Mandy (Ed) (1994) *Gender Planning in Development Agencies: Meeting the Challenge.* Oxfam Publications.

3 Women Linking for Change, International Gender and Development Conference, Thailand: 26 February — 2 March 1994. Internal Briefing for all Staff.

3 Health and reproductive rights

1 EUROSTEP Position Paper on Population and Development, 1994

4 Women's socio-political rights

1 Healey, J and Robinson, M (1992) *Democracy, Governance and Economic Policy: Sub-Saharan Africa in Comparative Perspective*, London, ODI Development Policy Studies. See also Sparkhill, K (1994) 'Good governance from the perspective of the Overseas Development Administration', in *Good Governance: Report of a One World Action Seminar,* London, One World Action. pp48-50.

2 Steiner H J "Political Participation as a Human Right" in (1) 1988 *Harvard Human Rights Yearbook*, 77 at 85.

3 See Verba S and Nie N H, *Participation in America: Political Democracy and Social Equality*, Harper and Row, New York 1972.

4 Dr Dilys Hill, *Human Rights and Participatory Development*, The Commonwealth Secretariat, London 1989.

5 Fourth Edition, Oxford University Press, 1989.

6 Schuler and Kadirgamar-Rajasingham (ed) *Legal Literacy: A Tool for Women's Empowerment*, UNIFEM, 1992 at 13.

7 Dr Dilys Hill, *supra*, at 8.

8 Gaidzanwa R and Maramba P (ed), United Nations Convention on the Elimination of All Forms of Discrimination Against Women: a Zimbabwean Draft Report, UNICEF and Ministry of Women's Affairs, Harare, 1993 at 19.

9 Ministry of Women in Development, *Recommendation by the women of Uganda to the Constitutional Commission*, Kampala 1991 at 2.

10 African Charter for Popular Participation in Development and

Transformation, Arusha, Tanzania, 1990 at 17.

11 By 1987, the Covenant had been ratified by the Central African Republic, Congo, Egypt, Gabon, Gambia, Guinea, Kenya, Liberia, Libya, Madagascar, Mali, Morocco, Niger, Rwanda, Senegal, Sudan, Togo, Tunisia, Tanzania, Zaire and Zambia.

12 Distinction as to race, colour, sex, language, religion, political or other opinion, national or social origin, property, birth or other status.

13 Article 13.

14 Law is used in its widest sense. It includes the substantive and procedural rules of law (including customary law) and the institutions which enforce the law and their practices.

15 Martin D M and Hashi F O, 'Law as an institutional barrier to the economic empowerment of women', Working Paper 2, Poverty and Social Policy Division, The World Bank, 1992 at 21.

16 Butegwa F, 'Women's legal right of access to agricultural resources in Africa: a preliminary inquiry' *Realizing the rights of women in development processes*, Third World Legal Studies 1991 at 45.

17 See, for example, Wariara Mbugua, 'Women's Employment Patterns: Emerging Aspects of Economic Marginalization' in Mbeo and Ooko-Ombaka (ed) *Women and Law in Kenya*, Public Law Institute, Nairobi 1989 at 105-108.

18 16 (1992) ECHO, Association of African Women for Research and Development at 6.

19 Rosa Linda Martin 'Understanding Development and Women's Situation' *Issues in Women and Development*, Asian and Pacific Development Centre 1990 at 3.

5 Violence against women

1 Longwe, Sara Hlupekile (1994) Breaking the Patriarchal Bond in North-South Development Cooperation. Paper for the Women's Linking Project International Conference, Bangkok. 26 February — 2 March 1994.

2 Article 1, UN Declaration on the Elimination of Violence Against Women, December 1993.

3 Preamble, UN Declaration on the Elimination of Violence Against Women. December 1993.

6 Women's economic rights

1 Ashworth, Georgina (1993) *Changing the Discourse: a guide to Women & Human Rights*. Change Publications, London.
2 Women's Linking Project, Asia Regional Meeting, 25-30 October 1993, Jakarta, Final Report, p7.
3 Structural adjustment programmes are also referred to as economic structural adjustment programmes (ESAPs).
4 Women's Linking Project, Latin America/Caribbean Region Meeting, January 9-13 1994, Final Report, p4.
5 The implications of WTO and other changes to world trade are discussed in Joekes S and Weston A, *Women and the New Trade Agenda*, 1994, UNIFEM:New York
6 Longwe, Sara Hlupekile (1994) 'Breaking the patriarchal alliance: governments, bilaterals, and NGOs', in *Focus on Gender*, Vol2 No3, October 1994.
7 Women's Linking Project, Africa Regional Meeting, 8-12 November 1993, Harare, p10.
8 Nilofer, Shaheen (1994) Case Study: Sanagra Bikash Parishad, Income Generation Programme and Empowerment of Women, GADU, Oxfam.
9 Women's Linking Project, Asia Regional Meeting, 25-30 October 1993, Jakarta, Final Report, p14.
10 Nilofer, Shaheen (1994) Case Study: Sanagra Bikash Parishad, Income Generation Programme and Empowerment of Women, GADU, Oxfam.
11 Women's Linking Project, Africa Regional Meeting, 8-12 November 1993, Harare, p10.
12 Special industrial zones set up to make or process goods only for export.

7 Environment and sustainable development

1 Shiva, Vandana (Ed) (1994) *Close to Home*. Earthscan, London. p3-4.
2 World Commission on Environment and Development (1987) *Our Common Future*. Oxford University Press. p8
3 Siaddin Sardar et.al. (1993),*The Blinded Eye*, The Other India Press, Goa
4 Teresa Turner and M.O.Oshare(1993), 'Gender Relations and Resource Development: Women, Petroleum and Ecology in Nigeria', International Development Studies,PDS,St.Mary's University, Halifax, Nova Scotia Working Paper No.93.1

5 Penny Newman(1993),'Killing Legally with Toxic Waste' in V.Shiva cd. *Close to Home* Earthscan

8 Looking within: gender and working culture

1 Molyneux M `The Domestic Labour Debate' in *New Left Review*, 1979

9 Working with partners

1 Longwe, Sara Hlupekile (1994) 'Breaking the patriarchal alliance: governments, bilaterals and NGOs', in *Focus on Gender*, Vol2 No3, October 1994.
2 In some countries, people who have been abducted and presumed killed by the military or para-military are referred to as the 'disappeared'. Many organisations, run mainly by women, campaign against this.
3 For a useful explanation of how gender training is carried out within Oxfam UK/I, please refer to: Walker, Bridget (1994) 'Staff development and gender training in Oxfam' in Macdonald, Mandy (Ed) *Gender Planning in Development Agencies: Meeting the Challenge.* Oxfam (UK and Ireland).
4 Longwe, Sara Hlupekile. Breaking the Patriarchal Bond in North-South Development Cooperation. Paper for the Women's Linking Project International Conference, Bangkok. 26 February — 2 March 1994.

10 Power and partnership

1 Longwe, Sara Hlupekile. Breaking the Patriarchal Bond in North-South Development Cooperation. Paper for the Women's Linking Project International Conference, 1994; *see also note 2 below*.
2 An edited version of this speech can be found in Longwe, Sara Hlupekile (1994) 'Breaking the patriarchal alliance: governments, bilaterals, and NGOs'. *Focus on Gender*, Vol2 No3, October 1994.
3 Jain, Devaki (1994) 'Building Alliances', *Focus on Gender*, Vol2 No3 October 1994.
4 EUROSTEP is a consortium of Northern European non-governmental development agencies, which has begun to consolidate its efforts in a number of key policy areas
5 Macdonald, Mandy (Ed) (1994) *Gender Planning in Development Agencies: Meeting the Challenge.* Oxfam Publications

Appendix 1: Review of Oxfam UK/I's practice in working with gender

Tina Wallace

(Note: this is an abridged and adapted version of a paper written by Tina Wallace for the WLP Conference. The original paper is available from the Gender Team.)

Introduction

This paper summarises the main points in the reviews of Oxfam's work on gender issues, undertaken in 30 Oxfam UK/I field offices as part of the Women's Linking Project. Almost half of Oxfam's field offices are covered, but are not a statistically representative sample, and the case studies were limited in scope. The WLP Conference provided a forum to discuss the wealth of detailed experience which could not be included in them.

Writing a summary of so many diverse papers is a major undertaking; field offices spent a lot of time and energy compiling overviews which were written in many different styles, and highlight very different aspects of the work. Much of the data in them is not comparable, nor do all reviews address similar issues.

The reports received, and consequently this paper, do not cover all areas of Oxfam's work on gender because some critical areas are missing; there are no reports, for example, from East, Central and Southern Africa, and from the Middle East. For the writing of this paper, additional information has also been taken from Oxfam UK/I papers cited in the reference list.

In a short paper it is difficult to do justice to the variety and scope of the work that each office is doing on gender; for those who want to learn more, the individual reviews are available from Oxfam head office. However, the intention is, by highlighting key themes and shared experiences and discussing some of the broad issues, to inform staff

about areas of Oxfam's practice and experience over the past five years, and raise issues to be confronted in future work on gender.

The variety of methods used to compile these reviews included team meetings, file review, literature surveys, employing external researchers, meetings and discussions with partners. A joint action research project was mounted in the Caribbean involving over 100 women's organisations in discussions, workshops and interviews. Significantly, none of the reports was written by one female staff member working in isolation, which might well have been the case three or four years ago. However, the responsibility for compiling and submitting the reports appears to have rested on the shoulders of women in the team in the majority of cases. Those offices which spent time analysing their relationship with partners said this was a good learning experience, with both Oxfam staff and partners learning from each other, and developing new ideas. This is a positive outcome in its own right.

1 The contexts in which Oxfam UK/I works

While the details of relations between women and men — in the division of labour, and access to power, resources and control — differ according to their context, women's subordination is a global phenomenon, and overall trends can be identified. There is current emphasis on inadequate legal recognition and protection of women's rights, and lack of access to and knowledge of the legal system, and growing control over women through use of discriminatory laws (both civil and religious/ traditional). As the economic situation in most countries, but not all, declines due to adverse terms of trade for primary commodities, structural adjustment policies, environmental degradation, conflict, war or famine, the situation of the poorest becomes more and more difficult.

The most obvious manifestations of this complex crisis that many offices have highlighted is the breakdown of family life; the worsening status of women; the rising number of women-headed households; the rising workloads for women and the reduction in their time to rest or participate in other activities; and the rise of violence against women. For several offices the lack of public recognition of women's workloads, the fact that their status does not improve as they take on more work, and the realities of growing violence against women are especially critical issues.

Another major problem faced by women and recognised by Oxfam UK/I's field office reports is mobility — lack of freedom for women to move around as they need to, and the different problems for women caused by increasing male and female out-migration in search of employment. In particular, many reviews noted that increased poverty

has led to the creation of increasing numbers of women-headed households due to male out-migration, family breakdown or conflict, and that these households are among the poorest because of their relative lack of access to labour, credit and land, or fora where decisions are taken. It has been estimated that the growth in women-headed households ranges from 15 per cent in some countries to well over 50 per cent of households in parts of Africa.

These current trends link and interact with the familiar issues concerning production, reproduction, access and control, which continue to face poor women. Country reviews cited:

- unequal and limited access to key resources — including knowledge from extension staff, credit, land, labour, technology and tools;
- employment in low-paid jobs, menial jobs or in the informal sector where returns are often limited because of lack of access to credit or markets, or unemployment;
- lack of recognition of women's roles in production and community work (they continue to be seen and treated only in their role as wives and mothers);
- lack of recognition of their heavy domestic workloads, often leading to women working several hours longer than men every day;
- limited or no access to decision making in the family, the community, the nation and international level;
- less access to education and health care than men;
- low status, subordinate to men in their households, and to laws which often favour men, and religions which accord them a subservient role;
- lack of control over many key resources;
- in the context of growing poverty, increasing violence against women, and sexual harassment for urban or employed women;
- growing hardship caused by the environmental decline in the availability of natural resources such as fuel wood, water, and animal fodder.

1.1 Omissions from country analyses

In the country reviews, there are some gender issues that are noticeably absent from the analyses. Only two or three offices mentioned the issue of rapid population growth, family planning policies, and approaches to women's reproductive health as critical issues affecting both government and male attitudes and behaviour towards women, and women's health and status. Secondly, the spread of AIDS as a key issue in development and its impact on women both as sufferers and carers is also largely absent in these papers. This would have not been the case if papers from East and Central Africa had been written, but the problem of AIDS is one which spreads across all geographical regions and is fastest

growing now in parts of Asia.

Most of the papers do not comment on the existence, or otherwise, of a strong women's movement, or the presence of women's networks in the country or region, or how women themselves are confronting gender inequality as an issue (Caribbean and Haiti are among the exceptions in discussing these issues). New government initiatives, such as those in India to include women in local and regional government, are barely mentioned, and where they are, as in the Philippines, they are seen only to affect urban women. The broad policy framework of governments, the impact of women in government, new initiatives taken by women's groups or movements to confront some of the negative issues outlined in these contexts are not discussed, possibly because the primary focus for many offices is on micro-projects.

Particularly in Asia, there is little recognition of the specific problems for women in conflict, and of women refugees, even though women make up the majority of refugee populations. There is also little analysis of how gender issues inter-relate with environmental issues, and gender and environment are dealt with separately. The gender issues arising from the predominant growth-oriented development approach (promoted by IMF, the World Bank and others) are also not addressed.

Finally, with very few exceptions, the reviews do not present gender-disaggregated statistics to back up their assertions. Oxfam UK/I should consider how these statistics could be gathered.

Many of these omissions were noticed and these issues — especially women's reproductive health and the need to liaise with existing women's organisations — were fully discussed subsequently at the WLP Conference, and highlighted as key areas for Oxfam's future work.

1.2 Oxfam UK/I's role and experience

The length of time since Oxfam UK/I field offices began to engage explicitly with gender issues ranges from one to ten years. For some Oxfam UK/I field offices, the need to address the problems of vulnerable women and to confront their inequality is clear and paramount. For others, concerns about interfering with the culture, or causing difficulties with partners remain serious blocks to addressing these issues.

Oxfam UK/I may work with women in some projects without necessarily addressing the issues of inequality. The constraints to working on gender issues are many. Partner organisations with whom Oxfam UK/I works, and staff within Oxfam UK/I field offices themselves, may share the values and perceptions of their culture, which keep women in a subordinate position, and may hold views that are incompatible with working to improve women's status. Often, beyond

the immediate problems, the overall context itself is hostile to transforming gender relations: repressive political regimes, weak NGOs, a strong role for the state in family affairs, and negative social attitudes. In most contexts, there is a lack of trained and skilled support staff or consultants for Oxfam UK/I staff to draw on to help them work through these issues; there are few available materials in local languages addressing gender issues which they can use, and few concrete case studies or examples to draw on; the work is slow and complex; and field office staff have many other priorities for their work, set both by themselves and by Oxfam head office.

In addition, as the India reports stressed, women partners often lack the confidence and self-perception to see new opportunities, many development planners and NGOs fail to recognise women household heads, gender is seen as a women's issue and not a mainstream issue, and men dominate the positions of leadership in most organisations.

1.3 Working at different levels

Whatever the problems, it is clear from these reviews that the majority of offices are trying to work at different levels and in a variety of ways to address the poverty faced by poor rural women; and in some cases — in Africa and Latin America — poor urban women. Some, such as the Caribbean office, have been involved with gender issues for as long as ten years, and were active in lobbying Oxfam to establish a Gender Unit in Oxford in the 1980s. Others are only now beginning to systematise their work in this area. Many offices reported that their interest and involvement in working with gender issues has grown significantly during the 1990s, spurred on sometimes by a country evaluation, by growing awareness of the issues, by encouragement from GADU, or in some countries by pressure from partners.

The aims of work on gender issues and with women[1] vary widely between offices, ranging from those who try to incorporate a gender perspective and approach in all their strategic aims for the programme (which are often framed as supporting sustainable development strategies which favour the poorest sectors of the population) to more specific aims around women and gender, for example, to increase women's access to resources, to enable women to meet their day-to-day needs in a context of subordination, growing poverty, worsening status and heavy workloads, and to strengthen women's productive and leadership skills.

2 Strategies used by Oxfam UK/I in work on gender

The field office reports show that change has taken place over the last five years in many offices; gender is now seen as a central issue for development. None of the offices who reported dispute the need to address women's as well as men's needs and interests in development, though how to do this remains problematic for several offices.

The work is slow; there are many problems, and the impact of work on gender remains to be assessed. However, offices have now accepted the centrality of women's needs, and many are attempting to work on gender issues — from a variety of starting points, and with different understandings of what exactly the key issues are.

However, the different types of projects listed by offices do not appear to address many of the major problems described in the country contexts, and show that, with some exciting exceptions, Oxfam UK/I's work on gender tends to be focused on standard projects for women. There are some areas where Oxfam UK/I appears surprisingly weak: there is little work on women's reproductive health, violence against women, and women's education, and, in terms of choice of partner organisations, there is little work with progressive women's groups.

Definitions of what constitutes work with a gender perspective were not consistent or clear. The fact that so many offices said that they do not apply a gender analysis to their mainstream projects, and within these projects much of the work with women is an 'add on' and does not affect the original gender-blind design of the projects, is a cause for concern. Several offices — in India, the Philippines, and Brazil — saw this as a major issue and intend to address it in the future. Only a few offices take a gender approach in all their work and assess the gender implications of every project, and work to ensure every project promotes women's interests; and a handful of offices work on issues they have identified as major problems for women, such as reproductive health, legal constraints, lack of access to land, rights after divorce, which involve work at both a local and broader regional/national level.

Information on the amount and nature of gender-focused work cannot be extracted from Oxfam UK/I's existing project application form (PASF). This lack of information makes it difficult to monitor spending on projects which address women's needs and subordination in women-only and mixed projects. In their reports, field staff were asked to make 'guestimates' of the costs of their gender and development work; the majority of the 15 offices which answered estimated that between 20 and 40 per cent of their money was spent on such projects. Three offices — Tokar, Senegal and Ahmedabad — gave a figure of 100 per cent, saying that they only support projects where there

is a strong gender awareness among partners or grassroots groups. At the other extreme, the Lebanon office stated that there were no gender aware partners yet and thus gave a nil figure; however, spending on women-only projects was 85 per cent, since the majority of partners work with women. For many offices, the amount of money spent on women-only projects is rising.

2.1 Practical and strategic needs

Oxfam UK/I's activities as represented in this report are not presented in terms of those that meet practical or strategic needs,[2] because categorising strategies requires knowing about the particular context and the content and impact of the work. It is often hard for outsiders to know which work will only tackle women's immediate and practical needs, and which work will, for example, fundamentally alter the gender relations of production in favour of women. In practice, the nature of the work that changes women's roles and access to decision-making varies greatly; in some contexts introducing women to paid work can radically alter their roles, status and confidence, in others projects addressing their income needs confirm women in their traditional roles and may only add to their work burden or marginally raise their incomes.

The lack of mechanisms to assess the impact of the projects makes it difficult for Oxfam UK/I staff to know how far these projects have improved the daily lives of women; how far they are challenging or changing women's status as subordinate; and to what degree such interventions increase women's access to resources or powers over decision making. It is also impossible to assess how far these small-scale, micro-level projects have a wider impact.

In some countries Oxfam UK/I supports projects which overtly attempt to challenge the status quo and increase women's access to key resources, raise their status or improve their control over their lives. Again, the lack of assessment of the effectiveness of these projects makes it difficult to draw conclusions about their success or otherwise, though some offices report that a new political climate is opening up debate about these issues and providing a more positive context (e.g. Mali, Zambia).

2.2 Working in emergencies and operational situations

Some of the differences in approach between field offices can be accounted for by the differences in cultural and political context. In some countries there is a wide range of NGOs, CBOs (community-based organisations) and associations; in other contexts there may be almost no

local organisations and only government or other international NGOs to work with. In these contexts, Oxfam UK/I may become operational.

Only a few countries involved in emergency (or operational) work wrote papers for the WLP Conference, and emergencies were not highlighted at the Conference, though the Gender Unit and the Technical Unit wrote papers addressing gender in emergencies.[3]

The papers that did refer to working in emergencies noted the fact that gender is often not integral to Oxfam's emergency work for a number of reasons: sometimes, inexperienced staff are recruited in a hurry and they do not receive any proper induction; there are no mechanisms in place for passing on Oxfam's institutional learning about working with gender in emergencies; the public health approach to emergencies has never been made policy; and the need for speed often means that baseline data is not collected, and data is not disaggregated.

Oxfam's experience in water projects, food and resources distribution is that if women's specific needs and roles are not taken into account, the projects intended to benefit them can make their situation worse. For example, poorly sited water points can add to their workloads or increase their risk of attack; water distribution taking place at times when they are engaged in other activities can prevent their access to water.

There are examples of Oxfam practice which have taken women's role as food and water providers into account — for example, where distribution was arranged directly with the women and delivered in ways, and at places and times, convenient to them. This has happened in Uganda, Kenya, and Sudan. Women have been used to monitor distributions in Sudan and Zambia, and several offices in Africa have had gender and emergencies training. The issues have also been discussed in conflict workshops in Asia. However, the experiences reported in these papers are patchy, and the impression given to date is that gender issues may or may not be taken into account in emergency work, and women may or may not benefit or be further disadvantaged.

By their very nature, emergencies are life-threatening and need to be addressed urgently. The characteristics of emergency work include a top-down, technical approach, the input of substantial amounts of money and resources, and the use of outside staff. However, many Oxfam UK/I staff see the potential for working in emergencies in a more developmental way, and taking gender into account is one essential part of such a strategy. The ratification of the public health policy in emergencies could be one concrete step towards this, as the technical staff paper suggests. Following up the experiences and proposals made in Bridget Walker's paper, 'Gender and Emergencies' (1994), could be another.

One or two offices talked of their operational work. In Afghanistan there is a commitment only to become operational[4] in situations where

there is the potential to address gender issues by involving women in the projects. That commitment is not evident in some other papers. Unfortunately so little has been written about Oxfam's operational work in these papers that no general observations can reliably be made.

2.3 *Working through partners*

When looking at the work Oxfam UK/I does with partners on gender it is important to raise two questions: first, how partners are chosen (in countries where there are real choices available), and second, how far does Oxfam's work on gender permeate relations with all partners; or is it confined only to women-led groups or partners overtly interested in promoting women's issues?

The country reviews listed the aims which different offices have in working with partners, or directly with grassroots groups, which range from the modest aim of spending a proportion of project money on projects with women which will directly benefit them, through to those who want their funding work to promote gender equality in a wide range of areas. The strategies used included raising awareness and developing the gender sensitivity of partners, and their gender practice in projects; creating opportunities for women in the NGO sector; working at both the micro project level and at the macro level of advocacy, lobbying, networking and research to promote women's interests — and in some offices address their inequality; promoting women's participation in decision-making and organisational activities; promoting women's access to resources.

The choices about whom to work with range from choosing to work only with partners who take gender into account (very few), to increasing the work with women-only projects, focusing on work with women, to trying to work closely with partners chosen for other reasons than gender, and who are resistant to addressing the situation of women, to raise their gender awareness. This last strategy is seen as problematic in many offices where there is a reluctance to be seen to 'impose' ideas about gender on partners, most of whom are male.

In many countries the majority of Oxfam partner and grassroots organisations are run by male leaders, and women, even if they are part of the organisation, rarely play a decision-making role. In many countries, however, there are women's movements, and grassroots women's groups with whom Oxfam is not actively engaging. With the exceptions of Brazil, Caribbean and Philippines, many of these groups were not mentioned in the reviews.

Staff work with partners using a variety of methods from informal discussions, training, networking, joint research (rare) through to

making concrete demands about the composition of the executive committee of the partner organisation, and the nature of their projects in relation to gender relations and women's interests. Some say they can only go at the pace of their partners, and try to encourage them to work in more gender-fair ways by listening to women, trying to find ways for women to participate, and ensuring women have some benefit from the project. Others go much further and make their funding conditional on women having been consulted, women being at least 50 per cent of the beneficiaries, and the positive impact on women being clear (e.g. Indonesia, Ahmedabad).

Where NGOs are relatively new and developing fast, for example in newly-liberalised political climates, they often tend to be urban-based and male-dominated, and the opportunities for working with them on gender issues appear limited. Although the majority of NGOs and grassroots groups are led by men, some of them are more open to discussing gender issues than others. Another factor is how many funders are operating; if there are many Oxfam's concerns may be ignored, if Oxfam is a sole or majority funder they may have more influence. However, it is interesting to note that some offices working in areas constrained by war or conservative religion appear able to find ways to work innovatively on gender, whereas in other more open societies less is being undertaken.

2.3.1 Work with women-only groups

Most offices support some women-only, women-run organisations and projects. The reasons for supporting women's organisations working only for women vary widely and include:

- where women are secluded this is one of the only ways to reach women;
- these are the only groups/ partners interested in women's needs and interests;
- these are the only culturally acceptable fora for women, and the only ones where women are allowed to participate;
- this is seen to be the 'acceptable' non-threatening way to approach work with women and gender;
- where there are strong women's networks or movements such as in the Philippines, or Jamaica, this is a radical way to address issues of women's disadvantage in law, politics, the family.

Obviously the nature of women's organisations varies enormously between countries, and often between rural and urban areas in the same country. So, for example, while urban-based women's groups in the Philippines are radical and challenge women's subordination in many ways, in rural areas they are far more focused on meeting women's immediate daily needs. Women's organisations can be at the forefront of

radical lobbying, they can also be very traditional and committed to the status quo for women. The primary focus of Oxfam UK/I's gender work appears in many offices to be on working with women and women's organisations which do not have a gender perspective, and work within traditional frameworks for women on meeting their practical needs. Some offices noted that church-based NGOs often reinforce women's traditional roles in most contexts.

In a few contexts, notably in Brazil and the Caribbean, Oxfam UK/I supports progressive feminist organisations (both urban and rural grassroots groups) who are in the forefront of challenging women's inequality in law, land rights, access to resources, and reproductive health. From Oxfam's rhetoric on gender it might have been expected that far more offices would seek out and engage with radical groups and women's movements, but such engagements are limited, and Oxfam UK/I's traditional reticence to get involved with groups seen as middle-class and urban-based is reflected here.

It is not possible to generalise about the potential for working to improve the status of women through women-only projects, and working with women-only groups is certainly a valid part of a gender strategy. Of course, some women-only projects are projects that reinforce women's existing roles and subordination, and even if they raise women's income or productivity they do nothing to enhance their status or access to decision making. Alternatively, some of the most radical projects Oxfam supports are also women-only projects where women are able to control the project, plan and implement it and control the resources.

Some offices, notably Mali, have drawn up and discussed the advantages and disadvantages of these approaches. The Mali field office argues that the benefits of women-only organisations are that women participate more fully and develop their organisational skills; and the organisations themselves are strengthened, and women can develop self-confidence and become more 'empowered'. The disadvantages are that men may intervene to take over or control the product of the women's labour. The Tokar review also highlights the disadvantage that, in societies where women and men have rigid roles, working with women alone can perpetuate their marginalisation within society.

2.3.2 Projects with mixed-sex groups

As has been highlighted, it is clear from the reviews that many Oxfam offices (e.g. India, Sudan, Brazil) do not work on gender issues in all their projects, and many of Oxfam's mixed projects do not analyse or tackle any gender issues, or even know what the impact of the projects are on women. Many offices recognise this as a weakness in their work and

intend to review their mixed projects — these form the majority of their work and are often referred to as Oxfam's 'mainstream' work — with a view to raising gender issues in future. These projects include agricultural and social forestry projects, extension, irrigation, village co-operatives, rice banks, peasant federations, and fishing associations.

This lack of engagement with gender issues in 'mainstream' projects in country programmes is clearly a serious problem, but one which many offices recognise and intend to address during this strategic planning period. This will involve ensuring that staff are aware and skilled and that they have the tools and negotiation skills to work through the issues with partners, who are currently unaware of or reject a gender approach.

In a few offices, a sensitivity to gender issues is evident in all their work and mixed projects are all appraised from a gender perspective and work is done to try and build a shared and common understanding of gender which includes changing relations between women and men. In some offices, for example Ahmedabed, Oxfam UK/I demands that women form at least 50 per cent of the participants and beneficiaries before they will fund a mixed project and that women are on the executive and have access to key resources. In these countries Oxfam UK/I is often working with partners to increase the involvement of women in the planning of projects, in the implementation, and the sharing of the benefits. Oxfam UK/I staff often work closely with mixed projects to sensitise men to the need to listen to women, to arrange meetings at times women can attend, to promote the confidence of women, and to increase their role in decision making.

In some projects, especially in India, NGOs run by strong charismatic men who have a commitment to improving the position of women can achieve significant change, even while the women remain excluded from the management. How far this is sustainable is not discussed in the reports.

The Mali report argues that working through mixed projects has the advantages of avoiding parallel activities, and the women involved can benefit from a wider range of projects. In Tokar, it is reported that it was only through mixed projects that the strict divisions between public and private life could be challenged, and women could get involved in all projects with male support. The disadvantages include the problem that, in mixed organisations, women are excluded from decision-making, their needs and interests often get subsumed, and there is less opportunity for them to be involved in and run activities. They can often become the labour in a project without reaping real benefits. Many mixed organisations, such as peasant or fishing associations co-operatives in Latin America and Asia, often overlook the needs of women, and in several 'resistance' cultures gender is seen as a threat to the national or

class interest, and such partners will not consider women's interests as separate from those of men within 'the struggle'.

3 Strategies for work with partners

3.1 Training

Oxfam UK/I is promoting training in a range of approaches for involving women in project design and management and promoting their active participation, both for staff and partners; yet to date there appears to be little feedback or information about how helpful these methods are and how far they have actually enabled women to have an impact on projects.

Training is probably one of the most universally quoted strategies, but as with staff training the content and style of training is not explained in the reviews and the pros and cons of different training approaches and packages remain unknown. One office (Philippines) stressed the need for Oxfam UK/I to do the training themselves, because of the unreliability of outside trainers who may not share Oxfam UK/I staff's gender analysis nor understand fully the context Oxfam UK/I works in. This training needs to be undertaken in a way which is consistent with the offices concept of partnership and may best be done as an integral part of discussions with partners.

It is not possible to assess how much time or money is invested in this strategy, nor how many partners have received training. In the future Oxfam UK/I will need to assess (qualitatively and quantitatively) the training and gender training it carries out, and to assess (subjectively as well as objectively) what, if any, changes result. Changing attitudes and practice is difficult, especially on gender issues; and whether training actually can effect real change needs to be assessed.

Although follow-up training, and activities to reinforce and support training, were not described, many offices concluded that one-off training is not effective and that training should be part of an on-going process.

3.2 Partners' participation in planning

The barriers to women's participation have not been spelled out in these papers, nor have the strategies used by staff for overcoming them. There are many reasons why women may not participate and these need to be analysed further, along with methods for addressing them. Offices did

not, by and large, discuss how they ensure women are involved and listened to, and it is not clear how many offices use methods such as gender-aware participatory rural appraisal (PRA), Moser or Harvard methodologies. The usefulness and relevance of different approaches are not addressed in the reviews but Oxfam UK/I needs feedback from the field on what approaches they find effective and which methodologies are the most relevant. Gender Needs Assessment is referred to in a few papers, but the resulting impact of that approach was said to be disappointing when it came to designing the fishery project in the Philippines.

Some offices have developed their own tools for gender-sensitive appraisal and planning, others said they were in need of such tools and wanted help from Oxfam head office.

3.3 Informal discussions with partners

This is a key strategy described by most Oxfam staff, who see their role as working closely with partners during the life of the projects they fund. However, the processes involved in informal discussions were not described, nor were the ways in which these discussions strengthen gender work presented in the papers. It is unclear how much contact Oxfam staff have with partners (in many offices it may involve only two visits a year), nor how they decide to focus or structure these discussions. The informal nature of Oxfam's tour reports and the reports on partners' meetings means it is hard to know how meetings are conducted and which kinds of informal approaches are the most successful.

3.4 Networking and linking

In a few offices, for example the Caribbean and Senegal, Oxfam UK/I plays a role in facilitating gender-focused meetings for international or national NGOs where they can discuss critical issues. Oxfam UK/I finances these meetings and seminars where experience can be shared and issues around gender can be debated. In the Caribbean and Brazil, Oxfam UK/I has funded the attendance of partners at women's meetings and feminist fora.

4 Projects undertaken incorporating gender, or focusing on women

Below are listed the various projects in which offices are involved in relation to women; only a few of them overtly address gender issues in

terms of changing women's and men's different levels of access, control, and decision-making. The majority are focused initially on improving the welfare and lifestyles of the women involved, though in some offices these projects are seen as an entry point for working on gender issues at a future time.

4.1 Income-generating projects

Though some offices reported moving away from it, much of Oxfam UK/I's work does focus on income generation. Many projects are designed to raise women's income to enable them to provide better for their needs and those of their families. Raising women's income is seen as a positive approach which can enhance the health and education status of the children, and sometimes of the women themselves.

Most offices recognise the danger that women's income may be controlled by men, and the possible danger of increasing women's workload through these projects without improving their status or well-being. Other offices point out that women's incomes may not be significantly improved by these projects because the women lack sufficient capital or skills or access to markets to make much money. But they support these activities because they provide a means to bring women together into groups, and in these groups work can begin on developing solidarity between the women, confidence building, and developing organisational and other skills.

Many of the women's organisations that work with women on these projects are seen to lack an understanding of gender issues and work within stereotyped women's roles; this was particularly stressed by offices in India and the Philippines.

Other field offices (Sudan, India, and Latin America among others) report that they try to ensure that these projects generate viable and useful incomes for the women, and advocate more training in production skills, organisational capacity and marketing to achieve that.

4.2 Credit and savings

A number of offices fund projects providing revolving credit to women for a wide range of purposes, ranging from inputs for income generation to personal such as burial societies. Many credit initiatives share the characteristics and shortcomings of income-generating projects. Often, while credit helps women in small ways, the amounts lent by projects are too small to enable women to escape the poverty trap. Credit is only one of many factors affecting women's livelihoods, and often little is done to improve their access to land or water or other critical factors of production.

4.3 Health

Many offices highlight the health problems faced by women; there are a wide range of health projects supported by Oxfam UK/I. These include training women as birth attendants and as primary health care workers. Health work includes training, health promotion, nutritional education, but little on women's rights in reproductive health. While population growth and family planning are issues raised in the contexts of many countries, few offices support projects which address the issues of women's reproductive rights (Indonesia and Vietnam are exceptions) or the need to confront oppressive family planning policies in certain countries.

Three or four countries highlighted the project work they undertake in the wider area of health and women's rights, including a media campaign in Sudan which raised issues such as female circumcision, child marriage, child spacing, and nutritional taboos. However, this kind of policy work appears to be rare; in Sudan the reason given for this was the lack of partners working in these fields, but this is unlikely to be the reason in countries with an active NGO sector and active women's organisations, such as India and the Philippines.

4.4 Education

While education and women's lack of access to education is given as a major factor affecting women's development in the majority of country contexts, few offices work on the issue of women's education. One reason for this may be that Oxfam UK/I has largely avoided involvement in education projects outside parts of South Asia and Latin America; this is in itself interesting, given that the field offices report an emphasis on the importance of education, and literacy. However, literacy work takes place with rural women in Haiti, Tokar, Sudan and Nepal, and non-formal education work with women in Hyderabad in India.

4.5 Agricultural extension work

While Oxfam UK/I supports significant numbers of projects training people in extension work, including agriculture, forestry, and stockrearing, only a few offices specifically train women in extension work. This is despite the fact that, in many if not most contexts, women look after animals, work the land, and play a key role in forest development and conservation. The interesting and notable exceptions to this include the training of women as paravets in Sudan and Chad, and

the training of women agricultural extension workers in parts of Asia. Many offices, including India and Brazil, noted the exclusion of women from mainstream projects including social forestry and agricultural projects.

4.6 Training for grassroots women

A significant number of offices provide gender training for women through partners or directly by Oxfam, and training for women to raise their skills in a range of areas including book-keeping, production skills, organisational skills, leadership, and marketing. Some offices are now embarking upon work with women's organisations in the area of appraisal, planning, monitoring, and evaluation, trying to increase women's understanding of gender issues and their ability to apply a gender-sensitive approach to project design and implementation.

These are critical areas, though few offices appear to have assessed the impact of their training in any systematic way and only a few, including Hyderabad in India, have listed indicators against which they might measure impact in the future, and some (for example Ahmedabad and Senegal) report increased confidence and competence among women in the communities with whom they work.

4.7 Lobbying and advocacy work

This is an area where only a few Oxfam UK/I offices support projects. Such work often involves urban-based women's organisations, who, while they often lack direct contact with the rural grassroots, can be effective at the policy level. This is certainly the case in the Philippines, where urban women's groups have put several key issues for women on the political policy agenda (though they are not supported by Oxfam), or in the past in Jamaica where a strong women's movement negotiated maternity and paternity rights in the 1970s. Mali, Burkina Faso and Ethiopia all report a lively debate on women's status and needs, but do not explain the role — if any — of women's organisations in this, nor Oxfam UK/I's role in the debate.

Oxfam UK/I's gender lobbying work mentioned in the reviews includes supporting a group campaigning for women's reproductive rights in Sudan, women lobbying for changes in women's employment rights in Ahmedebad and Hyderabad, groups in Brazil working to link macro and micro issues in order to campaign for change, and projects on law and employment in Senegal, and law and violence against women in Zimbabwe.

4.8 Urban work

The problems for urban women are raised in a number of country studies from India, Latin America and Africa (Sudan and Senegal) but only a tiny proportion of Oxfam UK/I funding goes to urban projects. Those that focus on women include projects supporting urban women's slum organisations in Latin America, employment, legal, and social organisation projects in Dakar, Senegal, and work with the displaced in Khartoum, Sudan, which is focused not on women but on families in the expectation that women will also benefit.

4.9 Social organisation

Many offices, especially in Latin America and the Caribbean and parts of Asia — for example Cambodia — report on their work in strengthening social organisation. Some refer more specifically to their work in developing leadership and organisational skills for women (e.g. Zimbabwe), in promoting exchanges and networking between groups, and in providing support to women's groups at the grassroots and national levels (e.g. Haiti). Promoting social organisation is another key strategy, through the lack of clarity about what this means in different contexts may limit learning from these experiences.

4.10 Supporting legal change

While most offices described the unfavourable legal conditions as a key problem for women in trying to improve their position, only a few offices appear to work with partners on this issue. Those that do work largely with urban-based women's groups who are actively lobbying for change. Examples of offices doing this work are Zimbabwe and Brazil.

4.11 Research on women's status and opportunities for change

A number of offices said they plan to do this in the future; very little work in this area has been funded by Oxfam UK/I to date, with the exception of the Caribbean study and one or two small studies is Asia and Latin America.

4.12 Other projects

There are a range of other projects that Oxfam UK/I supports in relation to women, including work on land issues (Senegal, South Africa, and

East Africa), water issues (Zaire, Ethiopia, and Mozambique), a drama project on women's conditions and rights in Jamaica, work to strengthen women's organisations especially in Latin America, legal assistance for women (Bolivia and Zimbabwe) and research — into the rural women's movement in South Africa and women's conditions in Caribbean.

5 How field offices address gender work

While in some teams all members of the team are aware of and involved in gender discussions, in some offices gender is still primarily the responsibility of a woman project officer — in some cases they feel marginalised or isolated, in others they feel part of the team.

Many offices made the point that Oxfam UK/I staff themselves need to be committed to the concept as a priority. Given Oxfam UK/I staff's work as facilitators and accompaniers of partners this appears to be an essential place to start.

Offices have described the activities they use to promote gender in the team, though almost none of the reviews assesses the impact of these activities, nor how effective their approaches have been in getting gender incorporated into Oxfam UK/I's work. Lack of evaluation of the effectiveness of these different ways of working means staff have little feedback on the impact of these different approaches. A number of offices describe changes they perceive within the team, though with few exceptions (e.g. Kenya, Senegal) the changes and impact are not systematically or regularly reviewed.

5.1 Culture

Innovative ways of working need to be introduced to enable staff to overcome their own cultural barriers (this is of course true for UK-recruited staff also). Some offices have tried interesting experiments. An example is in the Red Sea Hills, where women are particularly secluded and isolated within the society. Here, the field office has worked hard to overcome their subordination. One male and one female staff member now work together; this is revolutionary for the staff, as well as for the surrounding society.

However, other offices report little progress on overcoming the resistance of men on their staff to working with gender issues, and several reviews do not offer any strategies for tackling this issue.

5.2 Staffing and recruitment

Many offices did not mention this issue at all, while others highlighted it as one of the most critical issues. Those that mentioned it talked of the need to address gender imbalances in the team; others talked of the need to recruit gender-aware staff; one or two highlighted the significant role that a senior gender-aware woman had played in their team.

Recruitment priorities vary between offices, according to whether they want gender specialists on the team, or to promote gender awareness and responsibility for gender issues across all staff. An overlapping issue is whether the balance between men and women on the team is an issue. One or two offices have stressed the importance to them of having a 50:50 balance in the team, women and men, and have achieved this; other offices, while trying to increase the number of women, have found that the ratios have worsened over the last year or so. The reasons for this were not explained.

In many offices women remain in the minority and many of them feel isolated in that context. In addition, offices such as Nepal and offices in India highlight the unfavourable working conditions for women prevalent in Oxfam UK/I — long unsocial hours, travel at short notice, no childcare provision — which militate against women staying long in the team. Few offices addressed the issue of working culture, but it remains a major issue for Oxfam UK/I, both in relation to developing genuinely multi-cultural teams, and ensuring women can thrive in the work context.

5.2.1 Staff development
Many offices do not have much opportunity for staff development on gender because there are few agencies or consultants experienced in gender in their country or region. Others have had a lot of exposure, for example through attending Oxfam UK/I gender meetings (especially Action for Gender Relations in Asia (AGRA) meetings), visits from Gender Team staff, exposure visits, exchange visits to projects and other countries, and working with other agencies. Few offices appear to have sent their staff to learn from women's organisations or networks, even where these are strong (for example, in the Philippines).

A great deal of energy goes into training, research, and staff development (of Oxfam UK/I staff and partners) in this area of working with women, but a lack of clear indicators and assessment makes it hard to draw any conclusions about whether they are improving the situation for poor women, or what impact they are having. The few offices which have tried informally to assess success or failure report seeing positive changes in behaviour and attitudes.

The relative isolation of some countries in each of the three continents is an issue that needs to be addressed by Oxfam UK/I in the future, especially in countries with few internal resources for developing staff skills.

Though some offices do try and monitor their staffing policies, others are making decisions about staffing and recruitment on intuition. These different approaches should be monitored and evaluated to determine the advantages and disadvantages of each approach.

5.3 Training for Oxfam UK/I staff

Most offices have provided training for their staff, internal training or training with help from external trainers (including Gender Team staff), and plan to continue that training. Those that have not had training are planning for it in the future.

The content of the training varies; while some focuses on gender awareness, other training covers appraisal, monitoring, and evaluation of projects from a gender perspective, or exploring gender relations within teams. It is hard, from the reviews, to know precisely what training involves, and how comparable the trainings are, though it seems that staff do not share a consistent understanding of gender issues, nor of Oxfam UK/I's gender policy.

Offices start work on gender at different levels, and work in very diverse contexts, so it is important that the training is designed to meet their particular needs, though the question remains whether there are any basic concepts that all staff should understand. For some, staff training had to start by analysing the meaning of gender because they felt it to be an imposed concept which they did not understand, and neither did their partners. These offices needed to redefine the concept for their own use and application in their context. Others have focused more on developing tools and checklists for assisting staff to look at projects from a gender perspective, or to raise gender issues with partners where this may be a sensitive issue.

The length of time and frequency of these trainings is not reported, nor are follow-up strategies discussed, though some offices do note the need for on-going training. Several offices highlight the problem of high staff turnover in undermining their training strategy, and in some offices where only one person has been trained, the office has been left with no gender expertise when that person leaves. The majority of offices now aim to train all programme staff.

No offices appear to have attempted to evaluate the effectiveness of their trainings for staff, though many say it has improved their work in relation to gender. Training offered by the Gender Team is accompanied

by supporting publications and materials, yet there is little evaluative material available.

5.4 Progressing and mainstreaming

Different offices have reached very different conclusions on the value of having a woman responsible for gender work on the team, i.e. Women Project Officers. Some offices have found that they are essential in getting the profile of gender raised on the team, and ensuring time is spent on this issue. Other field offices have found that these women became marginalised from the rest of the team, and have moved away from WPOs to having the whole team answerable for work on gender. Some teams combine both approaches, given gender responsibility to all staff, with a woman officer preferably in a senior position providing the lead on gender.

5.4.1 Gender policy
No offices were explicit about the precise role and value of having a policy for supporting or extending their work on gender. While some offices have their own 'unofficial' gender policy — some in Africa have had them for a long time — others are content for the moment to work within the framework of the Overseas Division plan on gender, and want to work through the formal Oxfam UK/I Gender Policy and relate it to their own work in the future. Most offices want to develop their own gender policy eventually.

Oxfam UK/I will need to monitor the adoption of the Oxfam Gender Policy and how offices adapt it to their own needs and circumstances, and also to try and assess what difference having such a policy has made to Oxfam UK/I's work.

5.4.2 Strategic planning
Many offices have either included gender as a way of working on all the priorities in the strategic planning process which is becoming set practice in Oxfam UK/I, or they have made gender a separate priority. Yet, from reading the reviews of the strategic plans, it is suggested that gender remains an 'add on' concern for many offices, while the central analysis of the historical, legal, political and economic contexts in which Oxfam UK/I works remains blind to issues of gender relations. In many strategic plans, gender is still equated with working on women's projects, and issues of inequality are not addressed. A few field offices, including the Philippines, Indonesia, and Kenya, made gender central to their entire analysis, but this remains the exception to date.

5.5 Time use

Several offices highlighted the time that is needed to work with staff and partners on gender issues, and noted how limited staff time is in relation to the many competing and sometimes contradictory demands coming from Oxfam head office. Allocating resources for gender work involves rejecting some of the other priorities currently in the Overseas Division strategic plan. It also means ensuring that a gender approach is incorporated into all the other priority work such as advocacy, environment, sustainability, and rights.

5.6 Gender-sensitive planning, monitoring and evaluation

A few field offices — including Senegal, Cambodia, and India — have highlighted the need to develop gender-sensitive tools for project management for use at all stages. They will not fund projects unless they know what role women played in developing the project, how women will participate, how they will benefit and whether they will have any control over the benefits; and what, if any, negative impact might be expected.

A small number of offices are stressing that good appraisal, monitoring, and evaluation from a gender perspective is essential to improve Oxfam UK/I's work on gender, and have developed their own tools — for example, a framework for project analysis in India. However, Oxfam UK/I also currently lacks tools for measuring a range of work which is often seen as essential to Oxfam's way of working — including 'empowerment' through strengthening civil society, capacity building, developing social organisation, and valuing and promoting networking between organisations and individuals involved in development.

5.7 Institutional learning

Some offices raised concerns about how to promote institutional learning around gender, and some in Latin America promote women's forums and networks for information sharing and learning, but few offices had concrete ideas on how to promote institutional learning beyond workshops and developing networks. Few offices have undergone a country evaluation, though two mentioned the value of the learning gained from theirs (Lebanon and Bangladesh), others have done many project evaluations but ways of sharing these and ensuring learning from them are not discussed in the reviews.

6 Lessons from field office experience

While different offices have learned different lessons, it seems useful to highlight the most repeated lessons that Oxfam UK/I staff mention in their papers.

i. Working with gender issues is slow. It takes time to train staff and to get the issues understood in the office, and it takes time to work with partners on the issue. Often the work takes place against resistance from male staff and partners, and sometimes from female staff and partners too. It challenges existing relations and requires changes in attitudes as well as behaviour, and as such cannot be imposed.

ii. The religious and cultural forces that uphold existing unequal gender relations are strong and resistant to change, even in situations where women's roles are changing and their productive contribution to society is growing.

iii. Training is an important strategy, but it has to be seen as a continuous, not a one-off, process.

iv. Some of the work with women may increase their incomes but fail to change their status or access within the household. Other work may raise the profile of women without making any positive changes to their lives; this is the experience of many projects in which Oxfam UK/I has been involved. It is hard to find projects and ways of implementing them that significantly improve the situation and status of poor women.

v. There is a need to make better links between local and national women's groups, and to raise the profile of research, lobbying, and advocacy on issues such as women's rights, women's legal status, and violence against women, in order to address gender issues more effectively.

vi There is a need to involve men in women's projects and vice versa if the relationships between men and women are to change and men are to allow women greater access to resources, decision making, and control within the household, community and wider society. While there are different ways to address the issues (through women-only, mixed or men-only projects), relations will not change unless both women and men are involved and informed in the processes.(Some staff would not agree, but it is the prevailing view expressed in these papers.)

vii. In some contexts there is great potential to work for real change through women-only organisations, eg urban associations in parts of Latin America, women's legal groups in Africa. The potential for working in urban areas where women are often taking on new roles and responsibilities, and beginning to demand a change in their

rights and status is one which several offices now recognise, though few are yet involved in work in these areas.

viii. There is a need for Oxfam UK/I to develop gender aware tools for project management – for appraisal, planning, monitoring, and evaluation at a project (and programme) level. Some offices have started to develop their own tools, including checklists and forms, but more work is required from Oxfam UK/I head office which staff can then adapt to the local conditions where they work.

ix. The use of English in Oxfam UK/I communications cuts many field staff off from the debates going on in gender, and from many materials produced by GADU. This is an issue that GADU staff are very aware of and continually trying to overcome, and the need for a policy on translation has been raised repeatedly over the past ten years.

6.1 Some successes

A number of field offices reported areas where they feel they have achieved real successes. Again, these apply to only some field offices. These include:

- achieving better organisation among women's groups and associations, strengthening their leadership and performance;
- increasing women's participation in some projects previously dominated by men;
- Increasing women's participation in seminars and workshops;
- developing sustainable income-generating projects for women;
- increasing partners' awareness of gender issues;
- increasing Oxfam UK/I's and partners' understanding of the different roles of women;
- finding ways to work on gender that are appropriate within the cultural realities;
- benefiting refugee and displaced women significantly in some emergency projects;
- developing gender policies, or the adaptation of Oxfam UK/I's organisational Gender Policy.

6.2 Some problems

Some of the main problems identified in the reviews are:
- failure to enlist men's support for the work women are doing, or the changes women have asked them to make;
- lack of available, trained women who have mobility means that many

demands from partners and organisations for work on gender have not been met;[5]

- income-generating projects have often failed to improve women's access to decision-making, control, or improved status;
- some Oxfam UK/I staff are still resistant to the concept of gender and issues around gender relations, and continue to view it as imposed and not relevant to their work;
- heavy workloads of Oxfam UK/I staff sometimes prevent them from performing labour-intensive work on gender issues with partners (a gender approach has to compete with demands for staff to work on environment, basic rights, sustainability, communications, advocacy);
- some of the concepts being used do not appear relevant in some contexts, or are not translatable;
- in some contexts, the rhetoric on gender exceeds the capacity of staff and partners to implement projects that actually address gender issues.

7 Conclusions

Field staff have identified many of the barriers and opportunities to working with women and to addressing wider gender issues. Here I want to highlight a few areas of particular relevance to future work in this area.

7.1 Working on gender is complex and slow

One clear message that comes out of these papers is the slowness of the process involved in promoting the role and status of women. Gender analysis confronts existing ways of working and thinking, and existing power relations, in all societies. Gender is a relatively new issue for development workers, and is complex and sensitive. Inevitably, therefore, it is hard and slow work, that needs to address attitudes as well as actions, beliefs as well as ways of working.

Enabling women to become involved, participate, make decisions, and take control within projects and wider programmes is difficult. The specific contexts vary greatly, as does the scope for working to redress the balance in favour of women. A number of offices have made the point that while Oxfam UK/I's rhetoric on gender has a high profile, the reality is that achievements are modest, and many offices are still at the stage of searching to find ways to translate the theory and rhetoric into practice.

While there is a real commitment in many offices to work to redress the balance for women, many others report that there is a gap between

that commitment and the ability of staff to find and support projects and programmes which achieve this, especially in contexts perceived to be especially hostile or restrictive for women. More time needs to be allowed for this work, in a context where there is an understanding that significant change will be achieved only in the longer term. This may conflict with Oxfam UK/I's current focus on short-term impacts.

7.2 Diversity and difference between women have to be understood

Most offices emphasised wide cultural diversity, even within one country, and that the roles, responsibilities, and status of women vary greatly between different cultures. They stress that it is essential to start from the cultural context and find ways that are appropriate and relevant within that culture for addressing gender issues, and not to impose 'packages' of ideas from outside. While in the past culture has been invoked in some situations as an excuse for avoiding tackling gender issues, the point raised in these papers is different. Once the commitment to work with gender is there, this work has to be done in a way which is relevant to the women in that culture, and their vision of what they want to achieve and how they want to achieve it. A few offices perceive themselves to be in dispute with GADU about this, and feel that the approach from Oxfam head office is sometimes not sensitive enough to this cultural diversity, within and between countries.

Future work by the Gender Team and field offices needs to be culturally relevant and take into account what women in different contexts themselves are saying. Oxfam UK/I needs to find ways of working which are not externally imposed. The need to work and share experiences within and across cultures, and to work to support field staff in this difficult task, needs to be high on the agenda of gender and strategic planning specialists in Oxfam UK/I, and the Policy Department.

7.3 The need for tools to measure results

Work on gender does not often yield quick and measurable results. However, it is clear from these reviews that Oxfam UK/I staff currently lack the tools to measure change, or the impact of their work in the medium to long term, in all projects, including those with a gender element. Assessment of successes and failures remains at the moment largely intuitive, or limited to individual projects, and this is an area that Oxfam UK/I will need to address in the future.

7.4 Gender: integral to poverty analysis, or imposed?

For some offices, the impetus to work on gender issues came from staff or partners in country offices and is firmly rooted in their analysis of poverty and the causes of poverty. These see gender inequality as being at the heart of their analysis of poverty and exploitation and have made working for gender equality the pivot of their work; a few fund only partners who meet criteria they have set for achieving both better welfare and rights for poor women.

Other offices view gender issues as imposed on them by Oxfam head office. In one or two offices it is perceived to be a Western cultural imposition. Gender is a term that is not necessarily easily understood or translatable into other languages, and a commitment to the concept is not shared by all staff. In some offices there are divisions within the team; in others, there are felt to be divisions between the field office and Oxfam head office. As might be expected, in the few countries where the concept of gender is viewed as alien, work on gender is apparently causing confusion both to staff and partners.

Most offices are clustered in the middle of this spectrum in terms of understanding and commitment. Regional Managers and gender specialists within Oxfam UK/I, including the Gender Team, need to prioritise work with those areas most isolated or in need of support.

7.5 Oxfam UK/I: leading on gender and development practice?

As presented, the country reviews may give the impression that Oxfam UK/I sees itself as being in the forefront of work on gender. There is little reference in these papers to any work performed by other agents, including governments, other international, or local NGOs, or other groups. There is almost no reference to the work of women's organisations, networks or lobbying activities in individual countries or regions, nor do the papers give any impression that partners are pushing Oxfam UK/I to work faster on this issue.

This lack of reference to interaction with, or acknowledgement of, others working on the issues, needs analysing by offices: is it truly the case that no-one else is working on gender issues in the country, or are Oxfam UK/I staff are unaware of others' work? If it is the latter, it could reflect a weakness in reporting, or a more fundamental position that Oxfam UK/I offices are not engaging with other NGOs, governments, existing women's movements or networks that do exist in the country or region for reasons that are not explained. Oxfam UK/I needs to be more aware of, and relate more closely to other agencies and organisations working

on gender. This was recognised at the WLP Conference in Thailand, and should form part of the basis of Oxfam UK/I's gender work.

7.6 Gender relations in the private sphere

While a number of projects address the needs of women for access to income or skills, most projects fail to address women's relations in the domestic sphere. Very little work has so far been undertaken on violence within the household, male and female sexuality, traditional gender roles between men and women and their children, boys and girls. Little work has been undertaken to strengthen women's position vis-à-vis men in the context of the AIDS epidemic.

It was recognised at the WLP Thailand Conference that work on violence against women — at the domestic as well as the community levels — and women's rights to reproductive health had been largely neglected by Oxfam UK/I yet formed a core part of the agenda for many women's organisations.

These areas — of women's sexuality, of male violence, of women's rights to control their own bodies — are often seen as the most threatening issues, and pose some of the major challenges to existing ideologies about women and women's status. Yet subordination and lack of rights in these areas are increasingly being questioned, and they are issues Oxfam UK/I as an organisation cannot afford to ignore in the future.

7.7 The need to address issues at macro-level

Much of Oxfam UK/I's work with women, and on gender issues is focused at the micro-level, on fragmented projects. These projects often appear to bear little relationship to the problems highlighted in the analysis of the context where inequitable laws and customs, growing poverty of women under structural adjustment, and women's lack of education are often seen as central.

It will be important in future to identify how to relate work with partners — governments, international or national NGOs, grassroots groups — to the problems Oxfam UK/I has identified and is trying to address. This will involve working both at the micro, and other, levels on issues which seriously affect women's rights of access and control.

7.8 Language

Language is a conceptual as well as a practical barrier, and Oxfam UK/I needs to continue work on this issue at all levels — translation, finding

culturally appropriate images and concepts — if it is to become a multi-cultural organisation that is capable of tackling gender issues in such a wide range of contexts.

7.9 Changes over the past five years

Finally, Many Oxfam UK/I offices are now working with gender issues and are building up a body of experience on how to tackle this issue within the organisation and the programme. Many lessons have been learned and new issues are being raised in relation to gender.

This picture is very different from the situation five years ago, when many offices did not see the relevance of gender analysis to their work and the way they worked. While some still feel that the concepts are imposed from Oxfam head office, for the majority of offices this is not the case, and many staff are now committed to addressing the growing poverty of women as well as men. Gender has become integral to their poverty-focused approach to development and emergency work.

List of Country Reviews discussed in this paper:

Asia

Bangladesh
Cambodia
Indonesia
Pakistan
Philippines
Sri Lanka
Vietnam
India — Ahmedabad, Bangalore,
Bubaneshwar, Hyderabad,
Lucknow

Middle East
Lebanon

Africa

Burkina Faso
Chad
Mali
South Africa
Sudan — Kebkibiya, North Tokar,
Port Sudan
Zimbabwe

Latin America and Caribbean
Andes Region
Central America and Mexico
Brazil
Bolivia
Chile
Colombia
Peru

Other references

A total of 34 papers were read in preparation of this Report, including:
Technical Unit papers
Bridget Walker, draft paper on gender and emergencies, 1994
Bridget Walker, review of gender strategies in Africa, 1994
Mandy MacDonald, review of gender in the strategic plans of Asia and the Middle East, 1994.
Women to Women Linking Project Global Meeting, Declaration, Feb 1994
Recommendations on the implementation of Oxfam UK/I's gender policy: women's linking projects Thailand conference, Feb 1994

Notes

1 Gender is seen to address inequalities between women and men and includes raising women's relative status; working with women may address gender issues of inequality but may leave women's position unchanged and disadvantaged. Gender strategies need always to address women's status relative to men, strategies focused on women only may or may not do this.
2 In other papers discussing development and gender work, the work is often categorised as activities which meet women's practical needs (enabling them better to fulfil their existing roles and responsibilities), and work that meets their strategic needs, which changes women's relationship with men and the social, economic and political confines which are curtail women's lives.
3 Papers can be obtained through the Gender Team, Oxfam UK/I.
4 Oxfam is 'operational' in situations where it is impossible to work in partnership with local organisations.
5 This problem is limited to some specific contexts.

Appendix 2: Declaration from Southern women's organisations presented at Women Linking for Change Conference

We women of the South, chosen by regional meetings of the Women to Women Linking Project in Africa, Latin America, South-East Asia, South Asia, and the Middle East to participate in the Global Meeting of Women Linking for Change, are concerned that there is an increasing concentration of power in the North, resulting in the feminisation of poverty all over the globe. With the sharp rise of fundamentalism and domestic and communal violence, there is devaluation of human life, respect, and dignity. These processes are making women more powerless and our struggles for survival are becoming more difficult.

Though the challenges are great and the situation is complex, we have hope that we can change conditions and build a better tomorrow. We affirm the experiences and actions by the women's movement all over the world in the last two decades, and we assert that the empowerment process for women has begun. We are hopeful that this empowerment process will also give strength and support to the other movements of oppressed people. This is expressed in the increasing participation of women in politics and education, and in every sphere of life.

This is our vision: We want a just world

- that is free of oppression and exploitation, peaceful, safe, prosperous, respectful of all forms of life, and all human beings;
- where we women have choices, where there is equal opportunity for women and men and equal sharing of workloads between us;
- where we have access to, and control of, resources;

- where girls and boys have equal access to education and social services;
- where we can participate in decision-making processes at all levels from family and community to government;
- where our rights are guaranteed and protected by law;
- where gender-based violence, and all other forms of violence, are eliminated;
- where we have autonomy in decision-making, and control over our own bodies;
- where we have the right to own property, and are not deprived of our rights, regardless of our marital status;
- where we will be able to live without fear.

Demands: Considering all these, we demand the political will to support justice in gender relations and concrete plans of action to promote this. This requires change at all levels.

In the struggle against poverty

We demand:

- change in the economic, political and socio-cultural position of women, to redress poverty;
- a concerted effort to change the overall structure of patriarchal state domination; this should be done through analysis of state power structures, using identified pressure points to bring change;
- research on, and analysis of, neo-liberalism, state, IMF, and World Bank programmes and policies, the various forms they take, and their effects on women at all levels;
- action to influence opinion towards gender-sensitivity, by use of the media, lobbying at various levels, mass mobilisations around gender issues, information gathering, conducting research and obtaining the support of academic and research institutions, working with like-minded NGOs and human rights groups to bring about change;
- the humanisation and feminisation of science and technology.

We recommend:

- the development of alternative models for gender and development;
- the development and strengthening of coalitions for networking at international, regional, and inter-regional levels on violence against women, law, neo-liberalism, women's rights as human rights, and religious fundamentalism;

- lobbying on these issues;
- the creation of a clearing-house for exchange of information.

Strengthening the women's movement

The women's movements of South and North play an important part in women's resistance to all forms of discrimination, in the struggle for survival, and in strengthening women's power. We women of Asia, Africa, and Latin America call for the strengthening of women's organizations, with regard to their autonomy and capacity for analysis and action.

We recommend:

- institutional support;
- setting-up and strengthening of educational institutions for women;
- exposure and study programmes;
- development of second liners (future leaders) through training for project management;
- strengthening of political participation through the promotion of intersectoral coordination between women and other sectors, and strengthening the position of women within other areas of work: this will require evaluation of the specific situation of women in each country;
- broadening South-South and North-South relations between women, dealing with common issues as well as differences, through support for networks and consortia, and increased communications and media work;
- the provision of support services for all women, and particularly women victims of violence, such as legal assistance, education, and emotional support;
- the development of clear policy guidelines, through lobbying with governments, on the rights of groups and organisations to exist;
- the development of the individual woman as a person, strengthening her skills, potential, and knowledge, her self-confidence, self-image, and assertiveness, particularly in mixed groups.

To achieve the above, we recognise the need to develop our own frameworks and promote existing Southern models of analysis, not relying solely on Northern models.

In relation to funding issues

We demand:

- funding for formal and non-formal education for girls and women, and training to enable women better to analyse their own needs;
- funding for the people's own agenda;
- the development of women's projects which are sustainable in the long-term.

North-South relations and funding relationships

North-South relations, particularly as regards funding, present a challenge to both Southern organisations and the funding agencies themselves.

We recommend to the funding agencies:

- gender and development training for agency personnel and NGO staff responsible for project design and implementation, monitoring and evaluation;
- use of local resources for training and curriculum development;
- lobbying of governments by NGOs and funding agencies to ensure that gender issues are integrated into their policies;
- training for women in project design, and fund-raising, particularly for new organisations;
- that they do not restrict NGOs to a single funding source, to enable greater freedom in prioritisation and implementation of projects;
- that they promote women with a gender perspective to positions of responsibility and authority;
- that partners be encouraged to see funding agencies as a channel for lobbying.

We demand:

- the involvement of partner NGOs in project and programme design, implementation and evaluation, by means of participatory processes;
- response to the needs expressed by women themselves, even if these do not fit the agency agenda;
- support for innovative projects which will bring significant change for women;
- the use of the local/regional dialects in project proposals;

- the translation of agency policies and key documents into local/regional languages;
- the inclusion of translation costs in budgets;
- the synchronisation of the funding agency project evaluation/ processing cycle with the project monitoring/ evaluation cycle of the country;
- consistency in terms of minimum standards for funding criteria/ guidelines — the agency should be lobbied if these are violated in other Southern countries;
- the use of agencies as a channel for lobbying;
- that 'gender and development' units, like Oxfam's Gender Team, and other funding agencies, be given support for solidarity work, campaigns, information exchange, research, and documentation.

To Beijing and Beyond

We call for attention to be drawn to the Fourth International Conference on Women to be held in Beijing in 1995, and to other major international conferences, such as the Conference on Population and Development, and the Social Summit. We express our concern at a possible 'takeover' by the donors of the Beijing process.

We recommend to women's organisations of the South:

- that the women of the South participate actively in the preparations for Beijing through workshops, and seminars; and attend the conference en masse;
- that the women's organisations lobby representatives who will be going to Beijing to ensure that women's visions and strategies are on the agenda;
- that mechanisms be established to ensure implementation, monitoring and evaluation of the conference recommendations;
- that there is close collaboration with the media to publicise the conference preparations, proceedings, and follow-up;
- that national, regional and global platforms be established to enable the exchange of priorities and concerns;
- that existing channels be strengthened.

We see Oxfam's role in the Beijing process as complementing that of Southern partners and women's organisations at national, regional and international level.

We recommend to Oxfam:

- that Oxfam send a mixed delegation of Oxfam staff and partners to the Beijing conference, and, in addition, involve partners in the preparatory process;
- that Oxfam support lobbying and informational activities for the conference;
- that Oxfam provide resources for networking at global, regional, and national levels for preparation and follow-up to Beijing.

We recommend to other funding agencies:

- that priority be given to promoting women's strategic needs;
- that funding should not be used as a means of control, influence or division;
- support for women's networks, to allow them to:
 - prepare for Beijing
 - enable the participation of women and particularly young and elderly women, rural women, tribal and scheduled caste women, disabled women, and other women belonging to marginalised groups;
 - share information about the strategies to be adopted in Beijing
 - collaborate with Southern women's movements to ensure that issues of concern to them are on the agenda. These include the position of the girl child, the impact of fundamentalism and communal violence on women, the position of women who are immigrants, refugees or otherwise displaced, disaster management, and women's political participation;
- support for follow up and implementation after Beijing, including research and documentation for a News Feature Service, and the production of alternative documents analysing the implementation by governments of resolutions from earlier conferences, such as the Forward Looking Strategies.

Conclusion

We women from Asia, Africa, and Latin America express our appreciation of the Global Meeting of Women Linking for Change, and hope that the Bangkok Conference will be followed by other exchanges and consultations on gender and development. We call on Oxfam to continue the process of exchange with Southern partners, women's organisations, and other funding agencies. We invite Oxfam to translate

the conference recommendations into policies and action.

As women involved in the Southern women's movements, who have been engaged in this linking process, we affirm our personal commitment to continue to struggle for these issues, within our own networks, and as Oxfam partners at both national and regional levels, and to work for further North-South co-operation towards a just world for women.

Signed by:

Representatives of South Asia and the Middle East Regional Meeting:
• Neelam Gorhe, Stree Aadhar Kendra, India
• Sima Samar, Shuhuda, Pakistan

Representatives of Latin America Regional Meeting:
• Morena Herrera, Mujeres por la Dignidad y la Vida Urbanizacion Venezuela
• Giulia Tamayo, Flora Tristan, Peru
• Nalu Faria Silva, SOF Sempreviva Organozacao Feminista, Brasil

Representatives of South-East Asia Regional Meeting:
• Nursyahbani Katjasungkana, Solidaritas Perempuan, Women's Solidarity for Human Rights, Indonesia
• Luz Ilagan, Women Studies and Resource Center, Philippines

Representatives of African Regional Meeting:
• Rosalinda Namises, National Education Legal Assistance Centre, Namibia
• Fatoumata Sow, APAC, Senegal
• Josine Kagoyire, Communication Officer, Asbl Duterimbere, Rwanda
• Joyce Umbina, FEMNET, Kenya

Appendix 3: List of participants

Imtiaz Nuzhat Abbas, Oxfam
UK/I, Pakistan
Lina Abu-Habib, Oxfam UK/I,
Lebenon
Fatima Gebril Adem, Oxfam
UK/I, Sudan
Afrah Al-Ahmadi, Oxfam UK/I,
Yemen
Wilaiwan Angguravarij, Asian
Cultural Forum on
Development (ACFOD),
Thailand
Monique Archer, Interpreter, UK
Maria Betania Avila, SOS-CORPO,
Brazil
Alec Bamford, CUSO, Thailand
Mini Bedi, Community Aid
Abroad Australia — India
Sylvia Borren, De Beuk, Holland
Lynn Branchaud, CUSO, Thailand
Elsie Bravo, Oxfam UK/I, Peru
Rebecca Buell, Oxfam UK/I,
Central America
Mary Cherry, Chair of OXFAM
Trustees, Oxfam UK/I, UK
Annah Colletah Chitsike, Oxfam
UK/I, Zimbabwe
Mal Clare, The Vision Network,

UK
Fiorenza Colby, Interpreter, UK
Hilary Coulby, Oxfam UK/I,
Philippines
Assitan Gologo Coulibaly, Oxfam
UK/I, Mali
Bridget Crampton, Regional
Manager for South Asia,
Oxfam UK/I
Mariam Dem, Oxfam UK/I,
Senegal
Achta Djibrine Sy, Oxfam UK/I,
Chad
Debi Duncan, Emergencies
Officer, Oxfam UK/I, UK
Melka Eisa Ali, Oxfam UK/I,
Sudan
Alda Facio, Ilanud: Women,
Gender and Justice
Programme/Fempress, Costa
Rica
Mary Farries, VSO Thailand
Nynoshca Fecunda, De Beuk,
Holland
Shellu Francis, India
Maria de Lourdes Goes Arauso,
Oxfam UK/I, Brazil
Jane Esuantsiwa Goldsmith,

224

National Alliance of Women's
Organisations (NAWO), UK
Rajamma Gomathy, Oxfam UK/I,
India
Neelam Gorhe, Stree Aadhar
Kendra — SAK, India
Heather Grady, Oxfam UK/I,
Vietnam
Jane Gurr, OXFAM Canada
Angela Hadjipateras, IDS, UK
Arzeena Hamir, CUSO, Thailand
Judith Henderson, Thailand
Morena Herrera, Mujeres por la
Dignidad y la Vida, El
Salvador
Patsy Ho, CUSO, Thailand
Hanan Elhag Hussien, Oxfam
UK/I, Sudan
Luz C Ilagan, Women Studies and
Resource Centre, Philippines
Maureen Ivens, Interpreter, UK
Luisa María Rivera Izábal, Oxfam
UK/I, Mexico
Sue Jenner, Administrator,
Women's Linking Project,
Oxfam UK/I, UK
Juliana Kadzinga Manjenwa, MS
Zimbabwe, Zimbabwe
Josine Kagoyire, Duterimbere,
Rwanda
Deborah Kasente, Makerere
University, Uganda
Nursyahbani Katjasungkana,
Solidaritas Perempuan,
Women's Solidarity for Human
Rights, Indonesia
Amarjeet Kaur, Oxfam UK/I,
India
Gurinder Kaur, OXFAM America,
India
Anna Keene, Interpreter, UK
Shakiba Khawajaomri, Oxfam
UK/I, Afghanistan

Wanjiru Kihoro, ABANTU for
Development, UK
Ruby Lamboll, Overseas
Personnel Officer, Oxfam
UK/I, UK
Daisy Leyva, OXFAM America,
Thailand
Ernst Legteringen, Area Director
(Asia), Oxfam UK/I, UK
Sara Hlupekile Longwe, Longwe
Clarke and Associates, Zambia
Irene Machado, Oxfam UK/I,
India
Arlina C Mahinay, Oxfam UK/I,
Philippines
Carine Malfait, Interpreter,
Belgium
Lajana Manandhar, Oxfam UK/I,
Nepal
Candida March, Coordinator,
Women's Linking Project,
Oxfam UK/I, UK
Dianna Melrose, Policy Director,
Oxfam UK/I, UK
Mercedes Mendoza, Interpreter,
Belguim
Yameema Mitha, Oxfam UK/I,
Pakistan
Joy Morgan, Emergencies Support
Engineer, Oxfam UK/I, UK
Cecile Mukaruguba, ACORD East
Africa, Rwanda
Maitrayee Mukhopadhayay,
University of Sussex, UK
Suad Mustafa Elhaj, Oxfam UK/I,
Sudan
Rosalinda Namises, National
Education Legal Assistance
Centre, Namibia
Nguyen Thi Ha, Oxfam UK/I,
Vietnam
Helen O'Connell, One World
Action, UK

Vishalakshi Padmanabhan, Oxfam UK/I, Cambodia
Pok Panha Vichetr, Oxfam UK/I, Cambodia
Eugenia Piza Lopez, Gender Team Coordinator, Oxfam UK/I, UK
Miho Fujii Plantilla, Asian Cultural Forum on Development (ACFOD), Thailand
Penny Plowman, Oxfam UK/I, South Africa
Pramodini Pradhan, Oxfam UK/I, India
Lily Purba, Oxfam UK/I, Indonesia
Gertrudes Ranjo-Libang, Centre for Women's Resourcees, Philippines
Geraldine Reardon, Documenter, UK
Laura Renshaw, OXFAM America, USA
Rina Roy, Oxfam UK/I, Bangladesh
Sima Samar, Shuhada Organisation, Pakistan
Yvonne Shanahan, Gender Policy Adviser, Oxfam UK/I, UK
Nalu Faria Silva, SOF Sempreviva Organozocáo Feminista, Brazil
Kanchan Sinha, Oxfam UK/I, India
Mary Sue Smiaroski, Oxfam UK/I, Chile
Sue Smith, Gender Team Resource Officer, Oxfam UK/I, UK
Fatoumata Sow, APAC, Senegal
Nick Spollin, The Vision Network, UK
Ellen Sprenger, NOVIB, Holland
Maria Suarez, FIRE, Costa Rica
Caroline Sweetman, Gender Team

Editor/Researcher, UK
Giulia Tamayo, Centro Flora Tristan, Peru
Esther Tegre, Oxfam UK/I, Burkina Faso
Sheila Thomson, Gender and Development Research Institute, Thailand
Christine Trapp, Interpreter, UK
Joyce Umbima, FEMNET, Kenya
Ingrid van Tienhoven, NOVIB, Holland
Sonia Vásques, Oxfam UK/I, Caribbean Regional Office
Michael Vincent, Trading Director, Oxfam UK/I, UK
Mike Wade, Direct Marketing Executive, Appeals, Oxfam UK/I, UK
Bridget Walker, Gender Policy Advisor, Oxfam UK/I, UK
Galuh Wandita, Oxfam UK/I, Indonesia
Hui-chang Wang (Lan), Tigress Press, Thailand
Ara Wilson, Thailand
Faizun Zackariya, Oxfam UK/I, Sri Lanka